700 Z

ime to play : action
and interaction in
contemporary art /

700Z 3/15
 KD

Katarzyna Zimna is an artist and researcher based in London and Łodz, Poland. Her work has featured in exhibitions across Europe. She teaches at the Institute of Architecture of Textiles at the Łodz University of Technology.

Time to Play

Action and Interaction in Contemporary Art

Katarzyna Zimna

I.B. TAURIS
LONDON · NEW YORK

Published in 2014 by I.B.Tauris & Co Ltd
6 Salem Road, London W2 4BU
175 Fifth Avenue, New York NY 10010
www.ibtauris.com

Distributed in the United States and Canada Exclusively by Palgrave Macmillan
175 Fifth Avenue, New York NY 10010

ISBN: 978 1 78076 303 3
eISBN: 978 0 85773 625 3

A full CIP record for this book is available from the British Library
A full CIP record is available from the Library of Congress

Library of Congress Catalog Card Number: available

Printed and bound by CPI Group (UK) Ltd, Croydon, CR0 4YY

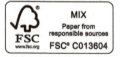

Contents

Illustrations

Acknowledgements

Time to Play emerged from my doctoral work at Loughborough University School of Art and Design. I am deeply grateful to my supervisors: Dr Jane Tormey and especially Dr Malcolm Barnard, who encouraged me to stray off the beaten track in pursuing my research and introduced me to the writings of Jacques Derrida. He was also the first to suggest that the results were worth publishing as a book.

I would like to thank artists and curators who gave their generous permission to reproduce images of artworks and actions.

I am also thankful to Anna Coatman from I.B.Tauris who guided me through the final months of the editorial process and to Hannah Wilks for expert copy-editing.

For providing some of the time to work on a book I am grateful to the Department of Visual Arts, Institute of Architecture of Textiles at the Łodz University of Technology.

My big thank you goes to my family – my parents Ewa and Jurek, my brother Grześ and my husband Artur for their love, positive energy and support.

I dedicate this book to my daughter Antonina who, quite recently, has given me a new and joyful perspective on play.

Introduction

Terms like 'play', 'playground' and 'playful' have become a part of the common art vocabulary in recent years. 'Play' means orientation towards the process, experimenting, stepping into different 'realities', treating viewers as playmates and changing identities. It is, in most cases, seen as better than the old-fashioned, deadly serious art-making – it seems to be more 'natural' and promises a liberation from notions of production, mastery and authority. This book investigates where this idea has come from and assesses its usefulness in analysing and explaining art.

Although *play* and *game* are recurring metaphors and rhetorical tools in critical or philosophical writing on art, play hardly ever figures in the lexicon of 'key concepts' of art. Despite its acknowledged links with creativity, it seems to be a neglected and marginalized notion in the discourse of art and aesthetics.[1] This project attempts to fill this gap, at least as an introduction to further studies, and to combine a cross-disciplinary analysis of the concept of play and its philosophical implications with the examination of the actual uses of play in the artistic practice.

When I first began to research 'play' in the context of art I was inevitably guided by popular preconceptions and connotations such as freedom, innocence, untamed creativity, fun and improvisation. I was attracted to the concept of play and the associations it evoked: pretence, make-believe, masks, carnival, alternative reality, micro-world or safe experiment. However, the notion of the 'artist as a playing

child' was for me a synonym for irresponsibility, detachment from 'real life' problems and superficiality. The most important aim of this research has become, therefore, to investigate how the idea of play can be approached in the context of art when we go beyond the popular interpretations of play. I was interested in finding out whether play is an important structural element of the concept of art, or whether it merely belongs with clichés and marginal phrases, strengthening stereotypical and ill-informed views on *avant-garde* artistic experiments. If 'play' is more than just a cliché, how has it contributed to or taken part in the development of contemporary art? How has it been interpreted and used?

There exist various, often contradictory, perspectives on play as a biological, cultural or social phenomenon, as well as theoretical positions locating play within aesthetics. Play, as an activity familiar to everybody, is often used as a point of reference or a metaphor, without an awareness of its complex conceptual connotations. Due to its ambiguous nature, it also easily becomes subject to various rhetorics. An important task of this book is to arrive at an approach to play that would be useful as a research tool in the analysis of artistic practices, and would avoid the ideological or aesthetic reductions of this concept to a set of desirable features. Philosophical, sociological and art-historical perspectives are combined to provide a multi-layered image of play and its interpretation in the context of art. Play is approached as both an 'internal' element of artistic activity or the concept of art (following the philosophical tradition), and as the 'external' model for the creative process (as applied in modern and postmodern art).

The title *Time to Play* refers to the *Zeitgeist* of our era of postmodern flux and hybrid identities, the ongoing and omnipresent spectacle of war and carnival in mass entertainment, film and media, virtual reality and avatars, virtual friends and graveyards, relative values and the crisis of religion: all of which seems to point to 'play' as an important, albeit ambiguous, driving force of cultural and artistic production. This book tries to capture the most seminal theories, ideas and practices that supported development of the 'playful' outlooks, tactics and strategies in recent art. It mainly focuses on process-based art, since the shift from art as production of objects to 'art as experience' can be seen as symptomatic of the general cultural 'turn to play'. 'Action' in the subtitle refers to projects that are

process-oriented, participatory or interactive, based on performance, using art objects as props or environments. 'Interaction' in the subtitle does not simply mean 'interactivity', but should rather be interpreted, in the specific play-oriented context of this book, according to the meaning of the Latin prefix *inter-*, as 'action-between'. This action or operation 'in between' the opposite or distant frames of reference, texts, media, identities, rules, conventions, 'worlds' in time and space seems to be the most vital characteristic of play as aesthetic criterion of contemporary art. In other words, 'action' describes performative, often play- or game-like forms of recent art, while 'inter-action' describes the operation of 'play' as a philosophical notion, an 'internal' element of the concept of art and its contemporary manifestations in particular.

Structure of the Book

Time to Play explores the role of play as a central but overlooked concept in aesthetics and as a model for ground breaking modern and postmodern experiments that have intended to blur the boundary between art and life. The main purpose of the book is to unpack a seemingly neutral and taken-for-granted notion of play, to go beyond well-established but one-sided views of it and to offer play as a useful and refreshing concept in contemporary art theory.

The book is interdisciplinary – it links the theory and history of twentieth and twenty-first century art with ideas developed within play, game and leisure studies, and philosophical theories by Kant, Gadamer and Derrida among others – in order to critically engage with the current discussion about the role of the artist, viewers, curators and their modes and spaces of encounter. It proposes to look at the development of the concept/model of play in art as a series of moments that have achieved their most advanced and widespread application in postmodern thought and artistic practice. This general agenda is pursued through the following steps. The remaining pages of the introduction explain the use of terms (e.g. the relation between the notions of play and game) and discuss the well-established modern approaches to play, coming from the different disciplines of natural and human sciences. This brief overview of play theories is indispensable because scientific interpretations of play have

conditioned many different manifestations and uses of play as a concept and as a creative tool in modern and postmodern art.

Chapter 1 briefly discusses two modern perspectives on the role of play in art (rational and pre-rational) and argues that they are supportive of two opposite models of the aesthetic experience. Revisiting the notion of play as introduced in Kantian aesthetics helps to elucidate its consequences for modern art theory and practice (aesthetics of autonomy) and to highlight modern *avant-gardes'* interpretations and uses of play (Dada, Surrealism, Marcel Duchamp) that opposed the Kantian 'rational' view of play. The pre-rational view of play in modern avant-gardes is analysed in connection with the trend of Primitivism and its metaphysical myths. Michel de Certeau's term 'strategy' is used to point out the conscious use of play as a creative model and a conceptual attitude, applied by modern artists to oppose the dominant, official cultural and social conventions. Additionally, this chapter examines the philosophical position of Hans-Georg Gadamer which can serve as an explanation of pre-rational interpretations of play in the context of art.

Chapter 2 redefines play in the context of post structural thought, with the help of Derrida's concepts of *parergon* and *pharmakon*; it also quotes earlier ideas by Mikhail Bakhtin ('the carnivalesque'). It offers an interpretation that goes beyond the modern dichotomy of play as alienated fiction or source of truth beyond culture and representation as well as other dichotomies such as: creativity/ repetition, creation/destruction, serious/frivolous, self/other. The second part of this chapter analyses postwar *avant-garde* art and its relations to the idea of play (in John Cage, Fluxus, Allan Kaprow, performance art), pointing out diverse sources of inspiration including the ideas of Zen Buddhism, John Dewey's book *Art as Experience*, the development of the entertainment industry (Disneyland) and the philosophical background of the notion of 'dark play' in the work of Nietzsche, de Sade and Bataille.

By applying Michel de Certeau's differentiation between 'strategy' and 'tactic', Chapter 3 analyses the transition between modern and postmodern uses of play in artistic projects. The main task of this chapter is to discuss the mechanisms and dynamics of recent participatory and process-oriented projects, focusing on the issues of relations and interactions among participants, the rules and structure of events, the

new roles of artists, viewers and institutions in process-oriented art, as well as the redefined notion of representation, with the use of concepts coming from the world of play.

General analysis of the sociocultural background of the 'playful *Zeitgeist*' affecting postmodern art and culture is carried out in Chapter 4. It briefly presents the evolution of the concept of 'work' in relation to the notions of 'work' and 'play' of art, and discusses possible changes in the structure of *ergon* and *parergon* ('proper function' and 'dangerous/attractive supplement') within the concept of art, brought about by the use of the strategy and tactic of play by twentieth and twenty-first century artists. It refers to the growing popularity of the concept of play in theoretical writing on art and culture as well as in curatorial practice. This chapter also argues that the redefined notion of play can become a useful criterion of the new aesthetics based on the states of dysfunctionality, unproductivity, ambiguity and being on the move – 'in between' solid narratives, outlooks and conventions.

What is Play?

The analysis of play, in any context, is to a large degree inimical to play's charm and attractiveness. I inevitably act as a killjoy by unveiling the various rhetorics of different uses of play in modern and postmodern art. Nonetheless, it is an exciting journey and a rewarding process, although not necessary 'playful'. But is play simply fun?

'Play' is a concept belonging to many fields of theoretical discourse: from biology to theology, aesthetics and politics, among others. It is also the name of an activity, easily recognized in its various manifestations, but impossible to pin down or define decisively. The tacit understanding of what play is may be stereotypical or influenced by one of the competing historical views on play. Although, to some extent, play *is* what we decide it to be, it is necessary to briefly introduce the most seminal interpretations of this concept to provide the theoretical background for this book.

The scope of play-related areas of study is far too broad to be addressed here. Many important nuances coming from pedagogy, psychology and biology will inevitably be left out. Due to the character of this book, I will mainly focus on approaches to play as a cultural phenomenon. The following pages are intended as an indispensable

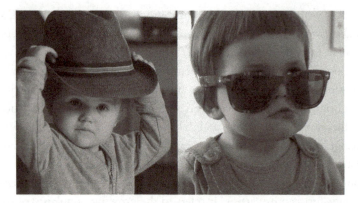

Figure 1. First steps into the world of play: Antonina (15 months) playing with her father's hat and her mother's sun-glasses (photos by Grzegorz Walendzik)

'glossary' of names, terms and perspectives that will be referred back to throughout the book.

Child's Play

Children's play is the most immediate image that comes to mind when we think of play. It is the activity of play as we all know it. It is a familiar, if distant, world of make-believe, physical competition or games of chance. Our tacit knowledge of what play is comes from this experience. Childhood with its play occupations can be seen as

> the tunnel we all pass through, those early years of wandering toward the light as we dream ourselves up. It forms us; it makes us who we are. And once we've left the tunnel, we begin to forget, lose what we knew and felt back there and peer longingly behind us into its deep, plush darkness.[2]

The experience of play as we know it from childhood and everyday observation evokes a series of key phrases in describing play: joyful, non-serious, sometimes mysterious or irrational and opposed to the sphere of purposeful adult activities. However, play can also be regarded as a functional cognitive tool – a way to make sense of the world.

Children explore multiple worlds and perspectives as they move in and out of their play. As astronauts and space travellers children puzzle over the future; as dinosaurs and princesses they unearth the past. As weather reporters and restaurant workers they make sense of reality; as monsters and gremlins they make sense of the unreal.[3]

In scientific discourse the interpretations of the functions of play vary according to the applied perspective. The earliest modern theories of play, focusing mainly on animal and children's play, were influenced by Darwin's theory of evolution, and they treated play as a decisive factor in animal and human development. In his 1855 *The Principles of Psychology*, Herbert Spencer formulated a surplus-energy theory of play, in which he describes it as the release of energy not utilized in the struggle for survival: play is, then, a substitute for serious activities, performed in their absence. Spencer's views were criticized by Karl Groos on the basis that they were not applicable to all play. Instead, he proposed in *The Play of Animal* (1896) and *The Play of Man* (1899) that play should be seen as a practice of skills. According to Groos, children follow their instinct to rehearse adult activities, so play must be seen as 'training', a 'pre-exercise' for life.

Twentieth-century theories of play in the fields of education and psychology continued to analyse play as a positive evolutionary factor. According to Jean Piaget,[4] play is an important aspect of learning, which helps to integrate new experiences into the motor and cognitive skills available at each age, and to strengthen the structures a child has already learnt. Piaget's theory 'gives play a clear biological function as active repetition and experiment which "mentally digest" novel situations and experiences'.[5] However, this locates play as an important but secondary aspect of cognitive growth – it helps to consolidate skills by repetition, but does not contribute to the acquisition of these skills. Play is then distinguished from intelligence, and does not have a cognitive value itself. It is seen by Piaget as a predominantly infantile stage of development.[6]

According to Lev Vygotsky's sociocultural theory of children's play, a child's development cannot be analysed solely as a steady growth of intellectual functions: 'It seems that every advance from one stage to another is connected with an abrupt change in motives and incentives to act.'[7] According to Vygotsky, make-believe play

originates as symbolic wish-fulfillment and is invented at the point when 'unrealizable tendencies appear in development'.[8] Play serves as the illusory realization of dreams and aspirations within an imaginary setting. A child can learn 'to guide his behavior not only by immediate perception of objects or by the situation immediately affecting him but also by the meaning of this situation'.[9] This helps children to separate thought from the object and immediate experience, and in consequence, develop consciousness, abstract thinking and imagination.

Psychoanalytic theorists such as Anna and Sigmund Freud, Erik Erikson and Donald Winnicott considered play the most important way in which children deal with unconscious emotions and express, indirectly or symbolically, suppressed feelings and fears. According to this view the main function of play is *catharsis*. Repetitive play helps children to master a situation and learn how to deal with stress in a safe context. Children in play create their own versions of past events and scenarios for the future, to satisfy their emotional needs. A child 'uses objects and situations from the real world of his own in which he can repeat pleasant experiences at will, and can order and alter events in the way that pleases him best'.[10] According to Sigmund Freud, play is a compensatory activity, but also one linked with violence, allowing the child to take 'revenge' on reality in the situation of play.[11] Erikson and Winnicott, however, regarded play as an essentially positive and creative activity, whose 'dark' sides (instincts, bodily excitement) can be controlled through rules and adult supervision: as Winnicott famously wrote, 'in playing, and perhaps only in playing, the child or adult is free to be creative'.[12] His important contribution to play studies, in the context of child development, is his theory of transitional objects (pieces of cloth, soft items, toys) that constitute the intermediary agents in between the narcissist self of the infant and the external world. In *Playing and Reality* (1971) Winnicott explains that the significance of these transitional objects is vested not so much in the object as such but rather in 'the use of the object'.[13] Therefore, it is the process of manipulating the object – the process most often identified as playing – that acts as mediation between subjectivity and objectivity, internal and external worlds, self and other.

The position statement *Play: Essential for all children* (2002) by the Association for Childhood Education International summarizes

the most important functions attributed to children's play, regarding it as a 'constructive behaviour', essential for healthy growth and development:

> Psychoanalysts believe that play is necessary for mastering emotional traumas or disturbances; psychosocialists believe it is necessary for ego mastery and learning to live with everyday experiences; constructivists believe it is necessary for cognitive growth; maturationists believe it is necessary for competence building and for socializing functions in all cultures of the world; and neuroscientists believe it is necessary for emotional and physical health, motivation, and love of learning.[14]

Play Rhetorics

Theories of children's play embed the analysis of play within the study of human development, and interpret play according to the interests and traditions of this field. The same can be said about any discourse that refers to play from other perspectives, including art and aesthetics. What is more, according to American play scholar Brian Sutton-Smith, our approach to play is always linked with the rhetoric we use to contextualize it. He identifies four main 'play histories' or, as he puts it, 'historically derived persuasive discourses' that frame play studies across the disciplines: play as *progress* (development, learning); play as *power* (competition, challenge, conflict); play as *fantasy* (imagination, freedom, creativity) and play as *self* (self-actualization, optimal life experience).[15]

This book is intended to guide readers across the dominant 'stories' of play and to expose their narratives, rather than to follow them. Sutton-Smith rightly suggests that, typically, play 'arrives in already existing collective packages, where the passions and the procedures are well prescribed'.[16] These 'packages' include specific interpretations of the concept of play which belong to various traditions of thought. It is important to become sensitive to where a particular interpretation or use comes from, how it is inscribed in a broader context and what effects are 'prescribed' by the 'producer' of the given narrative. In other words, there are no transparent or universal applications; they all serve specific needs; they are different representations of play. It is vital to

keep this in mind while discussing social and cultural manifestations of play and their premises.

Mihai Spariosu, in his study *Dionysus Reborn* (1989), on the operation of the concept of play in modern philosophy and science, argues that different approaches to play in Western thought come from two competing and opposite poles – 'rational' and 'pre-rational'. His whole analysis is inscribed in the rhetoric of power; he sees play concepts as subordinated to a 'power principle'.[17] As he writes:

> prerational thought generally conceives of play as a manifestation of power in its 'natural', unashamed, unmediated form, ranging from the sheer delight of emotional release to raw and arbitrary violence. Power can be experienced both as ecstatic, exuberant, and violent play and as a pleasurable welling up and gushing forth of strong emotion. Rational thought, in contrast, generally separates play from both unmediated or 'innocent' power and raw violence. Indeed, it sees play as a form of mediation between what it now represses as the 'irrational' ... and controlling Reason ...[18]

According to Spariosu, the pre-rational narrative characterizes play as vital, untamed and chaotic; it is a chance play related to archaic theories of the cosmos as a power game played by gods. It is also strongly connected with bodily powers – the players immerse themselves in play, in the direct sensual experience. In 'pre-rational' play, participants are both players and playthings – they are not in total control of their actions. The 'rational' notion of play separates play from 'unmediated power';[19] it is, therefore, non-violent and productive, although it remains competitive. This is play praised as beneficial exercise for the young, supporting healthy growth and development. Rational thought subordinates play to rules and conventions, limits the chance element and exposes communicative and representational aspects of play.

The classification of games proposed by Roger Caillois in *Man, Play and Games* (1958) can be inscribed within Spariosu's distinction to make it explicit. Caillois divides play forms according to the dominant element: competition (*agôn*), chance (*alea*), simulation (*mimicry*) and vertigo (*ilinx*).[20] Examples of the play of chance and vertigo, as experiential and non-rational activities beyond the subject's control,

are most often used to support the pre-rational interpretation of play. Competition play and simulation (make-believe) maintain the rational image of play, as controlled by the subject.

The opposing discourses above, identified by Spariosu, correspond with the most common rhetorics of play that continually reappear in the history of Western thought. However, none of them is to be seen as an ultimate matrix for play's 'real' nature, simply because this 'real' nature does not exist. It is a matter of constant negotiation or struggle between various perspectives, which subscribe to 'pre-rational' or 'rational' interpretations of play. Spariosu's approach provides a very useful research tool, although inevitably simplified. Nonetheless, it is possible to look at different theories and uses of play as following or tending towards one view or the other. In most cases, however, these two narratives coexist in various, often paradoxical, configurations, and they also structure the historical interpretations of the relationship between play and its opposite concepts: work, reality or seriousness.

Homo Ludens ('Man the Player')

Johan Huizinga's influential study of the play *Homo Ludens* (1938) judges biological and developmental approaches to play (i.e. 'discharge of vital energy', 'imitative instinct', 'need for relaxation', 'abreaction', 'wish-fulfilment', etc.)[21] to be inevitably fragmentary and partial. As he writes, 'It would be perfectly possible to accept nearly all the explanations without getting into any real confusion of thought – and without coming much nearer to a real understanding of the play-concept.'[22] He criticizes the basic assumption behind these theories: that 'play must serve something which is not play'.[25] According to him, the search for the biological function of play reduces it to an instinct and marginalizes its role in human life. The intensity, absorbing nature and fun of play activities 'find no explanation in biological analysis'.[24] In fact they cannot find explanation there, because, as he writes, play should be rather approached as a 'function of culture proper', 'a social construction' and 'one of the main bases of civilisation'.[?] Huizinga categorically opposes play as physiological and material; for him play is a 'meaningful' activity, which implies a 'non-materialistic' quality.[26]

Importantly, however, he remarks that 'although play is a non-material activity it has no moral function. The valuations of vice and virtue do not apply here.'[27] Huizinga locates play as separate from the 'domain of the great categorical antitheses' such as wisdom and folly, truth and falsehood, good and evil.[28] Nonetheless, he focuses his analysis on 'the higher forms of play' – its social and cultural manifestations – as opposed to 'primitive' or infantile forms of play, which are dismissed as 'pure playfulness'.[29] Due to the focus on the 'rational' and symbolic forms of play, and the omission of irrational or instinctive impulses, Huizinga's conceptualization of play has served as a point of departure for the majority of culture-oriented studies of play. As Hector Rodriguez remarks

> The philosophical starting point of Huizinga's study is the observation that, where there is play, there is also 'meaning'. Playing makes sense to the player. Most games presuppose a player consciously aware of the game's objectives, equipment, and rules.[30]

Huizinga describes play as a voluntary activity, performed with no practical or material interest, just for fun and with pleasure. Play is disinterested; it is an activity pursued for its own sake. The quality of freedom and non-obligation distinguishes play from the 'natural process' (reality). Although play seems inferior to 'reality', according to Huizinga, it 'may rise to the heights of beauty and sublimity that leave seriousness far beneath'.[31] Play, as he writes, 'is something added there-to and spread out over it like a flowering, an ornament, a garment'.[32] Play is therefore necessarily 'marginal', superfluous and relegated to spare time. It must never be regarded as a task – it is neither physical necessity, nor moral duty. One can cease playing at any time to switch to real-life obligations. To play means to step out of 'ordinary' or 'real' life – players are always aware of the border between real, 'serious' activities and the world of play, the 'only pretending' mode of behaviour.

Huizinga also stresses that play is limited in time and space and structured by a certain set of rules. These features constitute the world of play, or as Huizinga puts it, the 'magic circle'[33] of play demarcated from ordinary life – often located in 'forbidden spots, isolated, hedged round, hallowed, within which special rules apply.

All are temporary worlds within the ordinary world, dedicated to the performance of an act apart.'[34]

The rules of the play or game have, according to Huizinga, a civilizing and cultural function. They test the player's ability to resist violent impulses and they impose order within the world of play – 'a temporary perfection'[35] – as distinct from the chaotic and imperfect ordinary world. In Huizinga's view this affinity between play and order situates play within the field of aesthetics.[36] The impulse to create an 'orderly form' animates play and makes it an 'enchanting and captivating' experience for the players.[37] As Huizinga writes, '[p]lay has a tendency to be beautiful': 'It is invested with the noblest qualities we are capable of perceiving in things: rhythm and harmony.'[38]

A person who ignores these rules (a 'spoilsport') destroys the illusion of the 'magic circle':

> By withdrawing from the game he reveals the relativity and fragility of the play-world in which he had temporarily shut himself with others. He robs play of its *illusion* – a pregnant word which means literally 'in-play' (from *inlusio, illudere* or *inludere*). Therefore, he must be cast out, for he threatens the existence of the play-community.[39]

This play-community, the group of players, becomes bonded by the world of play, the shared code, 'language' and rules they temporarily abide by, different from the ordinary or 'real' ones. However, the formation of a closed group with specific rules and conventions of behaviour, entails the notion of exclusion as well as that of togetherness. This feature of play – its ability to bond and to antagonize, to initiate 'real-life' friendship or conflict – points to the seriousness of this seemingly non-serious human occupation.

As the main functions of the 'higher forms of play', Huizinga specifies a 'contest *for* something and representation *of* something'[40] ('competition' and 'simulation' play, in Caillois's classification). Representation in play can take the form of a simple 'display' or, in more advanced forms, a 'realization in appearance' – an imaginary stepping-outside oneself and ordinary reality.[41] In ritual it becomes mystical and is believed to cross the boundary between fiction and reality – to produce real-life consequences.

The word 'represents', however, does not cover the exact meaning of the act, at least in its looser modern connotation: for here 'representation' is really *identification*, the mystic repetition or *re-presentation* of the event. . . . The function of the rite, therefore, is far from being merely imitative; it causes the worshipers to participate in the sacred happening itself. As the Greeks would say, 'it is *methetic* rather than *mimetic*'.[42]

Huizinga suggests that play, in the form of ritual celebration, can cross the frame of fiction and evoke the 'presence' of the sacred event (non-representation). The above quotation can serve as a 'signpost' to the performative functions of play utilized in the contemporary discourse on artistic representation. As will be discussed in Chapter 3, *methexis*, a Greek term describing 'the relation based on participation' in the transformative rites of passage, has recently been applied as a 'non-representational principle' in performative and materialist accounts of creative practice.[43] However, this book will argue that both *methexis* and *mimesis* – direct performative experience *and* symbolic or imitative act – jointly structure the notions of play and representation.

Drawing on Huizinga's analysis, Roger Caillois lists the defining features of play as follows. It is:

1. free: not obligatory;
2. separate: restricted within limits of space and time;
3. uncertain: its course cannot be determined, and some latitude for innovations being left to the player's initiative;
4. unproductive: creating neither goods, nor wealth, nor new elements of any kind;[44]
5. governed by rules: under conventions that suspend ordinary laws;
6. make-believe: accompanied by a special awareness of a second reality.[45]

It is worth stressing that although Huizinga, in 'rational' fashion, refers to 'higher forms of play' as superior to biologically determined, infantile playful impulses and praises play for its ability to impose order and temporary perfection, he also uses 'pre-rational' rhetoric to describe certain aspects of play, i.e. he locates play beyond moral constraints and points out the *methetic* quality of ritualistic 'play'. His

account serves, therefore, as a good introduction to the discussion on the role of play in the context of artistic representation.

Play as a Frame

The connection between play and representation has been strengthened by Gregory Bateson in 'A Theory of Play and Fantasy' (1955), who approached play as a form of communication. Bateson identified two types of abstraction in human verbal communication: metalinguistic (about language) and metacommunicative (about the communication process and the relationships between the speakers, e.g. 'My telling you where to find the cat was friendly').[46] According to him, play can occur only when the participating individuals are capable of some degree of metacommunication, 'of exchanging signals which would carry the message: "this is play"'.[47] From this perspective play becomes an important agent in the evolution of communication, because of the use of signals that have a double meaning – that denote play *and* the activity which in other circumstances is not play. In other words, play is a form of representation; it consists of signals standing for something else (events, behaviours, identities). Bateson describes these communicative signals in play with Alfred Korzybski's map-territory metaphor: 'A map may have a structure similar or dissimilar to the structure of the territory. A map is not the territory.'[48] In the context of play this can be paraphrased as: 'Play consists of certain behaviours, gestures and situations which are similar or dissimilar to "real life" events. Play is not "real life".' However, according to Bateson, in some forms of immersive play (like gambling) and in play's derivative activities

in the dim region where art, magic, and religion meet and overlap, human beings have evolved the "metaphor that is meant", the flag which men will die to save, and the sacrament that is felt to be more than "an outward and visible sign given to us". Here we can recognize an attempt to deny the difference between map and territory, and to get back to the absolute innocence of communication by means of pure mood-signs.[49]

Play – although it is always a form of representation, a metacommunicative 'frame' transforming and delineating otherwise 'ordinary'

activities – can in certain circumstances delude the players into ignoring the frame, confusing the 'map' with the 'territory'. Such approach annihilates play. However, paradoxically, to maintain the frame of fiction, the players must keep it transparent, and behave 'as if' it does not exist. According to Bateson, in play, 'map' and 'territory' must be *both* equated and discriminated; the players must be aware that 'this is play' and at the same time act 'as if' it is not. This feature makes play an ambiguous experience located in between reality and fiction. Nonetheless, the 'transparency' of the frame and the play's close connections with 'reality' encourage non-representational narratives treating play as an ordinary activity.

Mihai Spariosu challenges Bateson's theory on the grounds of power relations. He asks: What if the players are not equals? What if it is only one participant who sees the activity as play? For Spariosu, play is not always intersubjective or always metaphorical and abstract: 'it is far from being exclusively nonviolent and rational, as Bateson's theory presupposes'.[50] It seems that Bateson's theory accurately describes the general operation of play; however, it does not prevent particular uses of play being loaded with power relations. The border between play and reality is also often difficult to trace. This issue will recur in Chapter 4, in the discussion on the uses of play in recent participatory art.

Play/Game

Elliott Avedon and Brian Sutton-Smith in their book *The Study of Games* (1971) clearly distinguish games from general play activities. According to them, games 'are repeatable because of their systematic pattern and their predictable outcomes. Play, on the other hand, is less systematic, and is open-ended with respect to outcomes.'[51] Katie Salen and Eric Zimmerman in a more recent study refer to games as 'systems' – contexts for player's interaction structured by rules,[52] which have a 'quantifiable goal or outcome' and always 'embody a contest of powers'.[53]

However, this division is not always functional. As Avedon and Sutton-Smith admit, forms of play/game exist that cannot be easily classified.

For example, there is yet another group often called either pastimes or games such as ring-a-rose, nuts-in-May, which have similarities with dance, drama, and song. These are games in the sense that they are organised (rules) and have a fixed sequence of actions (plot) and a resolution (outcome). However, they are not usually competitive, they do not usually have winners, and in fact they are often so cooperative that they are organised by ritual (fixed sequence) rather than rules (contingent sequence).[54]

Another, more contemporary form that is neither game nor play according to the aforementioned definitions, beside non-ritualized pastimes, is the non-digital, traditional role-playing game (RPG) such as *Dungeons & Dragons*. This is a collective, collaborative type of 'game', 'which allows a number of players to assume the roles of imaginary characters and operate with some degree of freedom in an imaginary environment'.[55] Unlike 'typical games', RPGs do not feature competition among players (as a goal of the game); instead the players form a team, members of which have to support each other and collaborate. What is more, 'rules and outcomes do not have the inevitability that they possess in most formal games, rather both features are negotiated, and rules are adjusted by the referee [game master] and his group'.[56] RPGs provide the players with the immersive experience of becoming someone else in an alternative reality. They are based on communication and make-believe, but also include an element of chance, since some moves and decisions are based on the dice throw. I have decided to restrict the scope of my discussion to traditional RPGs, as opposed to digitized/computer games like MMORPGs (massively multiplayer online role-playing games), because the traditional forms serve better as a model to describe the dynamics and forms of relations in recent participatory artistic practices (Chapter 3). However, some of my argument also applies to non-competitive digitized games. This example also shows that the boundary between play and game activities is not as easy to establish as it may seem.

Roger Caillois in his seminal book *Man, Play and Games* (1958) theorizes the opposition between play and game as the *paidia* and *ludus* elements of the play concept. According to him, *paidia* is a primitive

and basic impulse covering an immediate and disordered agitation; an impulsive and easy recreation, but readily carried to excess. It is a principle 'common to diversion, turbulence, free improvisation and carefree gaiety'.[57] *Ludus* is the structure of more developed forms of play – with rules and limits, customs and institutions in which a particular culture is rooted.[58] *Ludus* requires skill, patience and effort, but it is nonetheless 'completely unpractical'. In his analysis, Caillois stresses that all forms of play consist of these two ingredients in different proportions. There is no such thing as a 'pure' *ludus* or 'pure' *paidia* form of play. *Ludus* disciplines *paidia* ('a reservoir of free movement')[59] and *paidia* supplements *ludus*, which 'seems incomplete, a kind of makeshift device intended to allay boredom'.[60] In other words, the 'pre-rational' *paidia* (play) and 'rational' *ludus* (game) are interconnected elements of one play concept or activity.

Consequently, this book does not divide the concept of play into a play - or a game-type. It approaches game as a particular use or manifestation of empirical play. Nevertheless, since this distinction exists in language and in everyday use, some play forms will be referred to as games.

The relation between the activities of play and game can also be considered in the context of the theory of creativity. As Rob Pope writes, the dynamics between 'free play' and 'bound game' follow the relation between creativity and constraint.[61] However, as he stresses, both aspects have to be in balance for the creative act to emerge. Rules of the game can be shifted in the process of playful improvisation, thus they are a condition of transgression: 'Constraint is not a barrier to creative thinking, but the context within which creativity can occur.'[62]

Play as a Paradox

As the above theories of play show, it is impossible to give a precise and satisfactory definition of play that would not fall into the trap of certain one-sided or simplifying narratives. One of the possible solutions to this problem is to approach play using Wittgenstein's idea of 'open concept' as constituted by 'family resemblances'.[63] It is also justified to simply treat play as a concept based on ambivalence. The contradictions inevitably break into any attempt to define play.

Norman Denzin in *The Paradoxes of Play* (1982) aptly describes its ambiguous nature:

> Play is a recurring interactional form whose content and substance must be established on every occasion of its occurrence. Recognizable and familiar, evidenced in divergent cultural, ethnic, racial, age-sex graded communities, play is ineffable, always novel and unique; never the same, yet somehow always the same.[64]

Denzin, after Bateson, approaches play as a frame for action. Within this frame, as he writes, 'persons find themselves playing'. The shift from infinitive to gerund reveals the flexible and mobile character of play and locates it primarily as a social process. This process is deeply embedded in 'reality': 'the world of play is not – as Caillois, Huizinga and others would have it – distinct from and apart from everyday taken-for-granted reality. It occurs in the immediately experienced here-and-now.'[65] However, importantly, this process simultaneously holds out the possibility of being somewhere else, being someone else, and to some degree fulfils this promise. This close relationship of the players with the directly experienced 'reality' of the game is the starting point for creative interpretation and the processes of representation which occur in play: '[play] is at the same time in and out of reality'.[66] Play can be approached as both experience and representation.

Denzin also stresses that play contains elements of doubt, risk, threat and uncertainty: 'What play threatens is the player's body and the player's felt definition of self in the moment.'[67] Play must therefore be seen as stretched between safety and danger. It suspends or modifies rules of the given 'reality', thus potentially creating a 'safety zone', but also establishing an alternative which challenges the routine (the usual identifications and patterns of behaviour). The tension between familiar and unfamiliar, safe and risky, oneself and the other, repetition and experiment, reality and fiction, constitute the unique position of play. As Denzin summarizes:

> There is more to play than the recognition of a paradox of logical types; play transcends communicative and metacommunicative contradictions. It is, as I have suggested, a historically based, emotionally laden, physically embodied, relationally specific form of

Figure 2. *Alice trying to play croquet with flamingo and hedgehog,* illustration by John Tenniel, 1886

social interaction that turns on threat, histrionics, ritual, doubt and uncertainty.[68]

Play cannot be therefore defined as either 'rational' (communicative, subjective, controllable) or 'pre-rational' (violent, excessive, sensual); as either *ludus* or *paidia*; as either didactic tool supporting development or liberation from all constraints. Its existence relies on the ambivalence – on the movement 'in between' the opposites. As I will argue in the following chapters, this feature of play (both as empirical activity and philosophical concept) makes it a leading aesthetic criterion and important model for art projects in postmodern art, and process-based art in particular.

1

Modern Perspectives on Play

In the introduction I briefly presented various modern perspectives on play developed within the human and natural sciences. From these theories emerges an image of play as a disinterested, experiential and metacommunicative frame and as a process in which activities, gestures and objects do not only shape an experience 'as self' but also become 'something else'. I stressed the ambiguous character of play as stretched between opposite poles on many different levels: between reality and fiction, experience and representation, rules and freedom, safety and danger, and so on. After Mihai Spariosu, I also referred to two competing (and complementary) modes of Western thought – pre-rational and rational – that have structured historical interpretations of play.

The distinction between 'rational' and 'pre-rational' perspectives or narratives is useful in systematizing modern interpretations of play within the fields of art and aesthetics. The main purpose of this chapter is to examine the consequences of interpreting play as either 'rational' or 'pre-rational' in modern theory and practice of art. I will argue that there is a connection between this interpretation and the underlying notion of representation – the rational position uses play to support the traditional concept of representation, while the pre-rational one most often sees the 'play of art' as a domain where subjectivity and authorial control 'dissolve'. When one applies the pre-rational perspective to artistic practice, play becomes a tool to evoke 'experience' instead of 'representation', to reveal 'being' instead of representing it.

The present chapter will also briefly refer to the work/play dichotomy in the context of art, which will be further developed in the next chapter. As I will argue there, the traditional notion of representation is strongly influenced by the rational concept of work, which since Plato and Aristotle has evoked connotations with 'proper' function, hierarchy and order. In the present chapter I will discuss the impact of Kant, who introduced play as a condition of 'fine art'. In my view his aesthetic theory marks a turning point from work- to play-oriented approaches. However, its 'rationality' and subject-oriented character, and its contribution to the process of alienation of art, made Kant's theory a convention to be challenged in modern and postmodern art. Consequently, the 'pre-rational' notion of play has become a tool for avant-garde artists to oppose the traditional 'rational' post-Kantian concept of artistic representation.

'Rational' Play of Art

The notion of play as a 'rational' activity separates play from the 'unmediated power'[1] and the processes of life. This separation occurs due to the mediation of reason, language and cultural conventions. From this perspective, play is treated primarily as a process of communication initiated by the players who consciously suspend the ordinary rules and apply the alternative ones, which do not affect 'real life' consequences and practical outcomes. The domain of play becomes a 'magic circle', distinct from 'reality'. Importantly, from the rational point of view, players are in control of their play. Play is disinterested and it lacks objective purposes, but it is, nonetheless, functional. It supports education and development; it acts as safe training, vicarious activity, catharsis and so on.

The rational perspective on play in art can best be described in reference to Kant's theory because he introduced the concept of ('rational') play as a central element in modern aesthetics and, most importantly, because his account has served as a point of reference for both 'rational' and 'pre-rational' approaches in art theory and practice ever since. Kant uses the notion of play in two senses: as an actual activity, which he treats as disinterested and unproductive (a model for 'fine art'), and as a philosophical concept – a 'free play' of cognitive

faculties in the aesthetic judgement and the artistic 'genius'. It is the latter that he makes a central point of his aesthetic theory, stating that 'the delight which determines the judgement of taste is independent of all interest'.[2]

In the *Critique of Judgement* (1790), Kant exposes the basic features of 'art as play' by distinguishing between fine art and craft. The former, as he writes, 'could only prove final (be a success) as play, i.e. an occupation which is agreeable on its own account'.[3] Handicraft, on the other hand, is 'labour, i.e. a business, which on its own account is disagreeable (drudgery), and is only attractive by means of what it results in (e.g. the pay), and which is consequently capable of being a compulsory imposition'.[4] Although Kant praises free arts over crafts due to the element of disinterestedness, he nonetheless argues that the 'play' of art must be subordinated to some rules, a '*mechanism*, without which the soul, which in art must be free, and which alone gives life to the work, would be bodyless [*sic*] and evanescent'.[5] He also expresses a reservation; that it is misleading to regard free art as devoid of all restraint. The absence of restraint would convert art 'from labour into mere play', into something merely 'agreeable', instead of 'fine' art. As he writes, 'aesthetic art, as art which is beautiful, is one having for its standard the reflective judgement and not organic sensation'.[6] These remarks reveal the ongoing struggle in Kant – between the affirmation of freedom in art and the need to subordinate it to the laws of reason. The latter tendency predominates – Kant applies the concept of play as limited and rational to avoid the risk of nonsense and excessive freedom of imagination.

On a philosophical level, Kant describes 'free play' as an attribute of the aesthetic judgement and artistic genius. He defines 'genius' as 'the talent (natural endowment) which gives the rule to art' or, more precisely, 'the innate mental aptitude (*ingenium*) through which nature gives the rule to art'.[7] The operation of genius is not predetermined in advance – it does not follow any known rules – it must always be original. Although genius seems to be a 'power' originating outside the subject and transgressing one's limitations, it is also tamed by rational control. The works of art produced thanks to genius must be exemplary and they must serve as a standard for imitation by others. They must also conform to the critical judgement of taste, which

'introduces a clearness and order into the plenitude of thought'.[8] Kant excludes the 'original nonsense' from his notion of fine art. Through taste,

> [the] artist controls his work and, after many, and often laborious attempts to satisfy taste, finds form which commends itself to him. Hence this form is not, as it were, a matter of inspiration, or a free swing of mental powers, but rather of a slow and even painful process of improvement ... [9]

Kant describes artistic process as a negotiation between genius and taste; the initial playful moment of freedom must be followed by the laborious procedure of refinement and struggle with form. It can be said that the natural, 'pre-rational' artistic instinct must be followed by the 'rational' search for harmony within the limits of taste. The same rule governs the functioning of the internal powers constituting genius: imagination and understanding. They 'play' with each other – not producing any concepts, but staying within the limits of the rational mind. Imagination enjoys 'freedom from all guidance of rules' but it must become synchronized with 'the understanding's conformity to law'.[10] Although both 'playful' (genius and imagination) and 'reason-guided' (taste and understanding) aspects of the creative process are listed by Kant as requirements for fine art, he makes it clear that the latter two must be seen as dominant: 'For in lawless freedom imagination, with all its wealth, produces nothing but nonsense.'[11]

In my view, as stated in the introduction to this chapter, the rational image of play supports the conventional approach to representation (and vice versa). The crucial factor appears to be the idea of the controlling mechanism of the laws of reason – an unavoidable limit that prevents the irrational wandering of thought and art for art's sake as a private nonsense. For Kant, reason's productive activity is suspended in the act of aesthetic judgement but, nonetheless, its laws are binding. The most important characteristic of 'rational' play in terms of the notion of representation is, therefore, its connection with the rational, self-aware subject. Artists and viewers structure their aesthetic experience or activity according to the laws of reason. However, importantly, the 'rational' play of art is 'universally

communicable' and also 'exemplary' despite its subjective nature. Such an approach to subjective control is closely linked with the notion of mastery – as imposing order and dictating rules for others to follow. The act of representation, interpreted this way, becomes perceived as a manifestation of authorial power – as applying one's perspective as universal or even as the only valid one. This locates the artistic activity as a somehow privileged or elitist occupation. Artists (having been gifted innate talent by nature) are those who are capable of representing (interpreting) the world to non-artists. This position of power provokes the critique against artistic representation as a 'will to fixity and mastery'.[12]

It is also worth stressing that the concept of play in Kant seems to be very 'work-like'. It lacks work's direct orientation towards goals and it is not 'productive' of concepts (which distinguishes the aesthetic judgement from the cognitive one), but Kant stresses that play cannot be interpreted as the unlimited and 'free swing of mental powers'. According to him, the operation of genius is a 'laborious', 'slow' and even 'painful' process. To be regarded as 'fine art', art cannot be simply pleasurable; it has to be laborious, to be work-like. In my view, this vocabulary of work (including also 'control', 'mechanism', 'guidance of rules', 'process of improvement', 'conformity to law', etc.) is characteristic of the traditional approach to representation. Work or work-like play seems to belong to the traditional notion of representation due to the connotations of rationality, hierarchy, order, rules and limits. Nonetheless, despite its rational character, Kant's contribution can be seen as a 'play-turn' in terms of a general approach to the role of art and its place in Western society, as well as the responses it evoked in twentieth-century art.

Aesthetics of Autonomy

Kant's writings introduced the approach to aesthetic judgement (and, in consequence, to both the creative act and its reception) as occurring in the 'play mode' – as if reason was in 'idle gear', keeping watch but released from its usual functions. Although carefully restricted to avoid association with excess and nonsense (and therefore rational), play is a crucial characteristic of aesthetic judgement in Kant. Cognitive faculties of imagination and understanding are active, 'as if' they follow

usual rules – but they 'play' with each other without producing any binding concepts or rational outcomes. The whole process is basically disinterested; it does not follow any practical purpose, unlike cognitive judgement. In effect the 'play of aesthetic judgement' (and consequently 'play of art') becomes alienated from the goal-oriented 'reality'.

The popular notion of 'art for art's sake',[13] stripping art of purpose and conceptualizing it, therefore, as somehow a playful occupation, has its roots in Kantian aesthetics: 'In the nineteenth century, ideas of the autonomy of the aesthetic judgements soon became linked to the idea of the autonomy of art itself.'[14] Traditionally, up to this point, the position of art was grounded in the ancient Greek word *techne*, meaning 'craft' or 'skill' and connoting physical labour and technical expertise at the service of values and meanings dictated by society. 'The idea of artistic labour as a personal quest for perfection, in particular objects without immediate thought of buyers or clients did not arrive until the nineteenth century.'[15] Art gained its freedom and, at least in theory, was no longer subordinated to the dictatorship of the ruling classes, politics and the Church. Artists became masters of their own work, 'geniuses', seeing the creative act as close to God's actions in Genesis, bringing independent entities into being.[16] From the perspective of other members of the community, however, the emancipation of art and its 'creative' ambition was widely considered to be irresponsible, a whim which deviated from the 'proper' function of art. Artists, struggling for independence and living on the margins of conventional middle-class life, were often regarded as society's fools, vagabonds or parasites.

Although Kant limited the freedom of play by the matrix of the laws of reason, his theory of aesthetics has inevitably encouraged the process of art's liberation from all sorts of constraints. Play proved to be difficult to restrict and apply instrumentally. Unintentionally, Kant initiated what can be called 'the aesthetics of autonomy'[17] – the view of art as necessarily immune to any concerns other than the aesthetic or art-specific, in effect detached from the given reality. This view resulted in the approach to artistic production as 'divorced from the totality of social activities', which are 'confronted abstractly' in the work of art.[18] According to Rosalind Krauss, this perspective contributed to the 'shift that Walter Benjamin in his essays of the thirties called the historical

transition from cult-value to exhibition-value',[19] and the development of the formalist approach to art. The operation of ('rational') play had liberated art, to a large extent, from the traditional service to aristocracy and religion, but made it a 'free-floating commodity on the bourgeois market of objects and luxury goods'.[20]

Revolution of Pre-Rational Play

According to Peter Bürger, the European avant-garde movements negated 'art as an institution that is unassociated with the life praxis of men'. However, as he writes,

> Now, it is not the aim of the avant-gardistes to integrate art into this praxis. On the contrary, they assent to the aestheticists' rejection of the world and its means-ends rationality. What distinguishes them from the latter is the attempt to organise a new life praxis from a basis in art.[21]

Following Bürger's observation, I propose to consider play as a creative tool applied by modern artists and art theorists to bring art back to life and make it a model for social interaction. However, it is crucial to stress that in most cases those artists and theorists reached for 'pre-rational' play, because the notions of work (as *techne*, labour, production) and 'rational', work-like play were inscribed within the traditional rhetorics of artistic representation they wanted to contest. The desirable direction of this great artistic revolution since the beginning of the twentieth century – integration of art and life – has exposed play, primarily, as a domain of immediate experience and sensation beyond rational control.

According to the pre-rational outlook, as I mentioned in the introduction, play is a vital, untamed and chaotic manifestation of power, life or being. Play surpasses its participants; they are dominated by its dynamics, immersed in direct sensual experience. This state of 'losing oneself in play' can be exemplified by the situation of vertigo as in Caillois's classification. Players no longer use their rational control – they let things go. Their 'will to mastery' dissolves in the experience of 'decentring' – becoming one with the world, with play, with play-objects, etc. In this view, play is an opportunity to connect with life,

with the flow of events, here and now, in the heat of the moment. Play becomes, therefore, a manifestation of the laws and powers guiding the subject, not a subjective representation in the traditional sense.

The notion of play as pre-rational served as a model for modern avant-garde projects aimed against traditional modes and concepts of representation. 'Pre-rational' play became an attractive concept as a result of widespread interest in 'primitive' art and Freud's psycho-analysis, among other sources of inspiration in the 1920s and 1930s. However, its primary use and attraction was the opposition it could offer to the Enlightenment tradition: reason, sense, logic, hierarchy, the order and rules of Western civilization, the post-Kantian rational 'aesthetics of autonomy' and the dominant proper function of art as the self-conscious production of aesthetic objects. Dada and Surrealism, the movements that extensively used play, were provocatively anti-intellectual. As Hans Arp writes: 'Philosophies have less value for Dada than an old abandoned toothbrush, and Dada abandons them to the great world leaders.'[22] 'Philosophy' in art became disreputable because it was perceived as a tool of manipulation and political demagogy – an element of the materialist and rational civilization which brought the horrors of World War I into being.

The 'new' and refreshing spheres of interest for avant-garde artists had become those traditionally marginal and neglected: dreams, vis-ions, mental dysfunction, chance, play, games, group activities, non-professional or 'primitive' creation and everyday life. These particular realms became integral to what can be identified as the tendency of Primitivism – the search for the means that would 'draw closer to nature [origin/essence/truth/reality/experience] than ever before in the history of art'.[23]

Before I proceed to the analysis of examples of the strategy of 'pre-rational play' in modern art, it is necessary to briefly explain the use of the terms 'modern avant-gardes', 'Primitivism' and 'strategy' in this particular context.

Modern Avant-Gardes

Modern avant-gardes can be characterized using the set of key ques-tions they asked: How to overthrow the artistic *status quo* and tradition, and 'infuse new life into art'?[24] How to contribute to progress? How

to get closer to the authentic experience? How to provoke the viewer to react, to be active and engaged?

Their answers can be found in the manifestos they produced. Although modern artists criticized 'old' academic authorities, rational positions and philosophies of art, they were nonetheless actively engaged in explaining, defining and theorizing their practice in order to demonstrate its specific, unique and revolutionary features. The following are several excerpts from manifestos or programmes of different modern groups written at different times, which illustrate the revolutionary agenda of modern avant-gardes. The 'new central values' proposed by the artists have been emphasized in italics by the author.

As youth, we carry the future and want to create for ourselves freedom of life and of movement against long-established older forces. Everyone who reproduces that which drives him to creation with *directness and authenticity* belongs to us.[25]

E. L. Kirchner, Die Brücke, 1906

And so Dada was born of a need for independence, of *a distrust toward unity*. Those who are with us preserve their *freedom*. We recognize no theory. We have enough cubist and futurist academies: laboratories of formal ideas.

...

abolition of logic, ...: Dada; abolition of memory: Dada; abolition of archaeology: Dada; abolition of prophets: Dada; abolition of the future: Dada; ...elegant and unprejudiced leap from a harmony to the other sphere...Freedom: Dada, Dada, Dada, a roaring of tense colours, and *interlacing of opposites* and of all contradictions, grotesques, inconsistencies: *Life*.[26]

T. Tzara, Dadists, 1918

I. CIVILISATION, CULTURE, WITH THEIR ILLNESSES – TO THE TRASH. we choose *simplicity ordinariness*, happiness health, *triviality*, *laughter*. from laughter the spirit fattens and grows strong stout calves....

X. we praise understanding and therefore throw out logic, that limitation and cowardice of the mind. *Nonsense* is wonderful by virtue of its untranslatable content...[27]

S. Przybyszewski, Polish 'Primitivists', 1920

Dictated by thought, in the *absence of any control exercised by reason*, exempt from any aesthetic or moral concern.

... Surrealism is based on belief in the superior reality of certain forms of previously neglected associations, in the omnipresence of *dream*, in the *disinterested play of thought.*[28]

A. Breton, Surrealists, 1924

The new attitude that is being formed as a result of these searches is concerned with the invention of objects affecting man psychologically by means of physical phenomena. It is a new form of *magic*. The artist no longer feels that he is 'representing reality', he is actually making reality. Direct *sensual experience* is more real than living in the midst of symbols, slogans, worn out plots, clichés – more real than political-oratorical art.[29]

I. Lassaw, American Abstract Artists Group, 1938

The new art takes its elements from *nature*. ...
We demand art that is *free of all aesthetic artifice*. ...
We will draw closer to nature than ever before in the history of art.[30]

L. Fontana, 1946

Promote a revolutionary flood and tide in art. Promote *living art*, *anti-art*, promote *non art reality* to be grasped by all peoples, not only critics, dilettantes and professionals.[31]

G. Maciunas, Fluxus, 1963

The common feature of the above manifestos is their use of binary oppositions. All authors contrast the old (wrong), a status quo which they consider as traditional and widely accepted, even unquestioned, with the new (right), a domain regarded by them as suppressed and unjustly relegated to the margins (that which I have highlighted). The main function of all those texts is to call for the overturn of the long-established hierarchy. This characteristic of modern art is closely connected with the operation of traditional metaphysics which locates certain values as central and essential (I will get back to this topic in the next chapter). Modern art can therefore be described as ruled by 'centrisms', ideas regarded as dominant, right and positive in a given historical moment. In general, 'new' central values, even though they are unique to each movement, were located in the notions of progress, change, novelty, originality and revolution.

Primitivism

According to the *Oxford Dictionary of 20th Century Art*, Primitivism is a

> term employed in the context of 20th century art to refer to the use of Western artists of forms or imagery derived from the art of so-called primitive peoples, or more broadly to describe an approach in which the artist seeks to express or celebrate elemental forces by using unconventional procedures or techniques that bypass the methods normally associated with the trained painter or sculptor.[32]

Primitivism can, then, be seen as an approach to creative practice that is open to experimentation and exploration of the exotic territories, which are often perceived as 'non-professional' or simply marginal to the values represented by traditional Western art, with its requirements for training, knowledge and skills, a proper vocation. Interest in the 'primitive' is a catalyst for art's de-professionalization. Furthermore, the Primitivist 'experiment' is being undertaken in search of 'more fundamental modes of thinking and seeing'.[33] It seeks the means to represent those fundamental modes in a way as close to the original experience as possible.

The 'primitive' – African tribe members, Tahitian fishermen, peasants in Brittany, folk or naive artists, the insane and the child – were regarded by modern artists as unspoiled by history, culture and civilization and therefore 'living closer to the elementary aspects of human existence'.[34] The artworks produced by 'primitives' were, for the modernists, the manifestation of primary vision: seeing the world as for the first time, unconsciously and with wonder. Due to the privileging of nature over culture in the hierarchical opposition set up by the modern avant-gardes, the creative powers of the 'primitives' were regarded as superior to those of the professional artist. This view is exemplified by the exclamation by August Macke: 'Are not children more creative in drawing directly from the secret of their sensation than the imitator of Greek forms? Are not savage artists who have forms of their own powerful as the form of thunder?'[35]

Modern artists, depending on the perspective represented, were inspired by different aspects of 'primitive' art. Although most of them

praised its raw and 'natural' qualities, simplicity and spontaneity, the actual works produced out of this inspiration were formally distant from one another, ranging from symbolism to geometric abstraction.

For the Expressionist painter and printmaker Emil Nolde, the main quality of primitive art was its sensuality and vitality:

> The products of primitive peoples are created with actual material in their hands, between their fingers. Their motivation is their pleasure and love of creating. The primal vitality, the intensive, often grotesque expression of energy and life in most elemental form – that, perhaps, is what makes these native works so enjoyable.[36]

The pioneer of abstract art, Wassily Kandinsky, was also fascinated with the anti-intellectual, anti-analytical features of 'primitive' art. In the absence of rationality, however, he was looking for the spiritual, instead of the sensual, element in the primitive-inspired art. In 'On the Spiritual in Art' (1911) he suggests that even customary objects can make a spiritual impression when we encounter them for the first time. According to Kandinsky, 'this is how the child perceives the world'.[37] In his drawings and paintings, the artist was trying to preserve this fresh first impression or resonance of things and to develop the outer form that would be able to reflect the inner and essential feelings, the 'inner sound', as it exists in children's drawings. In his view, 'primitives' as well as modern artists 'sought to express in their work only internal truths, renouncing in consequence all consideration of external forms'.[38]

Dadaists believed that a true work of art belonged to nature and its 'organic processes of becoming'.[39] The Zurich group's representatives were looking for the inspiration in tribal art, as an artistic expression closest to nature, to oppose Western culture and civilization. This is how Hans Arp described his work and his use of non-traditional materials and methods:

> Instead of cutting the paper, I tore it up with my hands, I made use of objects I found on the beach, and I composed natural collages and reliefs. I thus acted like the Oceanians, who never worry about the permanence of their materials when making masks, and use perishable materials like sea shells, blood, and feathers.[40]

Dadaists also explored chance as a manifestation of natural powers ruling the universe – 'the voice of the "Unknown"'.[41] As Hans Richter recounts, the experiments with chance as the 'mysterious collaborator' of the artist made the Dadaists aware that they were 'not so firmly rooted in the knowable world as people would have us believe'.[42] Richter writes, 'We felt that we were coming into contact with something different, something that surrounded and interpenetrated *us* just as we overflowed into *it*.'[43] Incorporation of chance became a trademark of the Dadaist agenda to challenge the 'infallibility of reason, logic and causality'.[44]

> The adoption of chance had yet another purpose, a secret one. This was to restore to the work of art its primeval magic power... By appealing directly to the unconscious, which is part and parcel of chance, we sought to restore to the work of art something of the numinous quality of which art has been the vehicle since time immemorial...[45]

For Surrealists, the interest in 'primitive art' was closely linked with their pursuits of alternative, anti-rational modes of creation. Like Dadaists, they also experimented extensively with chance, as well as with dreams and the use of the unconscious, and they tried to reduce controllable and rational factors in the creative process. According to Surrealists, a conscious thought and consciously created art could not reach the most hidden and essential aspects of human experience. Goldwater refers to the primitivist aspects of this 'strategy' as follows:

> Thus by sinking back to a lower level of experience for its inspiration, art tries to become the expression of the basic qualities of the human mind – qualities which are primitive both in the sense of being pervasive and of possessing the power of occasionally overwhelming the more refined levels of the mind.[46]

Primitivism can be interpreted as a mode of creation, a certain attitude framing the creative process, a narration, rather than a specific imagery, a set of forms or a style. As Victor Li puts it in his book *The Neo-Primitivist Turn* (2006), 'the term "primitive" lacks singular definition and possesses protean, multiple identities. The "primitive"

is not an ontological entity – it is [a] relational concept that expresses various "modern needs".[47] As discussed above, these needs included: the expression of inner, essential feelings and 'energy and life in most elemental form'; preservation of the fresh first impression or 'resonance' of things; celebration of natural forces, ephemerality and randomness; reduction of conscious control and 'sinking back to a lower level of experience'. However, primarily, it was a need not to continue to 'represent reality', but instead to 'make reality'.[48] These motives behind the Primitivist positions disclose its 'pre-rational' and anti-representational character. The artists, and especially Dadaists and Surrealists, were openly anti-rational and anti-intellectual and they actively searched for ways to escape the restraints of subjective control and artistic mastery. In effect, 'pre-rational' play has become an attractive model in this respect. I do not mean, however, that 'Primitivist' equals play-like. What I suggest is that strategies of play in twentieth-century art, in most cases, were triggered by the first avant-garde's fascination with 'primitive' art. This connection can be traced when we look at the narratives or myths supportive of the Primitivist approach that can be also identified within the 'strategy of play' (interpreted as 'pre-rational'), which I label as the 'myth of origin', 'myth of presence' and 'myth of the Other'.

Myth of Origin

The phrase 'myth of origin' refers to the narrative that claims to trace back things to their original and primary state and calls for its regeneration – the return to what is presented as pure, unspoiled, essential and good. In this rhetoric, the natural state of humanity and the world is contrasted with the 'here and now', long detached from the origin. Artists and theorists who shared the Primitivist approach often referred to the dangers brought about by changes in forms and structures of civilization, and the need to turn back to nature. They saw Primitivist art as a remedy for art's artificiality and detachment from the 'origin'.

The 'myth of origin' also permeates the pre-rational interpretation of the concept of play in culture and society. Play, within this rhetoric, is treated as a 'pre-activity', and it belongs to childhood (both that of the individual and the collective childhood of humanity). This notion

of play as a primary activity of humans and the root of all culture was strengthened by Huizinga. The Primitivist myth of origin refers to exactly the same values as the concept of play as pre-rational and presents savage art as the cradle of art, a 'pre-art', closer to nature and essential experiences than the sophisticated and refined Western art. Play and the art of 'primitive' people meet in the mythical human Eden, paradise lost, the original innocent state of happiness, freedom and disinterestedness.

For the avant-garde artists, play, as a basic experience common to all people, served as a gateway to artistic creation freed from the burdens of civilization, artificiality and cultural training. It is a contribution of modern artists that play has become linked with creativity. Creativity, in contemporary understanding, is associated with the ability to think 'outside the box'; 'to play' with ideas or materials, means to refresh one's approach, go back to the starting point, to try to see things 'as if for the first time'.

Myth of Presence

The 'myth of presence' permeates narratives that value actual experience, practical knowledge and sensation, as superior to representation in any form. It is, in fact, a variation of the myth of origin that claims it is possible to achieve an effect close to the 'unmediated' experience, to the 'essence of being' through one specific form of representation, chosen at a given time in history, as the most natural and accurate. This myth belongs to the dispute on the primacy of speech over writing, which will be presented in the following chapter, as well as to the ongoing quest for the art form that would do away with the art's artificiality and become lifelike, which would 'present' instead of represent.

As Goldwater writes, the use of Primitivist means by modern artists was in many cases linked with their desire to present their subjects immediately, 'with as little "psychic distance" as possible' in order to produce a visual effect 'which will not be analyzed as a variegated formal composition, but will absorb the spectator, or be absorbed by him in a direct and undifferentiated way'.[49] The artist's emotions would therefore be 'present' in the work, not just represented, and the expressive power of an image would evoke similar reactions in

the viewer. The communication between the artist and the viewer would occur beyond the rational processes of coding and decoding, beyond language and logic. It would be more of a shared sensation or experience.

Such an attitude was also linked with the growing interest in the creative process as an ongoing experimentation, and the role of an artist as a creative agent, who not only produced artefacts but also caused reactions and immediate effects in the social and cultural spheres. The art of 'primitive' people was regarded by modern artists as vivid and sensual, woven into the processes of life. The objects and gestures of tribal art belonged to rituals, and were attributed with performative (*methetic*) or even magic powers. They were not meant to be contemplated but used and acted with.

> As primitive man, driven by fear of nature, sought refuge within himself, so we too have to adopt flight from a 'civilisation' which is out to devour our souls. The Savage discovered in himself the courage to become greater than the threat of nature, and the alarms and terrors of storm and of ravening beasts and of unknown dangers, never deserted him, never let him in – in honour of this he *drew a circle of guardian signs around him*, signs of defiance against the threat of nature, obstinate signs of demarcation to protect his possession against the intrusion of nature and to safeguard his belief in spirit. (my emphasis)[50]

This quotation by Hermann Bahr exemplifies the modern attraction to the 'performative' character of savage art as distinguished from the traditional Western 'descriptive' representation.[51] 'Drawing a circle of guardian signs' is not simply an imitation of nature, but an act of power, causing certain effects. It is like the utterance of a magic spell, involving the bodily and mental powers of the 'primitive' artist who confronts the dangerous world with this special act. It can also be seen as a ritual, an active confrontation with overwhelming natural phenomena which in 'civilized' man evokes the feeling of the sublime. The view of 'primitive' art as ritualistic and performative was to some degree inspired by Sigmund Freud's 1913 book *Totem and Taboo*. As he writes, art did not begin as 'art for art's sake. It worked originally in the service of impulses which are for the most part extinct today. And

among them we may suspect many magical purposes.'[52] Pablo Picasso recounts how African sculpture inspired him to paint *Les Demoiselles d'Avignon* in terms of performing a spiritual act, not just imitating interesting forms.

> But all the fetishes were used for the same thing. They were weapons. To help people stop being dominated by spirits, to become independent of them. ... *Les Demoiselles d'Avignon* must have come to me that day, but not at all because of the forms: but because it was my first canvas of exorcism – yes, absolutely![53]

A similar performative quality was attributed by modern artists to art and play of children:

> Surely you will agree with me that when a child builds the figure of a person from the cubes and arches of his brickbox, and makes himself a 'man', he is arriving at something more fundamental, more mysterious, and more organic than the shepherd in the ancient myth who is said to have discovered painting – for he with a piece of coal, outlined the shadow of his lover.[54]

According to Čapek, a child does not simply represent a man, does not 'trace his shadow', but instead he or she 'makes' a man and in doing so acts, to some extent, as the creator of a new being. Play was perceived by modern artists as an activity performed 'here and now' and the moment of creation as such became equally as important as the outcome. In this moment the artist can experience art as reality, can exercise his own creative power like a god and witness the origination of things. According to the 'myth of presence' an artist does not represent reality; his or her actions belong to reality and shape it. From the Primitivist as well as from the pre-rational perspective, play and art belong naturally to the tissue of life, and have the power to reveal its essence as well as transform it.

Myth of the Other

The issues of encountering the Other, or 'becoming' the Other (through role-playing), are constitutive of the Primitivist orientation as well as of play. The Primitivist Other – the mentally ill, African

tribesman or a child – was seen as an embodiment of natural forces, acting according to instincts, needs and feelings, untamed by the rules imposed by civilization. This Other was, therefore, perceived as a guide to the world of nature, to the original state of being. The Other played a double role: on the one hand he or she represented values repressed by the development of civilized society (like free sexuality, spontaneity, irrationality) and thus, in fact, danger to the social order; on the other hand, he or she was regarded as an innocent, a potential moral rescuer and renewer for the corrupted and amoral West. Both perspectives, however, present the Other as completely alienated from the Western self-identity.

> In the earlier primitivism [nineteenth-century], the primitive is regarded as inferior and justifiably superseded by modern civilisation, whereas in the later version [twentieth-century] the primitive is seen as corrective to the malaise of Western modernity. But in both cases the primitive is known, given a value, and exists only as an antithesis to the modern West, which not only remains the central point of reference but also is the source from which the idea of the primitive emerged in the first place.[55]

The Primitivist movement is often accused of strengthening the stereotype of the 'noble savage', exotic and amusing but completely detached from the existence and experience of 'civilized' humanity. No doubt this criticism is just, when we think of superficial fascinations and narratives created by modern artists to support their work. However, the Other, even on this very basic sentimental level – as a colourful, illegible mask – had entered the world of well-established Western identification and gradually transformed it. The Other became an attractive figure, different, mysterious, but worth imitating. Tristan Tzara in his 'Note on African Art' from 1917 calls the 'primitive' artist his 'brother', which indicates the process of incorporation of the 'external' values and approaches into the traditional frames of art.

> Influences of a foreign sort, which mix in, are the shreds of Renaissance lining, still hanging on the soul of those close to us, for my brother has the soul of autumn's sharp black branches. My

other brother is an innocent; he is good and laughs. He eats in Africa and in the bracelet of Oceanic Islands . . . [56]

It can be said that the Other became an alter ego of the modern artist, like a temporary mask or costume, which nonetheless leaves a trace on its wearer. Encounter with the 'primitive' inspired modern artists to use 'unconventional procedures or techniques that bypass[ed] the methods normally associated with the trained painter or sculptor';[57] in other words, to transcend their own professional identification, and the traditional functions of Western art.

The function of play as we know it from children's activities is also to develop one's identity. Children are confronted with different figures from real life, books and movies, and through the temporary identifications in play they can construct or transform their own self-identity. What is more, as Jacques Lacan argues, the Other can be encountered by a child as his or her own reflection in the mirror: 'It is this reflection from outside oneself, or what Lacan calls the "look from the place of the other", during the "mirror stage", which allows the child for the first time to recognize itself as a unified subject, relate to the outside world, to the "Other", develop language and take on a sexual identity'.[58] The encounter with self as the Other can also occur when one gets in touch with the sphere of unconscious wishes and desires. It is also an opportunity to transgress the mundane self, to recognize the Other in oneself. The use of costumes and masquerades also serves to challenge the idea of self as a unified and controlled whole with one and a proper identification (in terms of gender, social expectations, artistic conventions and so on).

In consequence, the 'external' position of the Other becomes questionable. It is rather one's own projection, the embodiment of fears and desires belonging neither to the inside nor to the outside. It is the indispensable figure in the process of establishing one's own identification but also the sign of the possibility of its change.

The Primitivist fascination with the Other, as belonging to a different culture, historical time or stage in human development, contributed to the gradual shift of perspective; from the ruling dichotomy of internal/external to the post-colonial and post-structuralist explorations of constitutive differences within society, politics and culture. The encounter with the external, Primitivist Other – including the

1playing child – was an important element in the gradual transformation of Western artists' interpretation of their own roles and transgression of the well-established role of art. In contemporary artistic practice the momentary change of identity, becoming the 'Other', or entering realms different from everyday experience have become part of an accepted artistic methodology which I identify as play. I will return to this issue in Chapter 4.

By creating narratives – myths supporting the Primitivist approach to creative process – modern artists legitimized their works as 'true art' with access to the original states of being. Artistic creation was seen as parallel to the organic processes of becoming, but not as representing them in the old sense (as imitation). By using spontaneous gestures, the unconscious, chance, automatic techniques, etc., artists hoped to reduce or eliminate the controlling power of reason and conventional codes of meaning-making – the authorial mediation – infected by culture, civilization, tradition, knowledge and skills. As Dadaist Hugo Ball writes,

> When art is brought into line with everyday life and individual experience, it is exposed to the same risks, the same unforeseeable laws of chance, the same interplay of living forces. Art is no longer a 'serious and weighty' emotional stimulus, nor a sentimental tragedy, but the fruit of experience and joy in life.[59]

Play as a pre-rational concept and a children's non-serious activity could then become a Primitivist tool to arrive at creative, non-rational states of mind, productive of absorbing, sensual, anti-intellectual art. However, the Primitivist play, interpreted as 'the Other of reason',[60] must be seen as a conscious strategy in the context of modern avant-gardes – their intellectual discourse, revolutionary outlooks and numerous manifestos.

'Strategy' of Play

I borrow the term 'strategy' from Michel de Certeau's book *The Practice of Everyday Life* (1988). However, I reappropriate it in the context of cultural and artistic play. In de Certeau, 'strategy' means 'actions which, thanks to the establishment of a place of power

(the property of a proper), elaborate theoretical places (systems and totalizing discourses) capable of articulating an ensemble of physical places in which forces are distributed'.[61] In other words, strategies are loaded with the notion of power operations of the dominant order. According to de Certeau, every strategy is bounded by its own clearly designated identity that dictates the proper moves and actions.

> As in management, every 'strategic' rationalisation seeks first of all to distinguish its 'own' place, that is, the place of its own power and will, from an 'environment'. A Cartesian attitude, if you wish: it is an effort to delimit one's own place in a world bewitched by the invisible powers of the Other.[62]

I use the word 'strategy' to describe methods and approaches aimed by modern avant-gardes *against* the dominant, official, cultural and social conventions. The 'strategy of play', as I identify it, was to a large degree a revolutionary tool. It was inscribed within the relations of power, and was based on a clearly articulated position of 'power and will', determined to overthrow the status quo. The artists in question were trying to establish their identity in opposition to the traditional 'proper function' of the artist. The Other (i.e. the 'savage' artist, the child, the madman) was not regarded as a threat, but as an attractive point of reference – a possible model – in the process of transforming their roles and identities. The strategy of play was aimed against the official 'strategies', but to a large degree, it followed their polemical methods and rhetorics, based on metaphysical dichotomies. As I introduced in the section on modern avant-gardes, the artists aimed to overturn the conventional hierarchy of values; they proclaimed new values to be central and essential, the old to be noxious or marginal.

The harnessed opposition between old and new exposed play as a desirable alternative to the traditional artistic 'work'. Play, interpreted as 'primitive', childlike and irrational, became an attractive remedy for the criticized sophisticated, academic and rational attitudes in art and social life. The strategy of play, as I will demonstrate in the following sections, goes beyond the inspiration of 'primitive' objects of art, expressed in the traditional form of sculpture, drawing or painting. Instead, modern artists directly employed various play activities in their artistic experiments. They searched for creative models 'outside'

conventional art frames, trying to implement non-art or popular art and entertainment into their practices.

'Artist the Player'

> If there is one activity in Surrealism which has most invited the derision of imbeciles, it is our persistent playing of games, which can be found throughout most of our publications over the last thirty-five years. Although as a defensive measure we sometimes described such activity as 'experimental' we were looking primarily for entertainment, and those rewarding discoveries it yielded in relation to knowledge came only later. . . . Furthermore, the urgent need we felt to do away with old antinomies that dominate work and leisure, 'wisdom' and 'folly', etc – such as action and dream, past and future, sanity and madness, high and low, and so on – disposed us not to spare that of the serious and non-serious (games).[63]

The above quotation from André Breton (1954) summarizes the Surrealist approach to playing games. Surrealists consciously tried to do away with metaphysical dichotomies structuring traditional approaches to the 'work' of art. They persistently explored the 'play' of art as a way to transcend these binary oppositions and to challenge the traditional forms of art, identified by them with social norms, conventional and conscious decisions, and aesthetic beauty.

Breton's words can be seen, however, in a more general context, as a description of the modern discovery of play as an artistic and conceptual strategy and a powerful tool to revolutionize art. This discovery, fitting into the Primitivist outlook and encouraged by the modern theoretical study on play (by Spencer, Freud, Huizinga and Caillois, among others), must be seen as the shared achievement of a few generations of artists who developed different play-like forms and methods, and who used play to achieve various effects.[64] I will briefly discuss the most innovative and seminal uses of play in the first avant-garde applied instead of, or together with, the traditional creative processes. In most cases play remained a means in the production of art objects or was treated as a complementary activity, not a final outcome. The artists still identified themselves as painters, poets and sculptors who modernized their artistic toolboxes.

In 1916, in Zurich, Hugo Ball and Emmy Hennings established Cabaret Voltaire[65] to provide a venue for independent outlooks and a free artistic spirit, in opposition to the overwhelming climate of politics, war and nationalism.[66] The playful, provocative character of a nightclub was well-suited to the pacifist or anarchist, multinational and experimental ideals of young art. The shape of the Dadaist cabaret was inspired by Futurist manifestos and actions; however, it was devoid of the Futurists' political, national and social, goal-oriented agenda. Dadaists celebrated artistic freedom, extensively experimented with various art forms and created a kind of a multimedia workshop of the bizarre, provocation and play: as Hugo Ball put it, a 'playground for crazy emotions'.[67]

The Dadaist show was always a collaborative work, transgressing professional roles – painters not only created the decorations and props, but were also engaged in performing drawing or painting on stage, reciting poems and playing instruments. In effect, each event was becoming a kind of a 'total work of art' composed of multimedia art forms and the crucial element of the viewers' active response.

The opening of the Gallery Dada in Zurich in 1917 was the result of an impulse to expand the range of forms of interaction with the viewers. Apart from exhibitions, the artists organized meetings, readings, lectures and guided tours with the aim of establishing direct contact with the public. Later in Paris in 1921, Tristan Tzara and the future Surrealists organized a Dada excursion to the little-known church of St. Julien de Pauvre, with the artists serving as guides. They advertised the event with posters 'offering a series of visits to selected sites, "particularly those, which really have no reason for existing"'.[68] No audience showed up. However, the important aspect of these kind of events organized by Dadaists and Surrealists was the willingness to go beyond the traditional artist's role, and to meet the public (surely, with the intention of provoking) on a new, non-artistic ground.

The Dada events encouraged excess, according to Marinetti's dictum that art 'must be an alcohol, not a balm'.[69] The gestures and methods of play, absurdity and parody, applied by Dadaists, offended, deterred, attracted and excited the public, but did not leave anyone indifferent. The artists wanted their collective activities to become a persuasive revolutionary weapon to make way for 'new' art, to change the bourgeois taste and expectation and, simply, to test the

limits. The artists could also infuse new ideas and values into the artistic scene, such as humour, irrationality, chance, chaos, lack of skill, nonsense and orientation on the process. Their projects can be described as 'carnivalesque' – 'a unique mixture of instable curiosity, playfulness and pure contradiction'.[70] Dadaists used humour and chaos to undermine the official style of social interaction. However, they had to face the consequences of their playful experiments. Like one of their predecessors, Frank Wedekind, a German performer and playwright, they knew that their activities 'revelled in the licence given the artist to be a mad outsider, exempt from society's normal behaviour' and that 'such licence was given only because the role of the artist was considered utterly insignificant, more tolerated than accepted'.[71] Dadaists and Surrealists consciously occupied roles as society's jesters or naughty children.

Surrealists, apart from organizing playful events in the tradition of Dada, indulged themselves in the collective playing of different kinds of games – their own inventions, or modified versions of well-known parlour pastimes. The list of the games, most of which were based on automatic techniques, is extensive and includes:

- Chain games (the texts or images created by adding one's line without knowing or being able to see the contributions of previous players): 'The Exquisite Corpse'[72] ('Heads, Bodies and Legs'), 'The Game of Definitions', 'Conditionals' (e.g. *If there were no guillotine. Wasps would take off their corsets.*), 'Opposites', 'Echo Poems', 'One into Another', 'Directions for Use';
- 'Inquiries' – games of questions and answers, in which the answering player is required to tell the truth or give the first answer that comes to his or her mind;
- Oral description of objects perceived by touch;
- Determining irrational characteristics of the object;
- Inventing new proverbs, superstitions and myths;
- Visual techniques: automatic drawing, frottage, fumage, decalcomania, collage, photomontage, potato and paper cuts, etc.[73]

Playing games was for Surrealists not only a great way of having fun together, but became in time a tool to stimulate creativity, generate ideas and get in touch with the unconscious. It can be seen as

a Surrealist methodology for coming up with unexpected insights and formal solutions. With the help of play, paradox, chance and collaboration, they tried to 'transform and revaluate the categories into which we habitually order the familiar world, and substitute a Surrealist viewpoint for the conventional one'.[74] As I quoted earlier in this chapter, Breton refers to games as activities overcoming 'old antinomies'. In the same essay he pays tribute to Johan Huizinga:

> And the great Dutch historian and thinker specifies that 'All things that have come to be recognized in poetry as conscious qualities – beauty, a sense of the sacred, magical power – are implied from the outset in the primary quality of the game.' It is clear that to shut oneself off from the play of imagination as adult discipline prescribes it, is to undermine the best of one's own humanity.[75]

The Surrealist 'Artist the Player' tried to exercise the whole potential of his or her mind through the exploration of its irrational, unconscious paths. The mixture of fun and seriousness, freedom and constraints offered by entering the world of games provided the best emotional and intellectual space for the Surrealist 'research'. As I have already mentioned, the unconscious was for Surrealists the sphere of the 'internal' Other and the limit of the authorial control. Moreover, because of their relation to the unconscious, games and automatic techniques were treated as democratic creative tools common to everybody. In effect, art could potentially lose its 'high' and detached position and become an everyday activity or a social experience, as 'primitive' art was considered to be. The idea of the democratization of 'high art' belonged to the overall agenda of modernization, revolution in the social structure and in the arts. Play and games were models for creative practice, but also for the desired forms of social interaction, where the rules were collectively negotiated: 'Rules are accepted voluntarily since they have the opposite purpose to constraints imposed on the individual by society. Their aim is the provision of pleasure, not the imposition of repression.'[76] The artists often quoted Freud's theory of the function of humour, 'that it is the revenge of the pleasure principle on reality. The game has a similar function, and none more so than this GAME OF PROVOCATION in which Surrealists take delighted revenge on its enemies.'[77] However, the games were also

played to draw the 'magic circle' of 'sur-reality' – an alternative world as a small, 'uncivilized' but democratic community, in which a man organically belonged to environment/nature/events, and did not just rationally 'control' them. The agenda of 'democratization' through collective and creative play has later recurred in various practices, for example those of the international CoBrA group established in 1948. Even though these artists rejected Surrealist aesthetics, they eagerly embraced the potentials of collective work/play. For them, this was a method to transgress traditional artistic intentionality and mastery resulting from the pursuits of individual style. In this respect they drew their inspiration from 'primitive art' and children's drawings in particular. Collective creation, similar to collective play, was a gesture unlocking the ivory tower of art and opening it to everybody.

Experiments with language (sound and writing) and the incorporation of language games into Dada and Surrealism, such as some of those listed above, were the result of contacts and creative exchanges between painters and poets. Guillaume Apollinaire, the French poet, art critic and proponent of 'primitive' art, was one of the main contributors to the growing interest in the 'first principles of language', jokes and word games among the avant-garde. He himself was influenced by children's poems, the work of Alfred Jarry (particularly the play *Ubu Roi*) and the writings of Raymond Roussel, and he introduced Marcel Duchamp and Francis Picabia to the creative output of the latter. Both artists took an inspiration from Roussel's attitude of 'antisense', his playful motives, use of homonymic puns, code, enigma and a general climate of mystification.[78] Duchamp developed the concept of wordplay into one of the main strategies of his art; language games and puns 'appear throughout his career, in all formats from offhand remarks, to the titles of most of his works'.[79]

During Katharine Kuh's 1961 interview of the artist, Duchamp said:

> ...puns have always been considered a low form of wit, but I find them a source of stimulation both because of their actual sound and because of the unexpected meanings attached to the interrelationships of disparate words. For me, this is an infinite field of joy – and it's always right at hand.... If you introduce a familiar

word into an alien atmosphere, you have something comparable to distortion in painting, something surprising and new.[80]

For Duchamp, play with words – traditionally considered to be a childish and 'primitive' form of humour – was a means of evoking the 'unexpected' and infusing multiple meanings, ambiguity and the conceptual approach into his works. It was also a strategy to overturn the well-established dichotomies of high/low and serious/non-serious. A famous and provocative example is his *Mona Lisa* with moustache and goatee, entitled *L.H.O.O.Q.* (1919). When the letters are read quickly in French ('el-hache-o-o-ku'), the meaning turns out to be '*elle a chaud au cul*' (she has a hot ass).[81] Together with a gesture of transforming the reproduction of the Western art masterpiece, this work is reminiscent of a child's provocative, sexually loaded play, aimed at teasing adults, in this case the 'adults' of the art world. Duchamp's approach can be described, then, as 'alteration' – a term later proposed by Bataille for the creative/destructive ambivalence of the creative act. However, Duchamp, as quoted above, was fascinated by the creative potential of wordplay and visual connotations; he produced endless puns for sheer joy and pleasure, and to discover the surprising qualities of ordinary words and objects. Despite the highly intellectual character of Duchamp's 'games' they retain the childlike, light and effortless quality of joyous play.

Another dimension of Duchamp's wordplay emerges in his equally playful penchant for masquerade and inventing non-existent personas and alter egos. During his artistic career Duchamp created a few aliases and used them in his correspondence, in artistic and non-artistic projects and collaborations:

> Thus, whilst we know of Duchamp's adoption of disguise mostly with regard to the R. Mutt and Rrose Sélavy personae, he was also *Marcel Douxami*, *Marsélavy*, and *Sélatz*, not to mention the ersatz names he was given by others: *Victor* and *Totor* by Henri-Pierre Roché, *Marchand du sel* by Robert Desnos, *Pierre Delaire* by Henri Waste. (De Duve, 1998: 399–400).

A final act in this unstable existence is found in the *Wanted* poster of 1923, an imitation of a police circular featuring Duchamp posing as a

criminal, 'George W. Welch, alias Bull, alias Pickens etcetry etcetry' (it goes on).[82]

The most often used persona was Duchamp's female alter ego, Rrose Sélavy ('*Eros, c'est la vie*'). This figure emerged in a series of photos of the artist dressed as a woman taken by Man Ray (1921). Later, Duchamp signed a few works with this pseudonym (i.e. the 1926 film *Anemic Cinema*) and used it in a title of the 1921 assemblage *Why Not Sneeze, Rrose Sélavy?*

In 1921 Duchamp and Man Ray created a photograph of a bottle of toilet water with the image of 'Rrose Sélavy' on it. The bottle is labelled *Belle Haleine Eau de Voilette* ('Lovely Breath: Veil Water') – which is a phonetic play with the phrase 'Belle Helene Eau de Toilette'. This work is in fact a multi-layered masquerade and a chain of substitutions – Duchamp 'looks' like a woman named Sélavy on the bottle of 'toilet' water *Belle Haleine* that sounds like *Belle Helene*.[83] The photographed object indeed becomes the 'veil' water – its actual function causes confusion and its fragrance is supposed to 'veil' the odours, but the 'masking' function is also related to the artist himself and his own cross-dresser disguise. The artist, in these and other works, employs the creative potential of simultaneously using double or multiple planes of rational (*and* irrational) thinking. Through his own disguise Duchamp exposes the fluidity of artistic (and non-artistic) identity, the ongoing tension between the absurd, the irrationality *and* the precise calculation, or even manipulation, involved in the artistic process. He questions not only the feminine/masculine opposition, but also those between fiction/reality, art/life and serious/non-serious.

Duchamp's masquerades contributed significantly to the development of the strategy of play as performance, with the possibility of literally stepping into the Other's shoes. Moreover, they brought attention to the fact that one's own identity is constructed and played out. Duchamp/Sélavy exposes the performativity of gender and sexuality, as theorized later by Judith Butler.[84] According to Katharine Conley, 'Duchamp disguised as Rrose Sélavy but still recognizably Duchamp in most of Man Ray's photographs also projects a layered sexual identity that runs from the masculine to feminine and back to the masculine again.'[85] In *Belle Haleine* he remains himself 'as' the 'Other', residing inside *and* outside his usual identification at one and

the same time: 'Marcel/Rrose mobilizes this transitive field, occupies both sides (or even an in-between) of the ambivalent (or perhaps more accurately, multivalent) playing out of gender and sexual identities.'[86] Duchamp goes beyond the male/female and self/other oppositions, clearly using play-masquerade as a tool of subversion. However, Amelia Jones also speculates that maybe Duchamp's performance is a reaffirmation of a patriarchal state of affairs 'in which the best woman is a man'; an appropriation of woman's role in order to control.[87] In the present context of this book, this perspective evokes questions about mastery in general: is it possible to go beyond one's *ego* in art and social life and overcome the will (or the necessity) to control? I will address this issue in Chapter 3 in the section relating to artist as a game master.

The use of disguise in Duchamp, the calculated role playing, can be interpreted as his discovery and use of play not as an exotic and 'primitive' supplement, but a necessity and philosophical condition for the artistic act. Masquerade as a conceptual tool unveils the multi-layered structure of artistic activity and its reception, and the functioning of the art world as such. It highlights play that is not opposed to the rational mind (not stereotypically 'naive', 'primitive', 'childish') but is, rather, deeply embedded within rationality in order to be able to transgress it and bring new and unexpected insights. Duchamp as a 'master' of subversive, rational *and* pre-rational play exceeds the modernist/Primitivist approach to play and the creative process in general. He is justly credited with being the initiator of the postmodern characteristics of ambiguity, fluidity and movement 'in between' opposites.[88] While all of his strategies (use of wordplay, chance, humour, games, costumes and performance) were explored and applied by other artists as well (as discussed in the previous sections), Duchamp's *oeuvre*, nonetheless, marks a shift in the application of the strategy of play – from the 'pre-rational' supplement to the much more consciously applied conceptual device. This approach was further developed in the postwar era by American artists John Cage, Allan Kaprow and Dick Higgins, among others. Artistic play after Duchamp can only be analysed with the help of post-structural thought, as I will show in the next chapter.

As I mentioned earlier, interest in pre-rational play in the first avant-garde was not directly inspired by any philosophical theory, but was, rather, a reaction *against* the rhetorics of rationality which pervaded



Western thought. However, the subsequent pervasiveness of pre-rational concepts and interpretations of play in reference to the theory and practice of art can be supported by the position developed later by Hans-Georg Gadamer. Although his overall approach to aesthetics and the role of the artwork cannot be regarded as 'pre-rational',[89] Gadamer's writings can serve as a summary of the modern 'pre-rational' interpretation of play. Moreover, his ideas can also be linked with growing interest in participatory art and its various manifestations, from the avant-garde provocations and postwar process-oriented art to the recent projects of community art or art in the public sphere.

To be Played by the Game

In *Truth and Method* (1960), Gadamer criticizes the Kantian tradition for its affirmation of subjectivity and the disinterestedness of aesthetic experience, due to which, in his view, art becomes detached from life and loses its place in the community. Gadamer tries to overcome the duality between 'beautiful appearance' and 'practical reality' initiated by the Kantian aesthetics and to re-establish art's claims to knowledge and truth. He acknowledges Kant's contribution to art's emancipation from scientific truth requirements, but criticizes him for the alienation and 'subjectivization of aesthetics':[90] 'Thus we make every work of art, as it were, into a picture. By detaching all art from its connections with life and the particular conditions of our approach to it, we frame it like a picture and hang it up'.[91]

To bring art back to its place in the life of community and to 'reality' in general, Gadamer uses the concept of play. He interprets play in the opposite way to the 'aesthetics of autonomy', in which play has been approached as an agent isolating art from reality (practical purpose, function, etc.) and any concerns other than the art-specific. In Gadamer, play is the manifestation of being in the world and does not isolate its participants from 'reality' and each other, but rather binds them together in the collective experience. Gadamer's approach to the notion of play can be interpreted as pre-rational, because he stresses the 'primacy of play over the consciousness of the player'.[92] Players become one with the world of play – their subjective experience is of secondary meaning. Gadamer's intention, as he writes, is to 'free this concept of the subjective meaning that it has in Kant and Schiller

and that dominates the whole of modern aesthetics and philosophy of man'.[93] He therefore refers to the notion of play as a mode of being of things, ways in which the world appears, indifferent to the human will to control.

> If we examine how the word 'play' is used and concentrate on its so-called metaphorical senses, we find talk of the play of light, the play of the waves, the play of gears or parts of machinery, the interplay of limbs, the play of forces, the play of gnats, even a play on words. In each case what is intended is to-and-fro movement that is not tied to any goal that would bring it to an end.[94]

Play, as an independent movement, becomes identified with being. To support this thesis, Gadamer quotes Huizinga's remark: 'The savage himself knows no conceptual distinction between being and playing; he knows nothing of identity, of image or symbol.'[95] Consequently, Gadamer argues that this 'being' of play should be primarily understood as 'being-played' (from the perspective of players). As he writes, 'The attraction of a game, the fascination it exerts, consists precisely in the fact that the game masters the players.'[96] Play becomes a primordial state without goals and efforts. It allows for immersive repetition and letting things go, similar to the natural 'play of the light' or 'play of the waves': 'The structure of play absorbs the player into itself, and thus frees him from the burden of taking the initiative, which constitutes the actual strain of existence'.[97] This concept of play comes close to the Eastern philosophical positions, such as Zen Buddhism, which inspired postwar American artists to experiment with the play of chance and indeterminacy. I will discuss this particular manifestation of play with reference to John Cage's work in the next chapter.

How does this image of play fit into aesthetic theory? First of all, 'play is neither the orientation nor even the state of mind of the creator or of those enjoying the work of art, nor the freedom of a subjectivity engaged in play, but the mode of being of the work of art itself.'[98] According to Gadamer, artistic play occurs 'in between'; it is not inscribed exclusively within the activities of either the players or the spectators. The mode of being of the work of art is, from this perspective, independent of the consciousness of the artist and spectators, just like play is independent of the players – it has its own

essence. The work of art 'is not an object that stands over against a subject for itself'. Instead it 'has its true being in the fact that it becomes an experience that changes the person who experiences it'.[99] Jean Grondin aptly describes the implications of Gadamer's perspective:

> the experience of art . . . is not relating to [an] isolated object, which one could objectify. The play of art does not lie in the artwork that stands in front of us, but lies in the fact that one is touched by a proposition, an address, an experience, which so captures us that we can only play along.[100]

Play, in Gadamer's theory, can be summarized as a force which artists and viewers can play along with and in which they can immerse themselves. It relieves participants from the burden of responsibility and the limitations of their rational minds. It opens up liberating new creative paths to explore. It leads to the elimination of the passive public – everyone becomes engaged in the creative act (a notion which, for instance, was literally applied in Allan Kaprow's Happenings). The pre-rational notion of play as a transforming experience surpassing its players – performative and interactive – seems to go beyond representation. Participants in play or the artistic act are not separated from 'reality'. They can recognize and experience the truth or essence of being, but not in a strictly cognitive or methodical way. Play, from this perspective, is not representational because it makes it possible to experience things as they are, or come to be – it is a manifestation of 'reality'.

However, according to Gadamer, in art, play is no longer free-floating and ephemeral; it acquires a higher form – becomes 'transformed into structure':

> I call this change, in which human play comes to its true con-summation in being art, *transformation into structure*. Only through this change does play achieve ideality, so that it can be intended and understood as play. . . . As such, the play – even the unforeseen elements of improvisation – is in principle repeatable and hence permanent. It has the character of a work, of an ergon and not only of energeia. In this sense I call it a structure (*Gebilde*).[101]

From the above quotation we can see that for art to be 'lasting and true,'[102] for Gadamer, it cannot be play any more – it must become a higher form, namely work. However, this concept of work is produced out of the concept of play and it contains some of Gadamer's characteristics of play. Play, crystallized into a work of art, transforms the world back into its 'true being'.[103] Art 'teaches' about the play of being but cannot itself be regarded as play (pre-rational, untamed, exuberant and so on). Although it emerges from play, it becomes precisely the opposite of play – work – not a dynamic *energeia*, but a fixed *ergon*. It is therefore a tool to recognize the world's truth and essence.

I mention this shift from play to play-like work in Gadamer's account in order to show the conflict between the idea of 'pre-rational' play and the intentionality and meaningfulness belonging to the artistic process. To solve this conflict, Gadamer finds it necessary to point out the ultimate transformation of play into a permanent structure. I have already mentioned similar (and inevitable) inconsistency in the modern avant-garde's approach to play. Pre-rational play as an idea acted as a key to the world of spontaneous, intuitive, fresh and anti-intellectual art that could become one with life – true and immediate experience. Utilized in art, however, play becomes a conscious 'strategy', a tool, a calculated method applied to arrive at certain effects. As I will argue in the following chapters, the above conflict can be solved when we look at play in art as both 'rational' and 'pre-rational' – or more precisely as a movement in between these two 'opposite' poles. I will discuss this issue at length in the next chapter, in reference to the concepts of *ergon* and *parergon* and Derrida's *pharmakon*, as well as postwar examples of art projects that explored the potential of play as a source of vital, untamed creativity and activities transgressing the traditional dichotomies of work and leisure, serious and non-serious, useful and useless, central and marginal, safe and dangerous, sacred and profane and so on.

2

Play is a Movement in between the Opposites

In the previous chapter I analysed two strong and seemingly opposite concepts of play – rational and pre-rational – in the context of well-established aesthetic theories and modern art practice. I argued that the rational, work-like idea of play supports the traditional approach to artistic representation as under subjective, authorial control, while the interpretation of play as pre-rational encourages attempts to go beyond representation. From this latter perspective, the artistic act (process and outcome) can become a 'heightened' experience, instead of the 'picture' framed and hung up on the wall, detached from 'connections with life and the particular conditions of our approach to it'.[1]

In order to suggest a possible way of overcoming this dichotomy, in this chapter I will present the philosophical perspective on play (in which play is seen as an internal ingredient of the concept of art) that goes beyond rational/pre-rational classifications and helps us to analyse various manifestations of play in process-oriented postwar avant-garde and post-modern art.

However, I will also take into account the notion of work because, in my view, the long-established approach to representation is shaped according to the principle of work as ancient *ergon*, proper func-tion, controllable mechanism, with its implications of stability, fixity, hierarchy, mastery, etc. In order to determine the role and position of play in this traditional framework, I will refer to Jacques Derrida's

examinations of the idea of supplement and the Kantian *parergon*. Using post-structuralist Derridean notions of the 'logic of supplementarity' and 'undecidability', I will propose a revised approach to the concept of play (as *parergon*, *passé-partout*, passport, *pharmakon*) and its relation to work (*ergon*) that would overcome the metaphysical dichotomies which traditionally structure the concepts of play and art. I will argue that the notion of play as 'undecidable' must be seen as a constitutive element of art (together with work as *ergon*) and a trigger for representation. I will also discuss the roots of prejudice against representation in Western thought, as described by Derrida with his speech/writing example.

Why do I choose Derrida's terms and line of thinking as a point of reference for my analysis? He uses the concept of play as a tool to overcome metaphysical dichotomies. The deconstructive project of decentring any system – including philosophy, politics and art – exposes play as a leading principle. By 'play' Derrida means movement of any structure, like 'give or tolerance . . . , which works against ideas of self-sufficiency and absolute completion'.[2] As he puts it, 'play is the disruption of presence'.[3] It is the possibility of presence and absence (experience and representation), 'undecidability'. Such an approach to play widens the characteristics of play presented so far and opens up new avenues of exploration within the context of art. It also enables a much more flexible approach to the notion of representation. Moreover, the set of concepts borrowed from Derrida and adapted to the context of play proves to be very helpful in discussing contemporary art projects that extensively utilize various playful strategies. In the second part of this chapter I will apply the above-mentioned theoretical tools to analyse the most seminal interpretations and uses of play as a concept and a creative strategy in process-oriented postwar avant-garde art.

Work as *ergon*

As I have already noted, in my view, the concept of representation in the traditional sense has been constructed with vocabulary from the sphere of work. However, it is the notion of work in a specific sense – not simply an empirical activity of labour or production, but

an underlying principle – that can be derived from classical Western philosophy. The concept of work which I would like to apply here was introduced by Plato and Aristotle. It has a broad meaning and includes the general purpose of any object and the obligation of humans in the spheres of ethics, politics and social life. In *The Republic*, Plato introduces the concept of a specific *function* possessed and performed by every object and a living being.

> 'So again, could you cut off a vine-shoot with a carving-knife or a chisel or other tool?'
>
> 'You could.'
>
> But you would do the job best if you used a pruning-knife made for the purpose.'
>
> 'True.'
>
> 'Shall we then call this its "function"?'
>
> 'Yes, let us.'
>
> . . .
>
> 'And has not everything which has a function its own particular excellence?'[4]

The 'function' (work, *ergon*) is therefore a specific characteristic and purpose of something, an action or activity that it performs better than anything else. The *ergon* of a pruning knife is to cut a vine-shoot well, and this is its proper function. The same rule applies to humans. As Nickolas Pappas explains in his book on *The Republic*: 'The word *ergon* by itself can be indeterminate. Literally "work" or "deed", it applies to anything that requires work – my business, the fruits of my labour – or even very broadly, any act. But one's *ergon* often refers to the occupation that is *proper* to the person. . . . '[5] Plato further develops this principle of specialization, of the single function, in the idea of the division of labour in his ideal city. He presents a model in which every person performs only one job. This guarantees that the work is done well, which in turn is profitable both for the individual and the whole community.

> 'So do we do better to exercise one skill or to try to practise several?'
>
> 'To stick to one.' He said.
>
> . . .

'Quantity and quality are therefore more easily produced when a man specializes appropriately on a single job for which he is naturally fitted, and neglects all others.'

'That's certainly true.'[6]

This specialization is not seen as something forced and prescribed by the social order, but rather as natural, facilitating the work and improving its quality. However, it is important to stress that although Plato's Socrates often uses the word 'natural', his perspective should not be confused with a modern encouragement of self-development, pursued freely according to one's talents or whims. Performing a 'proper function' in society is not advised by Plato because it could be a means for personal self-actualization. This is rather a call to conform to one's destined path and to identify with only one professional role in society. This model, according to Plato, is crucial for the existence of the city, because people are not self-sufficient; they have to gather in communities to exchange services and goods. Performing one's *ergon* is therefore a means to contribute to the well-being of the state, and in consequence, the well-being of the individual. This rule was also applied in the medieval hierarchical society dominated by the Catholic Church, and remained unchallenged by Luther. Even today, in capitalist and post-industrial economic systems every person belongs to the functional net in private and professional life. Although the rules are much more liberal and allow self-actualization and changes of direction, it is extremely difficult to function outside the system and to change profession freely.

Aristotle, following Plato's conception of *ergon*, mainly develops its ethical implications. The 'goodness', excellence, virtue (*arête*) of any object or living being depend on the extent to which they fulfil their destined function. In Aristotle, the notion of *ergon* – as all his philosophy – is structured by teleology (Greek – *telos*: end, purpose), which presupposes that all that exists has an inherent purpose or a definite goal to meet. For Aristotle this final goal for humans is 'living well', in the state of happiness (*eudaimonia*). Fulfilling one's 'proper function' (*ergon*), which in the case of humans is *logos* – rationality – is a means to attain the state of happiness.

As [Aristotle] points out, one traditional conception of happiness identifies it with virtue. Aristotle's theory should be construed as a

refinement of this position. He says, not that happiness is virtue, but that it is virtuous *activity*. Living well consists in doing something, not just being in a certain state or condition. It consists in those lifelong activities that actualize the virtues of the rational part of the soul.[7]

Work is therefore a virtuous and rational activity, the means and the end to a good life. According to Aristotle, man should devote his life to performing his proper function and should not get distracted or derailed by activities like play. Unlike in the Homeric or Heraclitean traditions, as Mechthild Nagel writes, 'Aristotle affirms here unambiguously that play and seriousness are opposites. *Paidia* signifies trivial pursuit, cheap amusement...; in fact to exert oneself and work for the sake of amusement [*paidia*] seems silly and utterly childish.'[8]

The Greek word *ergon* can have different translations, including: process of production; product; achievement; action; task; activity; and function.[9] In Plato and Aristotle the meaning of *ergon* is used to describe the unique, essential, proper function of humans and things or their only goal or purpose. This notion of *ergon* as 'proper function' has been the base of the concept of work for centuries. 'Proper' implies 'right and suitable' which carries an implicit valuation: work – stable profession – is good. What is more, the word 'proper' (from the Latin *proprius*) means 'one's own, individual'. Niall Lucy describes the traditional connotation of this word as follows:

> The classical instance of propriety is of course the proper name, which is thought to belong to individuals as one of the very marks of individuality. I don't answer to just any name – I answer to 'my' name only. In this way my proper name seems to be essential to my sense of identity, despite the fact that my proper name is not strictly my exclusive property.[10]

Ergon is therefore linked with the issues of identification and one's self-identity. Who we are is strongly informed by what we do and how we are 'labelled'. *Ergon* also restricts this identity, and our self-consciousness of it, within certain limits appointed by ourselves and by others.

In terms of art, *ergon* can be interpreted as the traditional identification of artist as maker, the highest form of *homo faber* (Latin for 'Man the Smith' or 'Man the Maker'), the producer of artistic representations of 'things' (objects, situations, people, ideas, etc). *Ergon* connotes orientation towards preconceived goals, with the use of a profession's proper skills and tools. On a philosophical level, it is inscribed within the metaphysical dichotomies of Western thought. It connotes hierarchy, order, permanence, structure, determination and purposefulness as opposed to frivolity, chaos, transcience, chance and the lack of pre-defined goals. *Ergon* conforms to moral rules as well as social conventions. It also implies the existence of the rational, self-aware subject in control of his or her life, creative process and creative outcomes. States of uncertainty, getting lost or 'playing along' with the fluid and ephemeral processes of life, from the perspective of *ergon*, must be seen as dangerous and destructive, because they lead to excessive freedom and defer or preclude the achievement of goals. Artistic *ergon* can also be compared to the Kantian idea of *genius* as a predisposition, which in both cases remains limited by the laws of reason and serves the highest value: a good rational life, social order or aesthetic beauty. In the case of *ergon*, however, the predisposition may often turn out to be an imposition – the obligation to act according to accepted values and conventions. *Ergon*, due to the above characteristics, as an element of internal (and external) control and the will to mastery, seems to be a leading principle in the traditional approach to artistic representation.

I will now turn to the Kantian notion of *parergon*, in order to conceptualize the conventional role of the 'play of art' as a supplement of the 'central' and dominant notion of the 'work of art' as *ergon*. The Derridean concept of the 'logic of supplementarity' would, in turn, lead the way to overcoming the hierarchical and dialectical relationship between *ergon* and *parergon*, work and play of art.

'Dangerous Supplement'[11]

In the Western world, work and play constitute a binary opposition of two distinct realms, with further possibilities of differentiation as active/passive, serious/non-serious, productive/unproductive, useful/useless, real/make-believe, and so on. The traditional ('rational',

Protestant, capitalist or post-industrial) relationship of these two terms, as well as within the *ludus/paidia* dialectic within the concept of play, is based on the dominance of work and its authority as a central value. What is more, this relationship is clearly defined as 'either/or'. We either work or play. Play is activity performed outside the working hours.

According to Derrida, Western metaphysics has always been based on dichotomies: 'speech/writing, life/death, father/son, master/servant, first/second, soul/body, inside/outside, good/evil, serious-ness/play, day/night, etc'.[12] The dominant of these listed polarities has invariably and automatically been the first term, referring to 'unity, identity, immediacy and temporal and spatial *presentness*'[13] and treated as pure, original, positive, necessary, essential and valuable. The second, related to multiplicity, simulation, distance and absence, has been in turn regarded as negative, supplementary, excessive, less important, less valuable and so on. This valuation, present in any theoretical discourse or everyday conversation, is very often subtle, intuitive or unintentional, but nonetheless structures our metaphors, outlooks, attitudes and actions.

To expose the traditional relationship between the opposite terms and the possibility of its deconstruction, Derrida employs the word 'supplement'. In this formulation, the hierarchy of dichotomies such as those above is visualized as a main body, essence or whole as opposed to an addition, extra, fragment or *hors d'oeuvre*. In publishing, for example, a 'supplement' comes after the main body of the text and is regarded as secondary, performing a merely complementary role by updating or enhancing some aspects of the preceding work. The supplement comes into being only thanks to the existence of the first, original, and primary text and is incomplete when read as a separate entity. Derrida shows that this incompleteness belongs both to the notion of the main text and its supplement, and analyses the nature of supplementation in his reading of Kant.[14]

Kant, in his remarks in *Critique of Judgement* about the role of a picture's frame, a column, or drapery on a statue, describes these elements as '*ornaments [parerga]*, i.e. those things which do not belong to the complete representation of the object internally as elements but only externally as complements'.[15] Kant distinguishes the main body of the work (*ergon*) from the ornament enhancing and complementing

its beauty – something external, supplementary – the *parergon* (in Greek: subordinate, beside the main subject): 'The parergon, for Kant, becomes a category for relegating the marginal elements that complicate the categorical definition of a work. The parergon is the convenient limit to the ergon...'[16] As Derrida states, 'Kant makes clear, that which is not internal or intrinsic, as an integral part, to the total representation of the object...belongs to it only in an extrinsic way as a surplus, an addition, an adjunct, a supplement.'[17]

Derrida, in his own analysis, does not follow the traditional questions: what is inside or outside the frame, and how is the inside different from the outside? He is, rather, concerned with how the frame itself works. He examines the notion of *parergon* by asking whether it is possible to determine where the work of representation ends and *parergon* begins: are they really separate, clearly different, 'internal' and 'external'? If the work is completed, why would it need an extra, a frame? *Parergon* implicates lack, something missing on the inside of the work. What constitutes *parerga* 'is not simply their exteriority as a surplus, it is the internal structural link which rivets them to the lack in the interior of the *ergon*. And this lack would be constitutive of the very unity of the *ergon*.'[18] *Parergon*, as any supplement, is then essential to the constitution of the identity of the work of art, or any object or idea that is supplemented. This essentiality is also threatening, dangerous, because to some extent the supplement usurps the identity of the inside and exposes the fact that this identity is incomplete or cannot exist at all without the supplement. The danger of the supplement lies in the fact that it destroys the stability of even the most basic concepts, reveals questions where we expected to find the answer and exposes the emperor (in fact already naked). It pushes us out of the safety of black and white into an unpredictable slide through the grey scale.

In Derrida's reading, the hierarchy of *ergon* and *parergon* and other pairs of binary oppositions, standing traditionally for the essence and surplus, becomes questioned and deconstructed. What was the centre, the ruling concept, becomes dependent on the supplement, the mere addition. Furthermore, this logic opens up any structure that seemed to be completed. What is left, after the deconstruction of the traditional relationship of the two terms, is the third one, belonging neither to the inside nor to the outside in the old sense.

In terms of work and play, in traditional Western metaphysics, it is work that dominates play while play performs a supplementary role, as an outlet for surplus energy, a means of gaining vicarious experience and so on. When we apply the logic of supplementarity we can no longer treat the concepts of work and play as pure and separate. As with all other binary oppositions, they constitute each other; the lack of work evokes and defines the concept of play and vice versa. Play is no longer a mere supplement but, like *parergon*, has to be seen as belonging to the notion of work; essential to the constitution of its identity, being always present and absent, inside and outside, etc. Consequently, the 'logic of supplementarity' enables the analysis of work (as *ergon*) and play within the concept of art, as interconnected and mutually dependant. After reading Derrida, art is neither 'work' nor 'play', but exceeds the restricted meanings of these two terms.

Play as *parergon*

When we traditionally conceptualize work as *ergon*, 'proper function', perceived as belonging to or establishing 'reality' (stable self-identification), the mechanism of binary oppositions immediately creates its negative, an absence that can be filled by the concept of play. Single proper function is contrasted with a multiplicity of temporary activities, and single identity with double or multiple fluid identifications. Kant uses the term *ergon* in the sense of 'work of art' and he juxtaposes it with *parergon* (ornament, frame, supplement). Although I approach the notion of *ergon* in a different way (as 'proper function', task, activity), the relationship between Kantian artwork (*ergon*) and *parergon* as supplement can be compared to the connection between 'work of art' as *ergon* (proper function) and 'play of art' as *parergon* (playing with the proper function). This analogy can be traced in two ways. Firstly, *parergon* as ornament[19] connotes playful frivolity and excess, in relation to the functional and purposive *ergon*. Secondly, *parergon* as frame limits *ergon* and defines its identity (through challenge, parody, experiment, subversion). According to the logic of supplementarity, *parergon* as frame at once restricts *ergon* and works against its self-sufficiency, opens it for intervention, makes it fluid. What is more, in Derrida, *parergon* is compared to *passé-partout*. This French word, used internationally in art supply stores,

means a cardboard *frame* that works as a mounting for a picture, but also means a *key* that secures entrance or exit everywhere, a master key. This double sense of *passé-partout* corresponds exactly with the characteristics of play that I want to highlight and explore here.

In a sense, play acts as a conceptual frame for work, just as work frames the concept of play, and this rule applies to all binary oppositions, main bodies and supplements. However, more specifically, play acts as a frame bracketing 'reality', as described in the introduction. In fact play *is* a frame, it does not possess any content of its own. It changes the meaning of what it frames, because in framing it makes it isolated, bordered, extracted and doubled; labelled: *this is play*. Everything in play remains itself *and* becomes a representation of self or other. *Passé-partout* as a frame appoints a limit, a border. It fixes and locks inside or outside. However, by creating the double identity of what is framed, it also alludes to the second meaning – the master key, which allows the opening of all doors, enables mobility, interactivity, change and crossing of borders.

Passé-partout in everyday life can be located in the institution of the passport, which allows the crossing of borders, but at the same time marks the frame of one's identification and obligation. The passport permits the individual to be inside and outside the 'original' system; one can cross the borders physically, but emotionally, socially, politically, etc., one may not be able to get outside. To some extent one always remains 'here' and 'oneself', but the passport allows us to experience 'otherness' and being 'there', as well. It also works the other way round – the experience of remaining within the borders is determined by the possibility of movement. When a person holds a passport, even if it only lies forgotten at the bottom of a drawer, he or she can always potentially cross the border, get 'outside', become somebody else and begin a second life. The passport can then serve as a metaphor for the possibility of movement, being inside and outside, being one and the other at the same time. However, it also brings about the risk of the denial of access, if the passport is not the 'right' one, not accepted due to political circumstances. *Passé-partout* and passport exemplify operations of play. It is play as stability *and* movement, change; being inside *and* outside, included *and* excluded, being present *and* absent. It is play that links the opposites.

To analyse in more detail this specific characteristic of play, I turn again to Derrida and his text *Plato's Pharmacy*, a rereading of *Phaedrus*, Plato's dialogue on the mythical beginnings of writing. As I will discuss later in this chapter, the speech/writing opposition is described in Derrida as the root of all 'centrisms' and hierarchical dichotomies in Western metaphysics. His reading of Plato's dialogue aims at overturning the traditional relationship between speech and writing, and exposes the role of writing (and any other kind of representation) as *pharmakon* and 'undecidable'. I will argue that the same role can be ascribed to play-*parergon*.

In *Phaedrus*, Plato employs the Egyptian myth of the god Theuth, the inventor of writing, who presents his valuable invention to King Thamus. The king rejects this gift as dangerous and destructive to society. According to him, it breaks the chain of masters and disciples, replaces 'real' knowledge with just a 'written trace' and is a pseudo-remedy against forgetting. Writing is presented as *pharmakon*, either cure or poison − a support for memory, but 'substituting mere inscriptions, alien, arbitrary, lifeless signs − for the authentic living presence of spoken language'.[20] Plato uses the word *pharmakon* with two different meanings and it is the translation which decides what it stands for in a specific context. However, as Christopher Norris puts it, 'two antithetical senses of this word are everywhere co-present in Plato's text, defeating all attempts to close one or another according to a context'.[21] Derrida argues that *pharmakon* cannot be 'decided' (translated) as either cure *or* poison. *Pharmakon* is the primary example of what he calls the 'undecidable' − a term or concept that cannot be located on just one side of a binary opposition. In Plato, *pharmakon* is used to describe the nature of writing but also hemlock − the cause of Socrates' death. According to Derrida, in both cases this word suggests undecidability, the deconstruction of traditional dichotomies − which is, in fact, already present in Plato's text even if unnoticed by the philosopher himself and, what is more, contrary to his intention.[22] Writing-*pharmakon* acts therefore as a beneficial drug *and* a harmful philtre of forgetfulness; hemlock − as poison *and* a way toward salvation with cathartic power.[23] As Derrida writes: 'The "essence" of the *pharmakon* lies in the way in which, having no stable essence, no "proper" characteristics, it is not, in any sense (metaphysical, physical, chemical, alchemical) of the word, a *substance*. The *pharmakon* has

no ideal identity...'[24] *Pharmakon* is neither positive nor negative, neither harmful nor beneficial. This lack of stable characteristics of the *pharmakon* is linked by Derrida to play (in his particular use of this term):

> If the pharmakon is 'ambivalent', it is because it constitutes the medium in which opposites are opposed, the movement and the play that links them among themselves, reverses them or makes one side cross over into the other (soul/body, good/evil, inside/outside, memory/forgetfulness, speech/writing, etc.).... The pharmakon is the movement, the locus, and the play: (the production of) difference.[25]

This is exactly the concept of play that I find appropriate to use in the context of art. Before I expand on this issue, I would like to look closer at the figure of the god Theuth who can be seen as an embodiment of play. Derrida meticulously traces his multiple identities and bases his analysis on the assumption that the figure of Theuth was borrowed by Plato from Egyptian mythology where the analogous god can be found under the name Thoth – 'moon deity with the head of an ibis, god of wisdom, learning, and the arts; scribe of the gods'.[26] Traditionally, Thoth resides on the side of moon, night, death and writing, as opposed to the realm of sun, day, life and speech represented by his father Ammon-Ra. Derrida specifies his other functions: doctor, pharmacist, magician, bookkeeper, god of writing and god of death,[27] and points out that Thoth plays contradictory roles in Egyptian mythology. For instance, he is the scribe, inventor of writing *and* tongue of Ra, translating his will into speech.

> ...the figure of Thoth takes shape and takes its shape from the very thing it resists and substitutes for. But it thereby opposes itself, passes into its other, and this messenger-god is truly the god of the absolute passage between opposites. He is thus the father's other, the father and the subversive movement of replacement.... He cannot be assigned a fixed spot in the play of differences. Sly, slippery and masked, an intriguer and a card, like Hermes, he is neither king nor

jack, but rather a sort of *joker*, a wild card, one who puts play into play.[28]

This description of Thoth can serve as a source of metaphors useful in my further analysis of play in modern and post-modern art. Thoth can be compared to the artist who applies play as a creative method, who slips between professional categories, tests various identities, provokes, transgresses the boundaries and initiates the play of art. However, more generally, the image of the joker illustrates the role of the element of play in any structure. A 'wild card' can represent other cards in the deck and its identity is fluid, undecided between its own 'non-identity' and the one it stands for. It is at once itself and the other. Additionally, in different games the joker plays different roles; it can be neutral, beneficial or to be avoided; can be the highest trump, or be left outside the game. The joker can replace other cards but it does not belong to any suit. Like Thoth/Theuth, it is precisely inside *and* outside the system.

Here emerges yet another figure in the chain of *pharmakon's* embodiments: *pharmakos*, the scapegoat. Derrida supplements Plato's dialogue with this term, referring to the old rite of purifying the city from all evil performed in Plato's time. Outcasts, degenerates and useless beings were maintained at the public expense by Athenians in case of plague, drought, famine and other disasters, when through their death by burning they were 'prescribed' as a remedy to the suffering city.[29] The *pharmakos* was therefore playing a double role – as an evil within the walls *and* a solution for its defeat, the dangerous supplement – able to corrupt the structure from within *and* to heal its weakness. *Pharmakos* is, then, another metaphor for play – the means of the positive *and* negative transformation, infection *and* curation, sin *and* salvation. It is also metaphor for play as the possibility of communal togetherness *and* exclusion.

To Thoth, Derrida attributes a mask – a powerful symbol of performance, the temporary change of identity, mostly associated with carnival, ritual and theatre. The characteristics of the mask echo those of *parergon*, frame, *passé-partout* (in both meanings) and supplement. It belongs neither to the inside of its wearer nor to the external reality. It defines a new identity but it is only transitory, in the movement between the 'original' and proper face, name, function and the newly

adopted one. The mask locks its wearer inside the ephemeral frame, with a given code and rules of behaviour, but at the same time, by the fact of its own being, opens up endless possibilities of alternative 'realities'. It can be said that the particular (empirical) use of mask is limiting, but the transcendent mask, or the idea of mask, is the condition for movement, change, substitution – 'the subversive movement of replacement'.[30] As Derrida writes, 'Death, masks, makeup, all are part of the festival that subverts the order of the city, its smooth regulation by the dialectician and the science of being.'[31]

Carnival as a specific, performative form of ritual is an important aspect of the discussion of play, especially in the context of interactive art and my analysis of role-playing games in Chapter 3. Undoubtedly ritual and play are connected, if only in the shared characteristics of repetitiveness, their relation to rules, conventions and the sphere of work and the double meaning they impose on certain situations, behaviours, objects and gestures. However, there are also significant differences. According to Don Handleman, the play frame is easy to establish, flexible and allows wide space for individual expression, while the ritual's frames are fixed, difficult to modify and grounded in the binding values of truth, morality and the social order.[32] As Handleman writes, 'play doubts the social order while ritual integrates it'.[33] However, Victor Turner expresses a different view of ritual's role; ritualized role-playing enables 'participants to experiment with alternative social relations or to invent new ones'.[34] We can think, for instance, about the ancient Dionysia festival in Athens: 'Dionysus was a god who came from outside and temporarily suspended the activities of everyday life. His festival created a space outside the day-to-day reality of the polis.'[35] The celebrations included the custom of *aischrologia*, 'which allowed those of lesser status to jeer at those of greater',[36] and other occasions for role-reversal. It is also worth stressing here that both ritual and play, apart from the notions of community and participation, entail the possibility of exclusion. Integration of a social order (in ritual) and establishing one's identity (in play) can result in sacrificing/excluding those who are seen as outsiders (*pharmakos*, the scapegoat).

The 'art as carnival' model that refers to the above characteristic of ritual celebrations can be derived from the book *Rabelais and His World* (written in 1941, published in 1965) by Russian philosopher Mikhail

Bakhtin. Bakhtin approaches carnival as a form of social interaction located on the borders of art and life (a desirable location from the perspective of the twentieth-century avant-gardes). Carnival resembles a spectacle, but according to Bakhtin, it is not simply another art form:

> [T]he basic carnival nucleus of this culture is by no means a purely artistic form nor a spectacle and does not, generally speaking, belong to the sphere of art. It belongs to the borderline between art and life. In reality, it is life itself, but shaped according to a certain pattern of play.... Carnival is not a spectacle seen by the people; they live in it, and everyone participates because its very idea embraces all the people.[37]

Carnival is art-like (representational) and it belongs to reality (non-representation) – a reality shaped by the 'pattern of play'. The experience and the performance take place through bodily involvement, through immersive participation in the activities encircled in specific time and space frames. Participation in the carnival is not a matter of imitation; it involves the *methetic* 'transformation' of bodies and minds (at least for the duration of the carnival). Here, again, we see the value of the term '*methexis*', which refers specifically to participation, to an audience which simultaneously plays a role in shaping and creating the ritual or drama; an important feature of carnival is that everybody participates in it and there is no division between performers and viewers.

Bakhtin describes the role of the carnival in community life as a temporary dissolution of social hierarchy and a deep experience of human bonds in the spirit of togetherness and freedom from the official order. Carnival, presented by Bakhtin, becomes a temporary (and officially sanctioned) subversion of the ruling hierarchy and the dichotomies on which it is based – culture/nature, sacred/profane, serious/non-serious, work/play. It is, therefore, an experience of oneself as the Other and of others in new circumstances. Relations become redefined and structured according to alternative playful and subversive rules. According to Bakhtin, these new 'truly human relations' are not 'only a fruit of imagination or abstract thought'; they are 'experienced'.[38] When play instead of work becomes the ruling principle, in any social realm including art, a process of symbolic

inversion occurs, exposing and transforming the 'central' concept – for example, the 'high', the 'official', the 'sacred', the 'productive'. Bakhtin coined the word 'carnivalesque' to describe the literary mode which uses humour and chaos to undermine the dominant official style; this categorization is obviously applicable to other art forms and media. As Michael D. Bristol points out, the 'carnivalesque' mood, and laughter in particular, are valuable resources and instruments 'for any social group that lacks power but seeks to retain a strong feeling of solidarity'.[39] Play and laughter are therefore important elements of any 'critical consciousness'[40] that positions itself against the dominant power.

In addition to its participatory character, carnival, like any form of exuberant and ritualistic (or ritual-inspired) communal celebration, links the poles of the pre-rational and rational because, as a collective excessive experience, it happens beyond the control of the individual participant but allows for autonomous, self-designed role-play.

Play and Representation

It can be observed, even from the above chain of play's identifications (supplement, *parergon*, *passé-partout*, passport, *pharmakon*, joker, *pharmakos*, mask, carnival), that it is difficult or in fact impossible to capture the 'essence' of play. Like its symbolic figure – the god Thoth – play cannot be assigned a fixed spot, proper function, name or purpose. The distinctive characteristic of play seems to be its 'undecidability': being neither one thing or another, but 'in between' opposite poles: here and there, real and make-believe, serious and non-serious, present and absent. Play is the locus *and* the movement (lock and key); it is a deviation from 'proper function', one stable 'reality', meaning, purpose, reference, identity, which nonetheless use it as a point of departure, the 'inside' to be framed. *Parergon*, as playing with *ergon*, remains connected with the stable and well-established principle in the given context, but also subverts and transgresses it.

Play – as a movement between detached or opposite elements – can then be seen as the condition of the creation of metaphors, for the movement of thought (or hand) beyond the restricted paths. Play activates the possibility of seeing something 'as something else' and, what is more, the ability to act as if it *is* something else, and at the

same time to be aware that it is not. In other words, play enables double or multiple identities or identifications, double or multiple 'realities', to be present *and* absent at the same time. This feature allows 'brackets of fiction' to exist within whatever is designated as 'reality'. For that reason, in the broadest sense, I consider the notion of play as a condition of representation – language, writing, art and the empirical activity of play, among others.

In my view, this perspective situates the concept of play beyond the conflict of rational and pre-rational narratives. Play as an 'undecidable' can be manifested as a subjective and controlled activity, but which is simultaneously enabling the states of 'heightened experience' – immersion, improvisation, direct sensation – and 'anti-mastery'; letting things go, uncertainty, indecision, incompetence and indeterminacy. In art, however, these states or elements belong, in most cases, to the calculated strategy or tactic, so inevitably must be regarded within the representational frame. Nonetheless, in my view, inscribing the concept of play (the 'undecidable') as an internal element of the notion of representation makes the latter inclusive of practices that contest the traditional *ergon* of art and use 'experience' instead of, or together with, traditional artistic means and materials. Play as a trigger for representation implies that there is no need to go beyond representation in art, but also that it is not possible to do so.

In order to look closer at reasons why play, nevertheless, has been interpreted and used as a non-representational (pre-rational) tool, and to explain further the utopian character of such projects, I will now discuss Derrida's analysis of the deep-rooted prejudice against representation in Western thought and of the speech/writing opposition as fundamental for the 'metaphysics of presence' (referred to as 'the myth of presence' in relation to Primitivism in the previous chapter).

The art of representation is therefore a long way removed from truth, and it is able to reproduce everything because it has little grasp of anything, and that little is a mere phenomenal appearance. For example, a painter can paint a portrait of a shoemaker or any other craftsman without understanding any of their crafts; yet, if he is skilful enough, his portrait of a carpenter may, at a distance, deceive children or simple people into thinking it is a real carpenter.[41]

Plato sees artistic representation as the imitation of things we deal with in our life (which are already copies or shadows), with no access to the world of ideas or the world of origins – the truth. Therefore art is only an imitation of appearance. Plato ranks imitation lower than narration, which is recounting events in the 'first' person and comes from personal experience. In this tradition, the classification and hierarchy of art forms is dependent on the closeness of a given practice to the truth, the essence, the original experience, the real existence of things, etc. There continues a quest to discover the form of representation that would be the closest to reality as essence, not just a 'mere' appearance or interpretation (e.g. role playing, which would entail 'becoming' the shoemaker instead of painting his portrait).

Derrida, in his analysis of Plato and Jean-Jacques Rousseau, uses the example of speech and writing to deconstruct the conventional primacy of the 'origin' over the representation. For Rousseau, essence, truth and authenticity are located on the side of 'nature', which, across his whole *oeuvre*, is presented as opposed to culture, which is false, modern and degenerate. Writing, according to Rousseau (much like Plato in *Phaedrus*), exemplifies detachment from nature, from what is good and original: 'Writing, which would seem to crystallize language, is precisely what alters it. It changes not the words but the spirit, substituting exactitude for expressiveness.'[42] Writing substitutes a living presence – which is not always perfect, but reliable – with a calculated pretence.

The question that can be derived from Rousseau – how to avoid representation as a cultural 'artifice' – seems to be crucial for many practices in the history of art, and in that of twentieth-century art in particular. How to come closer to 'being', to the world as we experience it, to truth? How to escape the elements of pretence, simulation, frame and authority which are inherent to art? Art (writing) as a medium of communication acts as a necessary evil, a *pharmakon*, and although not all representation is art, all art is representation (under the operation of play-*parergon*). However, paradoxically, the activity of play (interpreted as pre-rational) has become an attractive model in the quest for lifelike art. The pre-rational narratives stress that play occurs only through its players – it is inseparable from immediate experience. This is why it fits well within the rhetorics of presence and origin. It is an activity: doing, being, acting, performing, here and now, in the

given place and moment of time. In contrast to the traditional image of representation in art, play, as an ephemeral living presence, seems to be instinctive, expressive and innocent. What is more, play acts as a democratic 'communal forum' where people can 'come together' and act collectively and spontaneously against the dominant official structure that tends to represent them in a distorted, ideological way.

However, Rousseau's reflections on his own practice of writing reveal the ambivalence of his argument and its inherent paradox, or what Derrida names 'the logic of supplementarity'. In *Confessions* (1782) Rousseau admits that writing down his memories is a way to reveal the true nature of his feelings and reflections, impossible for him to utter in the presence of other people. In *Of Grammatology* (1976) Derrida quotes Rousseau, confessing:

> I would love society like others, if I were not sure in showing myself not only in disadvantage, but as completely different from what I am. The part that I have taken of writing and hiding myself is precisely the one that suits me. If I were present, one would never know what I was worth.[43]

Therefore, to some degree, speech as an ephemeral phenomenon depends on external conditions – favourable or deterring – and can never present the truth in an ultimate, objective way, but must depend on writing to perform this task. A written form can be filled with meaning that the speaker was unable to express in a given moment. What is more, speech reveals its detachment from the thought, so, according to Derrida, it is itself a form of representation and 'writing'. The idea which is seen as 'the source', 'the origin', 'the essence' always already contains the 'derivative' one, and its primacy as the original becomes problematic.

Derrida's readings of Plato and Rousseau show that in Western thought there exists a very powerful tradition based on the 'myth of origin' or the 'metaphysics of presence' – the preference of what is natural, authentic, pure and original over any form of mediation, imitation, representation and anything that 'comes after' the 'origin' – culture, civilization, technology, art, and so on. This lauded natural state exists in some timeless past and, as Derrida shows, it belongs indeed to myth, since any close analysis of such a perspective reveals

that every human act, including thought and speech, is already a form of representation: 'The belief that Derrida prefers writing over speech is mistaken. He is suspicious only of the idealization of speech because it involves a phantom promise of the natural, the pure, the original.'[44] Derrida does not deny that 'there exists a world "out there", or that language can engage with that world in a variety of practical ways.'[45] He just points out that we must pay attention to 'the problems involved in arriving at "the real" through our representation of it'.[46] We must be aware, therefore, that most theories of art try to establish one form of representation as more 'natural' than another – claiming that speech is more natural and therefore better than writing, music more natural than painting, participatory art better than traditional media, and so on.

Eastern Influences

Apart from post-structural philosophy, represented by Derridean deconstruction, an important role in the development and conceptualization of art as play in the postwar world has to be ascribed to the inspiration artists took from Eastern philosophies and Zen Buddhism in particular. The American postwar artist's fascination with Zen Buddhism had a significant influence on the development of the strategy of play in twentieth-century art, because it introduced an alternative approach to work and play, reality and fiction and other dichotomies; a way of tackling these structural polarities which was different to that of traditional Western metaphysics.

John Cage, pioneer of chance music, non-standard musical performance and composition, was one of the artists who disseminated a Zen-inspired approach to artistic creation; through his contacts among the avant-garde, his collaborations and his teaching in the Black Mountain College and New School of Social Research (his students included Allan Kaprow and Dick Higgins). Cage studied Zen in the 1940s and based many of his compositions on the structure of the *I Ching*, an ancient Chinese philosophical book.

> The master in the art of living
> makes little distinction between
> his work and his play,

33

3



his labour and his leisure,
his mind and his body,
his education and his recreation,
his love and his religion.
He hardly knows which is which.
He simply pursues his vision of excellence
in whatever he does,
leaving others to decide
where he is working or playing.
To him, he is always doing both.[47]

The fundamental idea that can be derived from Zen philosophy, poetically summarized above, is the dissolution of opposites in the overarching flow of life. In Cage's works, and in the projects which his students would go on to devise and carry out (Kaprow's Happenings, the Fluxus movement), fascination with Zen was manifested in the strategy of 'letting go' or indeterminacy; surrendering authorial control and mastery and inviting non-art elements to be natural components of the aesthetic experience initiated by the artist. This included the use of everyday activities and objects, background noise, improvisation and contributions from viewers and passers-by. Everything, even the most banal everyday object or situation, could become a part of the work of art because Zen does not distinguish between ordinary and extraordinary or high and low, and does not impose any other hierarchical classifications. As Cage remarks, 'Zen teaches us that we are really in a situation of decentring, ... There is then a plurality and a multiplicity of centres. And they are all interpenetrating.'[48] The hierarchical Western approach, enforcing order and separating 'centres' from 'margins', is put into question. As in Derrida's thought, there is no one proper and pure 'centre' which is not already penetrated by other 'centres'. Play acts precisely as the all-permeating movement decentring any structure ('playing with *ergon*') or as the humorous gesture of 'pulling out the rug from under any pomposity'.[49]

Furthermore, the work of art was to be devoid of the pressure of meeting the designed goal, the final effect. As Robert Linssen writes, Zen helps to give up 'strivings to "become", to possess and to dominate' and instead it teaches one to 'let go' in order to discover 'felicity and relaxation of *Being*'.[50] For Cage, this perspective entailed

a way of working 'in a spirit of acceptance rather than a spirit of control'.[51] Cage's 1952 manifesto consisted of these three lines:

> nothing is accomplished by writing a piece of music
> nothing is accomplished by hearing a piece of music
> nothing is accomplished by playing a piece of music[52]

These statements remind us of Gadamer's notion of play as a disinterested movement backward and forward, which 'has no goal that brings it to an end'.[53] The artist, his/her works and the audience, through the strategy of indeterminacy, can partake in the movement of being. According to Cage, 'Today, beside stability, we allow for instability. We have come to desire the experience of what is. But this "what is" is neither stable nor unchanging. ... "What is" doesn't depend on us, we depend on it.'[54] As Paul Griffiths writes, 'The composer thus becomes a proposer, one who creates "opportunities for experience" while denying himself those intentions of expressing, limiting, and shaping.'[55] This was the strategy for creating artworks that were 'open' and interactive with the environment, the audience, atmospheric sounds, random events and so on.

Cage's ideas were developed by Fluxus, a movement officially initiated by George Maciunas in 1962. Apart from the ideas of chance and indeterminacy disseminated by Cage, they combined the playful spirit of Dada and the scientific approach of Bauhaus, among other influences. Ken Friedman, one of the Fluxus artists, in the 1989 article 'Fluxus & Company', describes the research programme of Fluxus groups as characterized by 12 main ideas:

> globalism,
> the unity of art and life,
> intermedia,
> experimentalism,
> chance,
> playfulness,
> simplicity,
> implicativeness,
> exemplativism,
> specificity,

presence in time, and
musicality.[56]

The playfulness of Fluxus came from the artists' interest in jokes, games, puzzles and gags as structures for artistic actions and objects. However, as Friedman explains, there was more to play in Fluxus than humour and fun. The artists were interested in play as it occurs in scientific research, as a spirit of sudden creativity or a moment of unpredictable but blinding inspiration – 'the playfulness of free experimentation, the playfulness of free association and the play of paradigm shifting'.[57] Unlike nihilistic Dada, Fluxus had a constructive agenda of micro-transformations within various spheres of people's interaction with one another and with the environment. Fluxus artists from different countries and continents worked together on many projects to come up with new methods and results, just as is practised in collaborative scientific research. However, this scientific programme was a non-functional tool. The serious methodology was contrasted with absurd, playful or poetic works. Fluxus artists were balancing on the knife's edge in between work – as research, innovation, laboratory experiment – and play, as a fluid, changing spirit of freedom, a way to connect or juxtapose even the most disparate elements.

The global 'little laboratory' of Fluxus produced various ephemeral gestures, objects and situations in the form of artist books, mail-art, poems, performances, Happenings, noise music compositions and many others. The most specific art forms were boxes containing collections of cards, games, puzzles, texts and event scorecards. These works were similar in concept to hobby or do-it-yourself kits, and were instructions on how to make/perform an art piece. Ken Friedman describes the idea behind these works as 'musicality', meaning that the works 'can be realized by artists other than the creator'.[58]

This approach promoted the modes of collective work, collaboration and free exchange of ideas, instead of the authorial control and individualism inscribed in the traditional Western notion of artistic creation. The Fluxus artist as a researcher in his or her playful laboratory wanted to inspire the viewers and participants of art events to implement little experiments by themselves. He or she, instead of

being a maker, often remained the designer of the event, the animator of play to be enjoyed and carried out by the others. The instructions, programmes and plans to be enacted, in the form of intimate private happenings, as in the case of Yoko Ono's works, were addressed to everybody:

> TOUCH POEM FOR A GROUP OF PEOPLE
> Touch each other.
> 1963 winter[59]

George Brecht produced many Flux boxes and scores based on the model of games. In his *Swim Puzzle Box Game* (1965) he instructed the 'players' to 'arrange the beads in such a way the word CUAL never occurs'.[60] However, there were no beads in the box, only a seashell. Apart from its poetic quality and a Surrealist charm, Brecht's game implies the possibility of creating new rules, so the new game can be played. Brecht opens his 'box' for contribution, for creative input from the viewer or other artist. He also questions the exclusive authority of the artist and rules of his game. The play of art literally transgresses the initial intention locked in the 'box' and allows it to be played by the others in endless unpredictable ways. However, the first move inevitably belongs to the artist.

To a large degree this new approach to the work and play of art by Cage and Fluxus artists was intended to activate the public and to make art an anti-professional, anti-elitist occupation. This agenda was further developed in the practices focused directly at the viewer's experience and participation. As Duchamp writes in *The Creative Art* (1957), 'All in all, the creative act is not performed by the artist alone; the spectator brings the work in contact with the external world.'[61] On the following pages, I will introduce changes that occurred in the postwar approach to the gallery or museum space, and the viewer's presence in this space, which contributed to the development of the interactive and participatory playgrounds of recent art.

'Viewer the Player'

This section will analyse a few initial moments in the history of installation art relevant to the development of play as an artistic method

in post-modern art. As I will argue, the shift in approaches to the gallery space and to the viewer's navigation of this space was a further step in the quest for authentic, direct and multi-sensory experience in the context of art. It was also a way to activate the viewers, to make them aware of their own role in the 'performing of the creative act', to gradually transform them into artists' 'playmates'.

After Claire Bishop, I apply 'installation art' as 'a term that loosely refers to the type of art into which the viewer physically enters, and which is often described as "theatrical", "immersive", or "experiential"',[62] as well as that which uses 'materials and methodologies not traditionally associated with the visual arts'.[63] In my view, it is not a coincidence that this definition echoes that of 'Primitivism' (as 'using unconventional procedures or techniques that bypass the methods normally associated with the trained painter or sculptor').[64] The common agenda was to evoke an 'experience' that is not art-like but lifelike, that 'presents' things and not just 'represents' them. Installation artists eagerly supplemented traditional artistic tools and methods with new ones borrowed directly from the flux of life. The traditional *ergon* of art – as the production of representations – lost its status as a final purpose and became a context for process-oriented play-*parergon* in which artists and viewers could participate together.

One of the artistic events that influenced the emergence of installation art was the 1938 *Exposition Internationale du Surréalisme* in Paris. On display, apart from paintings, were typically (bizarre) Surrealist objects, like Dali's *Rainy Taxi*, a taxi with two mannequins on the front seats and water sprinkling down the inside of the windows. However, the overall arrangement by Marcel Duchamp, the curator of the show, was innovative and transformed the space into a suggestive 'Surrealist world'. Duchamp converted the main hall into a 'cave', with the use of bags of coal hanging from the ceiling. The only lighting was provided by a single light bulb, so the viewers were handed flashlights to manoeuvre through the darkness and illuminate the artworks for themselves. The floor was covered with dry leaves, grass and ferns and the air was filled with the aroma of coffee. According to the artists' expectations, the visitors interpreted this arrangement as a provocation and were not eager to immerse themselves in playful exploration of the space.[65]

The subsequent shift in the attitude of the wider public, in terms of what is proper and desirable in the exhibition space and what kind of experience can be accepted as aesthetic, can be attributed, to some extent, to the postwar growth of the entertainment industry in the United States. According to Mark Rozenthal, some links can be traced between the emergence of installation art and theme parks, with the first Disneyland[66] opening in California in 1955:

> Disneyland was perhaps the single most significant and influential force in shaping a large American public's expectations about similar experiences, suggesting that a total environment of sensory pleasures might be possible in a 'leisure' situation. . . . In other words, some portion of the art-going public came to expect and want to be catered to by cultural activities that offer [a] participatory compo- nent, and which installations are so thoroughly geared to provide.[67]

A theme park such as Disneyland can be interpreted as yet another model of a 'playground' that might have loosely stimulated the artists' pursuits in terms of transforming the viewer's role into more engaged modes of interaction, and of overcoming the isolation and detachment of art from other spheres of social life. Whether we accept Disneyland as a source of inspiration (or contestation) for artists in the early years of installation art, similarities exist that cannot be overlooked. In the 'theme park' model, the observer has an opportunity to become an active visitor, and to experience a different reality – to touch, see and interpret the experience for oneself – just like during an excursion to another country. John Hench, one of the chief designers of Disneyland, remarks: 'As guests traverse the tunnel, they leave behind the everyday routine of working, maintaining shelter, obeying rules; they enter a space where they can play voluntarily, and where we know they will have the opportunity to feel more alive.'[68] In other words, they can leave behind the world of work and experience a 'real meaning of life'. It seems different from watching a movie or spectacle or contemplating a painting on the wall. The 'visitor' can make some decisions about his or her own 'being' within the environment, one that is tangible and open for exploration in time and space: 'Not only the journey to Disneyland, but the journeys between the lands within Disneyland became active spatial stories.'[69]

Apart from the common purpose of providing the viewers with the 'heightened experience' of tangible and ambient 'reality', both installation art and Disneyland follow a specific social agenda. Walt Disney intended his parks to be 'reminiscent of American utopian communities'[70] where people can 'express their inherent sociability, but free of [the] contamination of modern cities'.[71] As Claire Bishop writes, many installation works (especially of more recent 'relational' character) try to generate communication between visitors, to foster direct face-to-face interaction and to 'set up functioning "microtopias" in the here and now'.[72] The frames of play are used in these works to separate participants from all the dangers and disappointments of real life (like the tall earth bank around Disneyland) and to provide them with the experience of natural human bonds and the long-lost spirit of togetherness – promises that bring to mind the Primitivist myths.

Despite the similarities between the rhetorics of installation art and the theme park, it is difficult to prove the actual role of the latter as a source of inspiration for the artists. Allan Kaprow, the pioneer of installation art in the form of 'Environments' (from 1958), in his early three-dimensional assemblages was interested primarily in the transformation of the typical 'art look' of art objects and arrangements – this was the intention behind the use of 'materials and images that referred to commonplace forms of entertainment and advertising, such as carnivals, shooting galleries, and sandwich boards'.[73] However, most of his inspiration came from the art world and included Jackson Pollock's action painting (as an activity incorporating space); Kurt Schwitters' *Merzbau*; Japanese *Gutai* group events (from 1954); John Cage's process- rather than product-oriented experimental approach; and first of all, the book *Art as Experience* (1934) by John Dewey, an American philosopher, psychologist and educator.

According to Dewey, the work of art cannot be reduced to the aesthetic object, but it rather must be traced in what this object 'does with and in experience'.[74] To achieve this effect art should become interwoven with the processes of everyday life and not 'remitted to a separate realm, where it is cut off from the association with the materials and aims of every other form of human effort, undertaking and achievement'.[75] However, Dewey, being a philosopher, rather than artist, does not propose specific artistic means. He leaves the possibilities open, simply pointing out the promises of art as 'experience':

Experience is the result, the sign, and the reward of that interaction of organism and environment which, when it is carried to the full, is a transformation of interaction into participation and communication.[76]

Interaction with the environment occurs through the senses and it consists of the processes of 'doing and undergoing'.[77] In the situation of art, the viewer must then be seen as the receiver as well as the producer of experience and meaning. By the 'experience', in the context of art, Dewey means a sort of revelation, a moment in the stream of events interpreted as unique. As he writes, it is 'defined by those situations and episodes that we spontaneously refer to as being "real experiences"; those things of which we say in recalling them, 'that was an experience'.[78] From the perspective of my book, 'having an experience' as opposed to simply experiencing things exposes the operation of play-*parergon* and the frames of representation. The usual 'meaningless' matter of life becomes meaningful, becomes double, symbolic, different from its ordinary self.

Kaprow's Environments were to a large degree the artistic interpretation of Dewey's theory. He intended to create an art form that would be 'as open and fluid as the shapes of our everyday experience', but not simply imitating it.[79] Like other artists from the New York circle at that time, he was interested in the use of junk, raw materials of industrial and everyday objects and spaces, as opposed to the 'white cube' of the gallery and museum which he saw as responsible for isolating art from life. Kaprow defined Environments as 'intensified interiors or exteriors' that gave the viewer the opportunity to 'GO IN instead of LOOK AT'.[80]

The first two Environments (*Beauty Parlour*) were created by Kaprow in Hansa Gallery, New York, in 1958. These were interiors arranged with 'layers of cloth and plastic sheets, loosely painted in heraldic bands', 'swarms of tiny blinking Christmas lights', broken mirrors, and spotlights aimed at the spectator, among other objects: 'An oscillating electric fan circulated chemical odours, and electric sounds were broadcast from loudspeakers.'[81] These Environments fulfilled the artist's intention of surrounding the viewer with various stimuli which were not 'represented' but 'present' to cause the direct sensation.

PLAY IS A MOVEMENT IN BETWEEN THE OPPOSITES

Works like these initiated a chain of changes in the approach to the viewer's interaction with the artwork and the space, which continues in recent art as well. It can even be said that the model of Disneyland (as an alternative reality) becomes much more relevant these days, due to the ongoing technological revolution and the domination of digital multimedia. According to US artist and writer Robert Smithson, 'museums and galleries could become venues for new forms of entertainment like discotheques'.[82] Due to the light and sound effects, and the monumentality of many projects (i.e. Diller and Scofidio's 2002 *Blur Building* or Olafur Eliasson's 2003 *The Weather Project*), the audience can indeed feel enchanted, immersed or even lost in the 'reality' designed by the artists. Viewers, in the artistic playground, can become children, scared or entertained, sitting around the magician who shows his tricks; but also consumers on a Saturday night in the techno club, 'guinea pigs' in the futuristic laboratory, tourists in non-existent states, and so on. Installation works introduced the approach to the gallery space (and the space of art in general) as an ambient 'micro-world', which has been developed further in recent participatory process-oriented projects.

Kaprow's Environments were only the transitional stage in his pursuit of lifelike or non-art art. In Happenings (from 1959) he enabled the viewer not only 'to be inside' the work of art, but to 'be an active participant'. Some Happenings combined new interactive elements with specifically designed spaces, like the former Environments; some were based mainly on interaction among the participants. The idea of Happenings was partially a further development of Kaprow's interpretation of Dewey, his readings of Huizinga's *Homo Ludens* and Erving Goffman's *The Presentation of Self in Everyday Life*, but it also came from observing his own children in their play. Kaprow's Happenings were among the first process-oriented works in which play-like activity was not just an artistic means to produce an artwork but a 'final product' itself.

Children's Play

'In the end, works of art are the only media of complete and unhindered communication between man and man that can occur in a world full of gulfs and walls that limit the community of experience.'[83]

According to Dewey, art 'as experience' should first of all become a *collective* experience, which occurs through communication as 'the process of creating participation, of making common what had been isolated and singular'.[84] Participation, as suggested by Dewey, was for Kaprow the possible solution to the problem of blurring the boundary between artist and viewers, between the commonplace and the 'artistic' – a strategy to achieve his non-art ideal of art. Children's play became the direct inspiration for the development of the new, wholly participatory form of art – Happening.

> Around this time [1960-61], Kaprow began noticing how his three small children played together in an unscripted yet wholly participatory way. Theirs was a self-generated kind of play in which a proposal – 'let's play house' – would either be accepted or an alternative – 'no let's make a fort' advanced. Roles would be negotiated, after which the playing would commence without an audience.... Kaprow wasn't interested in mimicking children's play in his art, nor was he inspired by sentiments about childhood. Rather, he began seeing 'childsplay' [*sic*] as an attitude towards playing that he could imagine in its adult forms.[85]

The most important aspect for Kaprow was the lack of audience, the anti-theatrical character of children's play. Instead of treating viewers as an element of the Environment – partially the active participants, partially the passive onlookers – he started to see them as playmates. They could become co-creators of the events inspired by everyday tasks and routines, games and exchanges. The artist's role was to prepare a general plan, which would be open to improvisation, chance and the participants' own choices and inputs.

> A plan is not the same as its enactment, however; one is an invitation to play, and the other is actually playing. While the invitation is meaningful as metaphor, the enactment of the invitation generates meaning as experience. The spectator 'embodies' the metaphor by enacting the plan, and it is the embodiment that constitutes our participation in the work.[86]

The artist remains an initiator; he proposes a metaphor to be worked/played with, but the whole process occurs on the edges of subjective control and improvisation, representation and experience, the individual and the collective and so on.

One of the first works that included the Environment-like space arrangement and the open-ended plan for the audience's participation was *The Apple Shrine* (1960). The gallery was transformed into a labyrinth or a modern jungle constructed with Kaprow's usual materials − cardboard, rags, straw, crumpled newspapers and chicken wire. The central place was occupied by a table with real and plastic apples on it. The viewer could either eat the real apple or take the fake one home. In his later works Kaprow has gradually extended the participants' options and, in most cases, he also replaced the gallery with the open-air environment of the backyard, farm, beach, woods, city dump, parking lot and many others.

The 1964 Happening *Household* took place at the Ithaca City Dump in New York. The general plan focused around the domestic conflicts between man and women and 'was played out using sexual stereotypes in a kind of children's war game'.[87] Some photographs of this Happening show groups of people − students and young families − immersed in a vital, joyous play of chasing, hitting and wrestling on the ground. The success of this Happening, as well as many other of Kaprow's works, lay in the fact that the metaphor the participants were enacting was meaningful to them; they could spontaneously contribute to its embodiment and feel part of the event. To some extent, they could act out their own fantasies and fears, just like children do in their play. The participants always knew the artist's intention behind the Happening and felt invited and treated as partners in the creative process.

In his essays Kaprow elaborates on the potential of non-art as play and the role of play in social life in general. According to him the traditional activity of 'art' (production of aesthetic objects) should be abandoned. The artist in a new role as 'un-artist' would act as a social educator in play. In the essay *Education of the Un-Artist, Part II*, Kaprow writes:

> Utopian visions of society aided or run by artists have failed because art has failed as a social instrument. . . .

Only when active artists willingly cease to be artists can they convert their abilities, like dollars into yen, into something the world can spend: play. Play as currency. We can best learn to play by example, and un-artists can provide it.[88]

The role of the 'un-artist' is to play and to lead others in the social exchange based on play. One strategy would be to give up art as a profession; instead, the un-artists could slip between professional categories and 'become, for instance, account executives, an ecologist, a stunt rider, a politician, a beach bum':[89] 'Replacing artist with player, as if adopting an alias, is a way of altering a fixed identity. And a changed identity is a principle of mobility, of going from one place to another.'[90] Kaprow's position fits, to some extent, within the 'play as *parergon*' model presented earlier in this chapter then and the role he designed for artists echoes Derridean metaphors describing the god Thoth. Kaprow approached play as *parergon*, the condition of movement, change and alteration. He also saw it as marginal to the traditional status quo, and called for the overthrowing of the 'fixed identity', the *ergon* (traditionally proper function) of the artist.

His version of play was a kind of modern secular ritual, a 'stratagem for the survival of society',[91] offering the experience of community and transcendence. It was important for Kaprow that play, unlike games with winners and losers, could be used as an occasion to act together and not against each other. He saw play as an activity providing its participants with fun, pleasure, satisfaction and relaxation from the pressures of the goal-oriented game model of life. Even if his Happenings, like *Household*, were sometimes plotted around a theme of conflict, their role was to overcome the conflict in a playful manner and to focus on the collective action.

I consider Kaprow's Environments and Happenings to be one of the most elaborate and theoretically articulated contributions to the development of the strategy of play in twentieth-century art. However, to a large degree he followed the Primitivist myth of 'pre-rational' play with its promises of direct experience instead of representation and a new form of collective ritual instead of isolation and detachment. What is more, Kaprow, who wanted his art to become lifelike, paradoxically based it on an idealistic model of play derived from antagonism and competition, 'play inherently

worthwhile, play stripped of game theory'[92] (educational, social, collective, fostering positive human relations, etc.). While Kaprow's formula for art becoming un-art play may seem overly optimistic or even naive, it is my opinion that the trends and shifts of art-making and consumption in the late twentieth and early twenty-first centuries have actually followed this path. However (as always in the case of play-*pharmakon*), the effects are much more complex than the planned social renewal. I will return to this issue in the following chapters in the context of recent participatory projects.

'Dark Play'

On the opposite (and complementary) pole to Kaprow's 'children's play' model, I identify the form of artistic play that, using Richard Schechner's phrase, can be described as 'dark play'. He defines this as an activity which might be physically risky and allows the playing of alternative selves. However, 'the play frames might be so disturbed or disrupted that the players themselves are not sure if they are playing or not'.[93] It is usually as a result of the element of danger that the border between play and reality seems to disappear. A clear example of dark play would be 'Russian roulette', a potentially lethal game of chance involving a gun loaded with one bullet, the cylinder spun, the muzzle pressed against the player's head and the trigger pulled. The tradition of dark play in modern art developed as a shadow version of overly idealistic Primitivism. Instead of innocence, creativity and sociability, the notions explored included danger, violence, sacrifice, destructiveness and confrontation. A hint of dark play was present in the provocative experiments of Dada and Surrealism; however, their actions were essentially safe and harmless.

George Bataille, a French writer connected with the Surrealist group, can be mentioned as a modern theorist of the 'dark' side of artistic creation, which according to him – like a ritual sacrifice – can lead to transcendence. He considered the joy of destruction as a primary impulse to draw in children and the 'primitive'. To describe this destructiveness or sadism he used the term 'alteration', indicating the state of change, both positive and negative. 'Alteration' refers to the 'partial decomposition, analogous with that of corpses and at the same time the transition (*passage*) to a perfectly heterogeneous

state corresponding to ... the sacred'.[94] 'Alteration' is caused by two seemingly opposite forces, destruction and creation: their synergy leads to a higher state of creative transcendence, reaching beyond the usual artistic effects, coming closer to the region where play and art are no longer mundane but become a Nietzschean game of gods.

Bataille was one of the first theorists to transgress the one-sided view on 'primitive' art and human creative acts in general. He considered high and low, sacred and profane, life and death as inseparable in an artistic impulse of any kind.[95] The moral innocence of children's activities in the tradition of Rousseau becomes juxtaposed with the innocence 'beyond good and evil', both creative and destructive, in the tradition of Nietzsche.[96] Bataille's position also exemplifies the approach to the creative act as permeated by the operation of play-*parergon*, which transgresses the 'proper' and the 'accepted' and enters the spheres of doubt, anxiety and ambiguity. 'Play of art' must be seen as a constructive as well as a deconstructive force. It is involved in the movement of structure and its boundaries. It enlarges some facts, manipulates them, shows hidden relations and exposes weak points or desires. It can apply a structure or deform and reshape it. The artistic strategy of play must be therefore seen as *pharmakon* (cure and poison); its effects cannot be predicted or defined in advance. Artistic creation becomes an activity that is more communion than communication; that has a power to transform its participants in ways that cannot be wholly grasped.

> If a poem genuinely affects, then it transforms being, doing so in a way that is beyond words; This sense of shock − of recognition and intimacy − is the essence of poetry, and is what connects it with sacrifice, which similarly effects a common consecration beyond expression.[97]

This process can be compared to the experience of the sublime − as overwhelming and testing one's reaction to the situation of 'shock'. The artistic act provides a chance to experience something 'unpresentable' or something beyond 'an absolute limit of human experience'[98] (e.g. death), or at least come very close to this experience: 'The most one can experience is the vertigo of the edge of the chasm.'[99] This is precisely the role of the 'dark play' of art.

One author who inspired Bataille's work, apart from Friedrich Nietzsche, was the Marquis de Sade – the influential proponent of personal and sexual freedom and the pursuit of pleasure regardless of social and moral norms. Sexual liberation in de Sade could be seen as a form of 'dark play' – the perverse device to test boundaries and limits, and gradually break all rules and to violate moral values. The passage between play, game and pleasure and abuse, violence and pain, and even that between life and death becomes blurred and relative.

The elements of Primitivist 'dark play' to a significant degree permeate the artistic work of Viennese Actionists (from 1965), and Hermann Nitsch in particular. Independently from the American art scene, the group developed an art form akin to Happenings, but mainly inspired by sacrifice rituals. The artists used animal and human blood, viscera and flesh of the slaughtered lambs in projects ranging from action painting to performative dramas based on the ancient Greek Dionysia and the Christian motifs of the Last Supper and Crucifixion. The main intention was to provide the viewers/participants with the experience of catharsis, the release of aggression and libidinal forces. Nitsch referred to these Actions as *Abreaktionsspiel* (abreaction play).[100] In *On the Essence of Tragedy* (1965), he points out the role of art

as a means to rebel against the censorship of our Super Ego. The intellectual and conscious control of our lower life energies is pushed aside in order to attain an insight into our subconscious, unbridled, chaotic libido. A short contact with these vital forces leads to their liberation. They are pushed to extreme satisfaction, ecstasy, joyful cruelty, sadomasochistic reactions, excess.[101]

Nitsch's art as ritual, in which the action lasted as long as a few days, involving the slaughter of animals and performers eating raw flesh takes the metaphorical 'something as something else' element of *parergon* to the extreme. This intended symbolic purification and liberation from feelings of guilt is achieved through the infliction of pain on animals and performers. This is the moment where the world of representation violates the 'reality'. Art does not become life, rather it threatens it.

Performance and body art in the 1970s were probably the two art forms that have reached most often for the repertoire of 'dark

play'. The direct contact between performers and their audience, the relations of passivity and activity, power and subordination have inspired experiments with the psychological reactions of the crowd, group responsibility, the tension between reality and fiction and so on. In the most radical cases, the viewers' misjudgement of the situation – whether it still belonged to the 'play' frame or had just crossed the line – could have had serious or even fatal consequences. In one of her most famous performances, *Rhythm 0* (1974), Marina Abramović placed on the table 72 different objects that could give pleasure or pain.[102] They included knives, razor blades, a gun and a single bullet. The participants were informed that they could use the objects on the artist's body in any way they wished. Their initial reservation developed into aggression in some of the participants, provoked by the artist's passivity. They stripped her naked, cut her body with razor blades; someone even put a gun against her head. The line between play and abuse turned out to be thin. If some of the participants, playing their 'alternative selves', had looked in a mirror they would have seen Mr Hyde looking back. Dark play is always one step away, one deferred gesture from falling into the 'chasm'. One step further and it is play no more, nor is it representation.

Evolution of Play

Theoretical tools such as ideas of 'rational' and 'pre-rational' play, notions of *ergon*, *parergon* and *pharmakon*, help us to understand and review the evolution of the concept and the artistic strategy of play in twentieth-century art. The models of play presented in this and the previous chapter served as a repertoire of strategies to modernize art and make it more lifelike, immersive, participatory and demo-cratic. Modern artists explored the potential of play as a source of vital, untamed creativity and unexpected solutions, and they praised games as activities transgressing the traditional dichotomies of work and leisure, serious and non-serious, useful and useless, central and marginal. However, in their artistic practices they tended to overturn rather than counterbalance the dominant hierarchy and hence to marginalize the traditional *ergon* of art. Their rhetoric, especially in the case of the first avant-garde, was one of revolution and negation of old values.

It seems that, especially in terms of Dadaists and Surrealists, the cliché of the 'artist as a playing child' is apt to some extent. Their playful strategy was aimed against the bourgeoisie – the social group composed of the traditional consumers of art, and also the one dictating the codes of proper behaviour and appointing rules, including the aesthetic ones. The artists were like adolescent children teasing the 'adults' and testing the limits of freedom – each time trying to push the boundary a little further. They were continuing the nineteenth-century bohemian 'game' of '*Épater la Bourgeoisie*' – shock the middle class. In the first avant-garde, games and play served as provocative and utopian models, carnivalesque devices, temporarily overturning the everyday status quo; and as an occasion to take revenge on 'reality' with its rigid social and political structure, and to come closer to more 'natural' modes of creation.

Marcel Duchamp's conceptual art as play with his masquerades and puns opened up a whole new perspective upon artistic production and relations within the art world. He pushed twentieth-century art to the fluid grounds of *parergon*, relative values and viewpoints, ultimately undermining the *ergon* side of artistic creation as making aesthetic objects. He also contributed to the re-evaluation of play as a strategy that transgressed Primitivist connotations. In Duchamp, play is intellectual and rational, able to transgress rationality and bring new, unexpected insights into the work of art. It is also the joint intellectual activity of the artist and the viewers.

Postwar, the experimental play of American artists such as Cage and Kaprow was a weapon no longer; it was much more open for viewers as potential contributors, co-artists, players and partners in activities that tended to blur the boundaries and borders between people and between the art world and 'real' life. I would even say that in the postwar era there occurred a gradual role-reversal; artists started acting more like adults who needed to take care of their viewers and provide them with an aesthetic/emotional/sensual experience in the most effective way possible. The development of installation art, which I compared to the model of the theme park, was another step in the artists' quest for 'heightened' experience instead of traditional representation, and collective sociability in the situation of art. Kaprow's invitation to the viewers to join the artists in their activities and play together was intended to create new spaces of

communication, instead of conflict or isolation as dominant modes of contact in the urban society. The contemporary manifestation of this approach is what Nicolas Bourriaud termed 'relational aesthetics', which I will discuss in the following chapters.

However, parallel to the 'positive' model of play (such as Kaprow's 'children's play'), there also developed an alternative approach; play as sacrifice, confrontation, the relation between slave and master and so on, which I labelled, after Schechner, 'dark play'. Both models continue to inspire artists and to produce contradictory interpretations of play – as didactic or subversive (or even dangerous) in social life and art.

I analysed play as a concept that emerged in tandem with that of the 'primitive': marginal to the traditional theory and practice of art, but which gradually attracted the attention of modern artists and contributed to the transformation of modes of practice and spectatorship, as well as challenging the notion of 'marginality' itself. I analysed the 'strategy of play' through the frame of Primitivism given the shared agenda of the deprofessionalization of art and the search for direct experience or sensation instead of its conventional representation. Artists used play-like techniques under the pre-rational 'umbrella' of Primitivism to experiment with chance, unconsciousness, automatism, verbal puns and 'letting go'; to overcome the controlling power of reason, skill, tradition and convention; and to celebrate the creative process as a disinterested immersion.

The aesthetic product, although still belonging to the artistic *ergon* in modern art, was often supplemented and even substituted (in the postwar avant-gardes) by traditionally marginal elements of supporting texts (manifestos, journals, scores), events (theatrical performances, excursions, trips, meetings) and activities (playing games, provoking the public, organizing collaborations, conducting research, experimenting). Many of these 'marginal' elements came from the 'playgrounds' of human life, spheres of leisure, entertainment or activities directly opposed to goal-oriented 'rational' and productive work. I discussed some of the models of play that were tested by the artists as tools of new art (or non-art): cabaret, festival, wordplay, parlour game, game of chance, playful 'scientific' experiment, child's play and 'dark play'. In most cases the notion of play was attuned to the Primitivist outlook, as instinctive, anti-rational, creative, collective and joyful. However,

some artists also utilized different aspects of play as an intellectual exercise and means to achieve a paradigm shift (Duchamp, Fluxus), a tool to overcome metaphysical dichotomies (Surrealists, Cage) and a means of confrontation and catharsis (Vienna Actionists, Abramović). All of these modern experiments with play can be interpreted as explorations of the *parergon* of traditional art in order to question, challenge and eventually transform art's 'proper function'.

Participatory or process–oriented forms of art have been gaining popularity in recent art, and it seems that the model of play or game has become a widely used one. However, the post-modern application of play generates a whole new range of questions, and they refer to the aspects of power distribution, political agendas, art as entertainment and a promise of non-representation − an immediate experience − instead of the artistic mediation. These issues will be discussed in the next chapters, together with the general sociocultural background of the 'turn to play' in postmodern art and culture. I will look closer at the 'evolution of play' that gradually transformed the artist from *homo faber* to *homo ludens*.

3

Play: From Modern Strategy to Post-modern Tactic

Twentieth-century artists tested new ideas and modes of creation, inspired by the sphere of play and games, to enhance creativity and broaden the range of artistic tools and to establish new forms of interaction with the public. Drawing on popular forms of play or entertainment was a strategy adopted by artists in order to avoid the traditional bourgeois conventions of 'consuming' the work of art, and, in general, was used as a way to stimulate the audience out of its usual passive role, either by provocation, shock and surprise or an invitation to become an active participant in the creative act. The inspiration of play as an interactive social activity influenced experiments with art forms that would come closer to 'authentic' experience than traditional modes of making and displaying art. The use of play was also an anti-commercial statement, in opposition to the work of art as a commodity, artefact and outcome of production among other modern gadgets and goods.

In this chapter I will analyse post-modern artistic practices that potentially assimilated modern provocative 'play strategies' so that they became frequently used tools of the 'professional artist'. I will discuss the difference between the 'strategy' and 'tactic' of play to show the transition between modern and post-modern applications of play in artistic projects. Although I will refer to particular trends in recent art – namely participatory projects – today's artists, unlike their modern predecessors, do not form movements under unifying slogans. This role is usually left to art critics and curators, who invent different

terms in order to categorize, describe, promote or even create certain artistic phenomena. A clear example is that of French curator Nicolas Bourriaud, who coined the term 'relational aesthetics' to describe projects by Rirkrit Tiravanija, Pierre Huyghe, Felix Gonzalez-Torres, Vanessa Beecroft and Surasi Kusolwong, among others. His definition of relational art as 'taking as its theoretical horizon the realm of human interactions and its social context, rather than the assertion of an independent and private symbolic space'² can be treated as a general description of the practices referred to in this chapter. These practices are participatory, interactive, public, dialogical and relational, and their common agenda is the use of performative means and the central role taken by the viewer or participant's interaction with the artwork or with each other in the artistic process.

Much like modern *avant-gardes*, contemporary art attempts to marginalize or hide its own professionalism, along with the accompanying conditions imposed upon it by the capitalist and consumerist roles it operates within. Art as a commodity is not trustworthy as a medium for anti-commercial, socially or politically engaged messages. It is not isolated from the commercial pressure of sponsors, collectors, art galleries and museums, all of which are entangled in the conflicting chains of financial and political dependence. Obviously, art as an aspect of social life cannot exist outside its rules. However, somehow, it has to pretend that it does, that it possesses the necessary distance to be able to comment on these rules. In effect, contemporary artists, like their modern predecessors, try 'to do away with art' as 'work' (specialization, production) and as 'representation' (mediation, artifice). In my view, play remains an important element in this process. However, it is no longer as revolutionary and strategic as it was in earlier projects.

The longing for the authenticity of experience not represented by someone else, and most often of the experience that is different from one's own everyday activities and identifications, contributed to the development of the contemporary 'role-playing' form of participation, employed in education, entertainment and art. The purpose of this chapter is to analyse uses and interpretations of play, offshoots of modern ones, in selected works of art from the 1990s to date that employ the tactic of role-playing. I will examine whether it is possible to apply the metaphor of the role-playing game (RPG) to critically

discuss elements of participatory projects such as the roles of, and relationship between, the artist and the viewers, and the characteristics of their encounter/artwork, as well as to redefine the contemporary notion of artistic representation.

'Strategy' versus 'Tactic'

Before I introduce the model of the role-playing game, I need to clarify the use of terms. In the first chapter I referred to the application of play in modern avant-gardes as 'strategic' (following de Certeau's notion of 'strategy'). However, in the course of time, there has occurred the gradual assimilation of play as an artistic tool. It is impossible to determine when the notion of play became an accepted component of the artistic vocabulary. Nonetheless, we need to differentiate between the use of play in modern and post-modern art (even though all classifications and distinctions of this kind are inevitably schematic). In contrast to the modern 'strategy' of play – organized around certain central values and as a revolutionary tool loaded with the notion of power – I propose to refer to the post-modern or contemporary use of play as a 'tactic' of play. 'Tactic' is also de Certeau's term, and he describes it as a 'calculated action determined by the absence of the proper locus'.[2] According to de Certeau, tactical actions fit into the official structure in order to modify it locally and gradually by interventions on the micro level. They use 'opportunities afforded by the particular occasion'[3] and lack a view of the whole (because, perhaps, the concept of a 'view of the whole' is a utopian one held by proponents of the strategic approach). The artistic tactic of play, due to the lack of universal *ergon* in social life and art, supports activities focused on specific problems 'here and now', instead of a general agenda of artistic or social revolution. The tactic is much more open-ended and dialogical than the strategy and it coexists with the rules of the given reality. Furthermore, as de Certeau puts it, 'The space of the tactic is the space of the other. Thus it must play on and with a terrain imposed on it and organized by the law of foreign power.'[4] It seems that the discourse of the modern Other as an external model – followed by the discovery of Other as self – has entered the cultural and artistic realm in later Modernism and post-modernism as its essential ingredient. As I will demonstrate in this

chapter, contemporary artists with their use of the 'tactic of play' have been actively exploring spaces and roles bearing a stamp of otherness, in order to disseminate 'marginal' viewpoints and values within the official domain.

As in the case of modern strategies of play, recent tactics must be seen as frames applied in order to structure a broad range of themes, interests, intentions and ideological concepts. I do not intend to analyse these concepts. I am only interested in the operation of the play-frame and its consequences for the artist and for the participants.

The difference in the functioning of the play-frame, as either strategic or tactical, can be discerned when we compare the provocative use of play in events organized by Dadaists and Surrealists with recent tactical 'urban games' such as the project *The Politics of Play* by Amy Franceschini and Myriel Milicevic. In Dada and Surrealism the idea to meet the public on a non-art ground was driven by the intention to do away with art as work/production. Theirs was the revolutionary intention to use art as a tool of social change – a radical tool imposing new ideas and rules against the dominant system of values in art and society. Play was used as a strategy to oppose work (art-work) in search of a new and better 'proper function' of art in a new and better world. This strategy was inevitably articulated from a position of power and will – 'we destroyed, we insulted, we despised – and we laughed'.[5] The Dadaists and Surrealists consciously and openly provoked and teased the public; their play was based on confrontation.

> The Berlin Dadaists reiterated the art of activism as one of the fine arts. By increasing the play-element of their production, which Ford had excluded from factory work, they conducted an avant-garde experiment with, and re-imagination of, the art forms of social movements.
>
> As a group, the Dadaists paraded the streets, giving speeches, inventing new slogans and putting up stickers.[6]

Dadaists and Surrealists often employed forms of public events such as street parades, meetings, excursions and readings, all in an atmosphere of grotesque, absurd humour and general turmoil supported with revolutionary slogans. In 1920 Parisian Dadaists organized the Dada Festival:

Breton appeared with a revolver tied to each temple, Eluard in [a] ballerina's tutu, Fraenkel in an apron, and all the Dadaists wore funnel-shaped 'hats' on their heads. Despite these preparations, the performances themselves were unrehearsed, so that many of the events were delayed and broken up by shouts from the audience as performers attempted to straighten out their ideas.[7]

The artists were performing in ridiculous costumes – in most cases unprepared – using chance, improvisation and the flow of events as their artistic tools. Such an attitude was typically evoking collective 'madness', 'throwing eggs, veal cutlets and tomatoes'[8] at the performers – the reaction anticipated by the artists, who wanted to push the viewers out of the contemplative detachment of the usual art-going public.[9]

In contrast to the earlier modern applications of play in process-based art, recent 'post-modern' projects are much more open in terms of the audience participation; more democratic and 'tactical'. They do not intend to change the status quo in art and society but to act locally with small groups and communities and implement little interventions in a playful, attractive manner. Artists avoid roles of authoritarian leaders (or their parody) but rather gently propose certain activities and coordinate them as 'leaders in play' or animators. A good example is the workshops organized in Paris by Amy Franceschini and Myriel Milicevic in 2006. Entitled *The Politics of Play*, they were intended to enable 'collaborative networks in the city through the medium of play'.[10] Activities consisted of brainstorming on the subject of the politics within play and the play within politics; research and observation of the given local area and community life; inventing games addressing certain issues arising from these observations and interacting with the space and its residents and, finally, the groups playing games. This project was designed to activate discussion about local problems such as a lack of 'green' space (plants, vegetation, grass) in the area or the perception of graffiti as a criminal issue or blight on the surroundings. The way the play was used was tactical. The group of players – artists, sociologists, designers, game designers, urban planners – proposed fresh ways of dealing with some issues, and they made it possible for local community members to join and contribute to the discussion. The seed was sown, and this is how tactical play works – it causes gradual evolution and not revolutionary changes.

However, such play does not necessarily have to be a didactic and politically correct group activity. It can be subversive, designed and played solitarily by the artist. A good example is the practice of UK artist Heath Bunting, whose guerrilla art in the public space (both virtual and real) refers to the conflict between the institution and the individual. His projects express and implement resistance to the commodification of the contemporary 'civilized' world and the omnipresent supervision and control imposed by authorities and institutions. They often take the form of tactical games played against official rules and regulations at the intersection of the legal and the illegal. One of these projects was *Anonymous Letter Box* (2005), accompanied with the 'how to' instruction published at the website:

1.4 Constructing an anonymous letter box.

Experience suggests that stealth is the key for installation of this type of letter box.

1. Find a street facing [*sic*] doorway, fence or wall that is currently unused by people or post and is accessible from the rear.
2. Create an address for your letter box and associated postcode.
3. Write by hand a building number and wait one month or longer.
4. Add a metallic building number and wait one month or longer.
5. Draw a letter box facia and wait one month or longer.
6. Add a metallic letter box facia and wait one month or longer.
7. Cut a letter box opening and wait one month or longer.
8. Add a secure box on rear of doorway, fence or wall.

1.5 Using an anonymous letter box.

1. Train the post person with unimportant but official looking deliveries.
2. Visit irregularly to collect mail.
3. Keep all surfaces wiped clean of dna material.[11]

As the artist suggests, an anonymous letter box is useful in creating alternative identities, which can be verified by having an address and

receiving mail. This kind of action is not innocent but it is also not used for any criminal purpose. It is simply a pursuit of interstices in the system; creating moments of freedom from 'Big Brother's eye'. The artist is fully aware that this game cannot be won and this is why it is worth playing – this is why it is important for artists to engage in such activities and to lead others in the exercises of free thinking.

It is crucial to stress here that adopting play models, in either twentieth or twenty-first-century art, should not be confused with playing. Play as such can occur during the process, but the 'strategy' and also the 'tactic' of play belong to the notion of work as a goal-oriented activity. I would even say that the tactic of play can be seen, paradoxically, as a 'marketing' tool today; it makes the art process/product more 'user-friendly', more accessible, more ideologically transparent, popular, fun and so on. What I find interesting is that the play models – the play-like remedies or 'supplements', strategic or tactical – tend to transform the characteristics of what we name as 'work' and also the traditional *ergon*, or 'proper function' of art.

The Role-Playing Game

I propose to test the notion of the role-playing game as a source of metaphors in the discussion of the mechanisms and dynamics of contemporary participatory projects, and of the issues of relations and interactions among participants, rules and structure of events; the new roles of artists, viewers and institutions in process-oriented art; as well as the redefined concept of artistic representation.

Role-playing – which I see as the common model for participatory practices, and the frequent source of recent 'tactics of play' – can be attributed primarily to children's play (gangsters and cops, playing house), as utilized by Kaprow. However, the contemporary version of this kind of play is also often performed by teenagers and adults in role-playing games (RPGs).

A 'role-playing game' has been defined as 'any game which allows a number of players to assume the roles of imaginary characters and operate with some degree of freedom in an imaginary environment'.[12]

As I explained in the introduction, in my discussion I refer to the the traditional RPGs such as Dungeons & Dragons and not computer or video games such as *Tomb Raider* or *Diablo*. This type of RPG is based on direct verbal interaction among players, and allows for the player's own initiative, use of imagination and a more flexible approach to rules than is possible in the digital environment. The small group of players is led by the game master (referee), who is responsible for creating/adjusting the game world and the main plot of action. The players 'perform' mainly through verbal communication: they describe their activities, negotiate moves and immerse themselves in the imaginary world as a team of fictional male and female heroes. Some RPGs are played with the use of costumes, often outdoors, and remind one of improvisational theatre (with no audience). The game 'allows people to become simultaneously both the artists who create a story and the audience who watches the story unfold'.[13]

In general, RPGs can be described as collaborative and interactive storytelling. As Gary Fine points out, due to the significant amount of freedom left for the players, 'fantasy games are in some ways more like "life" than like "games"':

> Despite the fact that the worlds in which characters interact have no physical 'reality', the social processes which operate are as 'real' and as significant as any which operate when people are working together or are playing together in other circumstances.[14]

It is also worth stressing that these processes (social, interpersonal, power relations and so on) belong simultaneously to reality and fiction; 'role-playing is never a state of pure imagining, because the player is always connected simultaneously to both the diegesis and the real world'.[15]

In my view, contemporary participatory practices share many elements with RPGs. Artists and viewers/participants often enact symbolic or real-life roles during the process which involves typical children's make-believe play or theatrical techniques. The artist – as organizer, manager, animator, director of the set – can be compared to the 'game master'. He or she chooses a certain reality, often quite distant from his or her own everyday experience and skill, which becomes the arena of the 'game world'. The creative process, in most

cases, takes the form of a social gathering – a 'game session', based on communication and collaboration among participants.

This last aspect of RPGs – with its emphasis on participatory, collective actions – was explored extensively in modern art strategies of play, and remains crucial in recent art. Following Kaprow's ideas of eliminating the public, modern and post-modern artists have developed diverse methods for transforming the viewers into active participants – the artist's 'playmates'. The RPG, as a metaphor for participatory artistic projects, suggests attempts to experience possibilities, relationships and contexts outside one's usual spheres of activity, or to experience one's own 'reality' from the outside and to offer the same opportunity to the viewers. As Tuomas Harviainen writes, 'through their experientiality and autotelicity role-playing games convey new information and create new correspondences between existing social and mental connections'.[16] The contemporary participatory practices I refer to in this chapter, like RPGs, aim at 'creating experiences'[17] or, more precisely, 'low-intensity liminal experiences'.[18] It can be said that the services offered by contemporary art to its consumers/participants, with the help of the 'tactic of play', are 'guided trips' to 'real' life.

Among examples demonstrating various applications of this tactic, I will quote the collaborative site-specific projects *A Trip to Asia: An Acoustic Walk Around the Vietnamese Sector of the 10th-Anniversary Stadium* (2006) and *The Finissage of Stadium X* (2007-8), curated by Joanna Warsza. The actions took place in the abandoned, post-communist stadium in Warsaw, built in 1955 with the postwar rubble; a gigantic sports venue able to accommodate 100,000 spectators. In the early 1990s this (no longer functional) relic of the past had been transformed into the early-capitalist market called 'Jarmark Europa' ('Europe Fair') run by Vietnamese, Russian and Polish traders. In 2008 the 10th anniversary stadium was demolished and in 2011 a new national stadium took its place for the Euro 2012 football championships.

The projects, including 'a walk, a football match, a Sunday radio station, a spectacle on a building site, an exhibition featuring real people',[19] were followed by the publication of *Stadium X: A Place that Never Was*, a collection of essays by philosophers, sociologists, botanists, artists and cultural critics. The multi-layered identity of the stadium and its planned future demolition served as context for the public discussion on the invisibility of the Vietnamese minority in

the life of the Polish capital city and Poland's postwar architectural legacy, among other issues the project intended to tackle.[20] The use of performative, play-like means in all of the project's episodes referred to the utilization of the stadium by different groups in different contexts, and served to establish a platform for communication (or confrontation), and a crossroad of different realities (and fictions).

Using the examples of *Stadium X* actions, among other contemporary projects, I will analyse four elements of the RPG model which I consider as suitable metaphors to describe today's participatory art. These four elements are: 'game characters' or 'game roles'; 'game world'; 'game master'; and 'game session'.

Participants as 'Characters in Play'

Alone, Swiss performance artist Massimo Furlan re-enacted one of the most spectacular games in the history of the Polish national football team – their 3-0 defeat of Belgium at the 1982 World Cup in Spain, reproducing the movements of the match's hero, Zbigniew Boniek, who scored all three goals. The 'match' was reported live by Poland's leading sports commentator, Tomasz Zimoch, and broadcast by Radio Kampus (97.1 FM).

> On 14 October, 2007 in Warsaw, at the 10th-Anniversary Stadium, Massimo Furlan was Zbigniew Boniek, Tomasz Zimoch provided a commentary for a game in Barcelona on a June day 25 years earlier, and spectators became football fans, waving Solidarity flags in Spanish stands.[21]

The performance by Massimo Furlan, apart from creating an imaginary frame of an iconic football match – an occasion for the collective experience of the past/present event – was, first of all, a chance for the artist to make his childhood dreams come true, to 'become' a famous football player. The same incentive led to his performances in 2002 in Lausanne, when he recreated the 1982 Italy–West Germany World Cup final as a fictional player wearing number 23, and in 2006 in Paris when he played Michel Platini in the France–Germany semi-final.

The opportunity to comment on the famous match within the frames of an art event attracted Tomasz Zimoch for similar reasons –

Figure 3. *Boniek!* A one-man re-enactment of the 1982 Poland–Belgium football match by Massimo Furlan, with commentary by Tomasz Zimoch; produced by the Bęc Zmiana Foundation and the Laura Palmer Foundation, curated by Joanna Warsza/part of *The Finissage of Stadium X*, 10th-Anniversary Stadium, Warsaw, October 2007; photo courtesy of Joanna Warsza

the opportunity to temporarily play the role of somebody else, in his case a performance artist. The tactic of play employed in this project allowed two main actors, Furlan and Zimoch, to step outside their usual professional identifications as an artist and a sports commentator. Although Zimoch played the 'sports commentator' in the performance of *Boniek!*, the frame of art, the fact that he had to comment on a partially fictional event, made it a completely different experience for him – he had to become a performer in the first place.

The audience consisted of gallery-goers – many of whom had never attended a football mach before – joining two main actors in their role-playing game. The art viewers spontaneously started playing sports spectators and to some degree, for the duration of the 'match', they could identify with this new role. As art critic and curator Anda Rottenberg remarks, 'First you enact, then you participate. It's like when you adopt [a] certain convention. First you only play-act, but at some point the distinction between play-acting and actually

experiencing real emotions gets blurred.'[22] However, the play frame remained strongly perceptible during the whole event. Furlan did not reproduce the football match. He created a fragmentary image, a representation, concentrating on one aspect: the movements of just one player.

The Swiss performer uses art as a medium to transgress the limits of a man's primary identity, mainly connected with one's professional life. In his actions he realizes the symbolic return to the childhood open-ended possibilities of the identity yet-to-become. The artistic activity of role-playing becomes a direct extension of children's fantasy identifications with imaginary figures. It is also an occasion for the viewers to join his pretend play and make the artist's experience more 'lifelike', as well as immerse themselves in the space between reality and fiction for the sake of their own play.

This project belongs to the tradition of spectacle. Becoming someone else, although directly experienced, is made 'true' in the final 'show' – performance – the traditional form of representation. The artist as a role-playing game participant, although mimicking the dream hero – a football star – experiences this identification within a fragmentary, modified context. He 'fulfilled' his dream *and* made statements about the impossibility of ultimately transgressing or transcending one's identification. Only in art/play can dreams of becoming someone else come 'true'. This impossibility, the crack in make-believe, becomes a part of the outcome, as does the reality-show element exposed in the interviews which revealed that the process of transformation, of learning one's role – the temporary shift of identity – attracted the audience even more than the final show. What excited them is the state of becoming; the possibility of change, and the fact that they watch the football star played by the 42-year old artist 'who smokes a pack of cigarettes a day'.[23] Role-playing, as I mentioned in the analysis of Duchamp's masquerades, always involves a double role – the new temporary identity *and* oneself as this other self. The artistic potential of role-playing comes exactly from the movement between the two.

A more radical example of role-play as making it possible to experience the 'inaccessible' was the multimedia project by Polish artist Zuzanna Janin – *I've Seen My Death, Ceremony/Games* (2003) – in

Figure 4. Zuzanna Janin, *I've Seen My Death, Ceremony Games*, 2003, photo courtesy of the artist

which she staged her own funeral procession. After death announcements appeared in national newspapers, the actual funeral took place. The artist disguised as an old woman, members of her family (aware that it was a performance) and a few acquaintances and members of the art world (some of whom were unaware) participated in the ceremony. Leaving aside the ethical controversy this project caused, I see it as an example of 'dark play' applied tactically to initiate discussion about 'the experience of absence' and 'death as a social event'.[24] As in Bataille, the artist provided herself and her invited guests with the experience at 'the edge of the chasm'.[25] However, for some participants it was not a game; they were not aware of the mystification. Thus, the game occurred at their expense.

Various roles designed by the artist for the participants of this project were, to a large degree, a condition of its 'success'. Janin, in her disguise, observing the burial of her other self (game character, 'avatar') could come closer to the inaccessible experience of her own non-being. Her family could face their fears, 'rehearse' the mourning and

'domesticate death' (in so far as that is possible . . .). The acquaintances experiencing the whole situation 'for real' made the frames of fiction almost invisible; they guaranteed the 'reality' element of the 'show'. This project is also a good example of the artist's control (as a designer of roles for other participants) within the frames of play/art. I will return to this issue in the section relating to the artist as a 'game master'.

Artistic Tours to 'Real Life' – 'Game Worlds' and Their Rules

'An account executive, an ecologist, a stunt rider . . . ':[26] these were sample characters/roles the artist could play to shift operations, to slip between various professional categories to pursue the un-art model, as proposed by Allan Kaprow. This strategy, eagerly applied by contemporary artists, allows them to enter and explore various 'realities', different from their everyday ones.[27] The artists enter different 'exotic' professional, social and geographical realms in order to experience new 'real life' roles, and to work/play with new tools within the frames of art. Their shorter or longer visits are aimed at addressing certain problems or subjects embedded within specific domains which are outside their own expertise, knowledge, everyday experience and so on. Travelling to these different 'worlds' also allows them to step outside the hermetic circle of aesthetic concerns, and, paraphrasing Emil Nolde, to work directly with the 'actual material of life in their hands'. The statement by the American artist Alexandra Mir about her project *Plane Landing* (2003) is a good description of this approach:

> Well it's funny because obviously I don't come from ballooning and I don't come from aviation. I'm a visual artist and I work in a wide variety of mediums. But every time I take on a new challenge in a new field that I have no clue about . . . I do a lot of research.[28]

The artists leave the studios of the art world and enter the worlds of aviation, biology, biotechnology, ecology, medicine, education, social care and social control, psychology, trade and services, among many others. They meet professionals, consumers, users and makers from these fields. The process of researching and exploring the new realm often becomes a long-lasting one, a part of the everyday routine for

the duration of the project. It includes reading, field research, making connections with experts, establishing communication networks, securing funding (often from organizations from the researched field, not necessarily from the art world), and so on. The artists collaborate with the experts but also become temporary specialists themselves. Both approaches very often complement each other in the project.

This was the case for the last episode of *The Finissage of Stadium X – Schengen*, when the Berlin-Bern group Schauplatz International built a typical Schengen zone's observation point. The Schengen Area, created in 1995, currently consists of 25 European countries. In terms of international travel it operates like a single state – with external and no internal border controls for travellers entering and exiting the area and with the common Schengen visa. The artists constructed a control observation point identical to the ones at Poland's eastern border, which is also the Schengen Area eastern border. They referred to the status of the stadium as a border zone, after researching the 'illegal' immigration problem of many Vietnamese vendors, and invited experts on national border-related issues to talk to the visitors.

A similar method was applied by Katie Paterson in her project *All the Dead Stars*, exhibited at Tate Britain (part of the *Altermodern* show curated by Nicolas Bourriaud). Her work was a map documenting the locations of thousands of supernovas from data supplied by astronomers and supernova hunters. At the symposium accompanying the exhibition Paterson recounted her work on this project and said that initially she had no idea whether there were five or five billion supernovas documented. She knew nothing about astronomy. She just wanted to pursue an idea that seemed interesting (to construct a map defunct in its essence), engage with an international network of scientists and dead star hunters and enter a field so different from her own. By completing her work and her research, before she moved to the next project, she became a kind of temporary expert in this field and an active participant in the supernova network. As we can read at the Tate website: 'Treating the cosmos as her playground, her works span vast distances, making connections between disparate points and timescales.'[29]

The whole enterprise – in the form of an office, a laboratory, a cafe, a shop, an installation, a map – may appear to belong to the

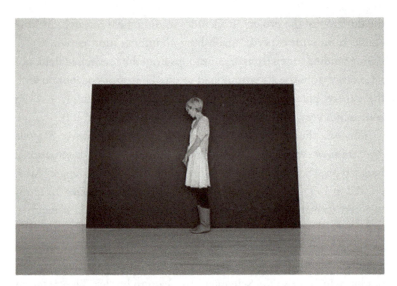

Figure 5. Katie Paterson with her work *All the Dead Stars*, 2009. Laser etched anodised aluminium, 200 × 300 cm. Installation view Tate Britain, 2009, photo © MJC, 2009 courtesy of the artist

researched reality, but it does not reproduce its functions. The artist applies a different (sometimes only subtly modified) set of rules, which do not belong to the world he or she enters, and creates the actual 'game world' in between two realities. The authors of the collaborative publication *An Architecture of Interaction* (2008) compare this tactic to 'playing a board game with a single set of pieces but using two different rule books concurrently'.[30]

> Yet rather than comply completely with the *rule structure* of a particular arena, it seems essential – and arguably the role of art – that artists create and implement their own *rule structures* as a necessary alternative or refreshing deviation from the standard *rule structures* of specific arena.[31]

To be able to combine different sets of rules effectively, the artist should become familiar with the 'rule structure' of the project's arena, especially if he or she wants to initiate a connection between the two realms. Although expressed in reference to artistic projects preceding today's participatory art, the following opinion illustrates the clash of two different realities in the common 'game world'. Richard, a local

resident, shares his reservations about the Group Material Gallery on East Thirteenth Street in New York (1981) in conversation with Tim Rollins:

> You know, like I don't know want to be nosy, and we all got our reasons for doing what we do with our lives, but I wonder – everybody here on the block wonders – why are you here?

> All I'm saying is that while a lot of the art and stuff I see happening around here is new and interesting and is kind of directed to the people who live here, I've also seen some lily-white shit spring up – in art exhibitions, in new bars and eating places ... It's like a lot of bored people from good backgrounds getting into the *bad* of the neighbourhood. And here we are struggling like hell to get rid of bad, you know? We find no romance in junk and shit.[32]

As can be seen from the above quotation it was not as much 'what' the artists were doing (exhibitions, research, talks, street workshops for children) but 'where' that caused controversy. The choice of a residential area that is alien and 'exotic' to the artists, from their perspective in some way the space of the Other, provoked mistrust on the side of the locals. To avoid confrontation like this, the relationship between contemporary 'relational' artists and the different worlds they operate in is, in principle, based on the intention of understanding and exploring the encountered 'rule structure'. Role-playing in recent art involves the process of assimilation, and this is also the default condition for any further artistic intervention. The comparison made by Freud – 'Might we not say that every child at play behaves like a creative writer, in that he creates a world of his own, or rather, re-arranges the things of his world in a new way which pleases him?'[33] – is no longer relevant in terms of the relationship between today's artists and the 'reality' they choose to occupy. As we can see from the example of Furlan, the creative act can become symbolic wish-fulfilment, just as takes place in children's play. However, this is the calculated side effect of the project, an additional gratification rather than the main objective, which is to create a space of negotiation, situated 'in between' different realms – not the manipulated vision of a perfect world or a private symbolic space.

The artists, instead of proposing their own authorial, self-expressive versions of certain spaces, situations or objects, more often create 'models'. A 'model' functions as a proposition, it does not impose anything; it is just an option, an alternative to the existing status quo, open for negotiation. Works by Thai artist Rirkrit Tiravanija are often referred to as 'models'. Tiravanija transforms galleries and museums into places for public use which are fully functioning, but not according to their 'proper' purpose. As his contribution to the *Making Worlds* exhibition at the 53rd Venice Biennale, he designed a bookstore. Text in the catalogue describes his projects as follows:

> When Tiravanija turns [an] art gallery into a functioning apartment where people can live, work, and sleep, or when he turns an entire art academy into an inn with hundreds of guests, as he did in Germany, he doesn't really expect to change the function of these institutions permanently but merely suggests the possibility of another model – the possibility of other ways of sharing things, and perhaps ultimately, other forms of human life.[34]

The artistic 'game world' is, therefore, less an artist's authorial creation than the encounter of two areas of activity ruled by different conventions. In fact it can be described as an effect of such an encounter. The 'game world' occurs when the reality of art meets any other human domain (i.e. the world of food catering) and frames it as 'something else' rather than its accepted everyday use. To refer to projects like these, Canadian artist and writer Bruce Barber applies the term 'littoral' art: 'Littoral describes the intermediate and shifting zone between the sea and the land and refers metaphorically to cultural projects that are undertaken predominantly outside of the conventional contexts of the institutionalized artworld.'[35] Like the fluid line between water and land, the spheres of recent participatory art, the artistic 'game worlds', are in most cases temporary, ephemeral or even immaterial. Similar to RPGs, the 'world' is produced mainly in narration by artists, curators, participants and critics.

A Trip to Asia: An Acoustic Walk Around the Vietnamese Sector of the 10th-Anniversary Stadium (2006) offered its participants an experience between 'urban roaming' and the 'headphone-guided museum tour'.[36] The participants, equipped with train tickets, an MP3 player,

a map, 5,000 Vietnamese dongs and a plastic bag with various wares, were instructed to take a train from Warszawa Powiśle to the next station – Warszawa Stadion. This trip

> took only three minutes, but it was precisely during that ride that the process began: perceiving a different reality, and investing it with an imagined, strange, consciously exotic dimension, intensified by the Polish-Vietnamese recorded commentary on that surrounding reality.[37]

After disembarking at Jarmark Europa, participants had to carry the bag to the appointed stall. They met and talked to pro-Vietnamese activists Ton Van Anh and Robert Krzysztoń, visited a Vietnamese video-rental shop and shopped in a Vietnamese grocery. The journey ended in the Thang Long cultural centre and the Pagoda – a miniature version of the One-Pillar Buddha of Compassion pagoda in Hanoi.[38] The participants, as tourists, were offered the experience of rediscovering the well-known market place, one they presumably had visited before, to do some bargain shopping: 'The action took place in the viewer's imagination rather than in actual reality, in the experience of another reality that, though invisible, is within hand's reach.'[39] The game world does not physically and permanently exist; it comes to being only through the players (artists/participants) and only for the duration of the 'game session' (artistic project).

Artist as 'Game Master'

The contemporary artist has been ascribed various roles in recent times, all of them beyond the traditional *ergon* of this profession. As a post-industrial *homo faber*, he or she is involved in the *processes* of cultural 'production', but not necessarily in making aesthetic objects. According to art critic Miwon Kwon, 'The artist as an overspecialised aesthetic object maker has been anachronistic for a long time already. What they provide now, rather than produce, are aesthetic, often "critical artistic services".'[40] Grant Kester refers to 'dialogic artists' who 'parted from the tradition of object making, and adopted a performative, process-based approach', as 'context providers' rather than 'content providers'.[41] Claire Doherty sees the role of the artists as

'mediators, creative thinkers and agitators',[42] while Nicolas Bourriaud adds: 'an entrepreneur/ politician/ director'.[43]

To stick to the proposed model of the role-playing game, I refer to the position of the artist as a 'game master'.[44] This phrase, which clearly indicates mastery and control, might be problematic for proponents of 'relational' or 'dialogic' art, who see the artist not as someone who dominates the process, but gently initiates and models situations. However, I would argue that this term is extremely well-suited to the ambiguous position of an artist in relation to the viewers/participants and other members of the art world as well. 'Game master' can be interpreted in many different ways, and I think this lack of a singular meaning is symptomatic for the play-oriented developments of recent art.

In RPGs, the game master (also called the 'referee') is a player designated to lead a game, to create a setting and coordinate action. This person has to prepare beforehand, and during the game, he or she describes the places, situations and tasks, builds the atmosphere and leads the others through the fantasy world. A good game master can make a game an exciting experience. Outside the game, in the Asian world a master would be a spiritual or a martial arts teacher, who guides young disciples through the journey of self-development. In the West, the word 'master' is more loaded with notions of power and gender – it designates one who has skills, goods and exercises control over his followers or servants. In the art world, the title 'master' – as, for example, in 'Old Master' – is usually a title reserved for artists of excellent skill, maestros in their domain, most often one of the great (male) masters of the past. It is also an academic degree title, a sign of scholarship and specialization.

All these notions of a 'master' seem to imply the dominant artistic position that twentieth and twenty-first century artists have tried to overturn. However, I still find it valuable to refer to them as 'game masters'. Locating leadership within the domain of play makes it an ambiguous function from the perspective of 'real life' and 'serious' occupations. The figure of a 'game master' is also a good pretext to refer back to some questions that have already arisen in the context of modern artists' aspiration to relinquish authorial control. Is the artists' position still and inevitably one of authority and domination, even if they deny it? Is a democratic negotiation of rules possible in art, as it

is in play? Do artists possess enough skill and experience to play roles as guides and community leaders, most importantly in projects that interact between the game world and the real world?

The 'relational' artists' activities fit quite well within the description of those of a typical role-playing game master. They organize, initiate, animate, coordinate, invite and propose situations and actions that are designed as open-ended and allow for viewers/participants' use of initiative, intervention, choice and so on. However, the question of mastery, in the traditional sense of skill and training, begins to be raised, especially when the artists enter the fields of human relations – working with groups from backgrounds often quite detached from their own and locating their game worlds within community life. Grant Kester puts it as follows:

> How do artists, whose education typically focuses on the accumu-lation of craft skills, the cultivation of an intuitive formal sensibility, or knowledge of conventional art history and theory, prepare for the complex ethical questions that are raised by projects that take them into unfamiliar spaces and contexts?[45]

It is difficult to assess artists' methods, successes and failures in this respect. The project proclaimed by some as insightful, sensitive and 'user-friendly' may be criticized as superficial and igniting conflict; an example of this is *The Battle of Orgreave* (2001), organized by British artist Jeremy Deller. On the website of Tate Britain we can read a short description of this action:

> This work brought together veteran miners and members of his-torical re-enactment societies who restaged the controversial clash between miners and the police during 1984-5. This collaboration resulted in a film, a book and an audio recording, which all function to resurrect the raw emotions from the period and provide a fresh account of events that have been distorted by the media.[46]

According to art theorist Claire Bishop the artist's initiative was problematic and its effects potentially harmful: painful memories were framed within the convention of a village fair, and the documen-tary film on the event was a one-sided critique of the Thatcher

government. According to Bishop, 'Although the work seemed to contain a twisted therapeutic element (in that both miners and police involved in the struggle participated, some of them swapping roles) *The Battle of Orgreave* did not seem to heal a wound so much as reopen it.'[47] Deller, in conversation with Claire Doherty, describes his role in the whole project as an initiator. For a year and a half, at first just on his own, he was researching the subject, talking to local people, preparing the ground. After this stage, the work was carried on mostly by the production agency and the invited experts. He says:

> I know what my limitations are and there were other people there who were far better experienced in making the thing happen than me. I had already done the work and set the situation up and so it was up to the experts to get on with it. Also, I was interested in how other people would interpret the idea, where it would go to. I knew it had its own life. I had no ownership over it.[48]

From this perspective, Deller – the 'game master' – was not fully responsible for the final outcome of this project. In fact, the project itself must be seen primarily as a process of negotiation and multi-layered interactions between all collaborators who took part in it – local community members, historical re-enactment experts, producers, filmmakers and so on. The 'battle' itself was just a part of the 'game', initiated by the artist. He did not approach ex-miners and policemen as vulnerable victims of the political system, in need of group therapy. He rather invited them to take part in the collective play and it was their choice to accept or reject the invitation, and their responsibility to negotiate the rules. What the real dynamics and politics of this particular play were is hard to determine. Nonetheless, the function of the 'game master' releases the artist from the pressure of being the only person in charge – the one who determines all moves from the initial idea to the final performance. As Deller says, it is his tactic to 'let go', to be open to various outcomes. He wants to be surprised by other people's contributions, but he also admits that it is laziness on his part.[49]

The question arises: to what extent can incompetence, even if acknowledged, be a part of the artist's tactic? What other qualities should or must characterize the effective artist-game master? Grant Kester

Figure 6. Paweł Althamer, *Bródno 2000*, photo courtesy of the artist, Foksal Gallery Foundation, Warsaw and neugerriemschneider, Berlin

mentions empathy or empathetic identification 'between artists and their collaborators' as a 'necessary component of dialogical practice'.[50] Such empathy becomes a natural aspect of the project when the artist operates within an area or community that he or she knows or has come to know well. It is a challenge, but the result can be rewarding. In February 2000 Pawel Althamer, a Polish sculptor and author of installations, video art and public art projects, invited his neighbours from the huge concrete housing block in the Bródno district of Warsaw to create a vast '2000' sign by turning on lights in specific windows. The action was very successful thanks to the surprising dedication of all residents who demonstrated the need for solidarity and 'community of action' against the anonymous and dehumanized landscape of this post-communist residential area. The artist aptly addressed the emotions, dreams and frustrations of his co-players because they were also his own.

Is empathy, together with other managerial skills such as team-building, enhancing motivation and communication, a sign of a professional approach? What does it mean to be a professional 'relational' artist? Is it to be a good community worker? Or to be a completely

unprofessional community worker and manager, who 'lets things go', does not appoint any goals and leaves his/her collaborators to make all the decisions? Or is a relational artist a kind of professional player, a juggler of other peoples' emotions and fantasies, a jester *and* a sage?

According to Wolfgang Zinggl from WochenKlausur, a Vienna-based collective engaged in participatory art, 'Art's opportunity to approach the problem unconventionally, naively, and open-mindedly is in principle an opportunity open to anyone who approaches the problem from outside.'[51] This specific intentional naivety, even light-heartedness, seems to belong to the contemporary profile (*ergon?*) of artistic activity. Dutch artist and art events coordinator, Wietske Maas, expresses similar views:

> Art's advantage is its playfulness, its ability to act between the formal borders of society's organisation without being obliged to abide by particular artistic, economic, political and social rules nor to fulfil their criteria. Art's radical potential is its deviation from existing rules or the creation of new freedoms between old rules.[52]

The artist's position is often stretched between that of a social activist or cultural animator and that of the outsider and incompetent non-specialist. Sometimes, however, the role of a community worker dominates the role of an artist. Artists become careful 'adults', responsible organizers of 'democratic' community play, instead of playmates, self-proclaimed 'game masters' (a much more exciting, if potentially disturbing option). In both cases their function is loaded with authorial power which, in my view, is inevitable and produces desirable and potentially creative group dynamics.

The function of a 'game master' is often found with curators, who become active organizers and coordinators of projects integrating various, often multiple artistic actions. This was the case in the series of events that formed *The Finissage of Stadium X*, curated by Joanna Warsza from the Laura Palmer Foundation. It was her initiative to invite Massimo Furlan and pair him with Tomasz Zimoch in their collaborative performance. Together with Anna Gajewska (film-maker) and Ngo Van Tuong (journalist) she organized *A Trip to Asia: An Acoustic Walk Around the Vietnamese Sector of the 10th-Anniversary Stadium*. She also was one of the people behind the series of events as

a whole – as one big project comprising six different episodes. It can be said (exploiting further the metaphor and the wordplay) that the curator becomes a 'game headmaster'.

Between Experience and Representation – Artwork/Action as 'Game Session'

As I mentioned before, traditional RPGs are about direct interaction among players and a game master, and they are based on communication and collaboration rather than the conflict or competition which structures typical sports, cards, or popular video games. This focus on the sphere of human relations, exchange and 'togetherness' is characteristic of the practices I analyse in this chapter. The attempts to name them suggest the direction of artistic and curatorial pursuits: 'new genre public art' (Lacy, 1995), 'relational aesthetics' (Bourriaud, 1998), 'conversational art' (Bhabha, 1998), 'dialogue-based public art' (Finkelpearl, 2000), 'dialogical art' (Kester, 2004). In all these artistic forms the encounter between the artist and participants or the interaction among the group of contributors is treated as the art process – just as the game session in RPGs is both the means and the purpose of the game. Nicolas Bourriaud describes the 'contemporary work of art' not as 'the termination point of the "creative process" (a "finished product to be contemplated")' but 'a site of navigation, a portal, a generator of activities'.[53] These activities bring into being the contemporary work/play of art and 'provide a structure to create a community, however temporary or utopian this might be'.[54]

The dialogic, relational art offers participants a plot to be enacted, a setting to be inhabited, or a problem to be negotiated. It also usually contains a hint on how to 'navigate' the space or situation – a provisional set of rules. These rules create an alternative to the usual, traditional, everyday function of the given 'world' (i.e. cooking in the art gallery). The above characteristics of the contemporary work/play of art fit into the description of a game by Antony Storr:

> Organized games have rules to which the players must adhere, and a game is spoiled if the rules are broken. In this way a game is a microcosm set apart from ordinary life, and much better ordered than our habitual, chaotic existence. The game displays a formalized

pattern in which each player knows his task and how he should behave.[55]

Even if the artist's proposition at first causes surprise and shifts the usual concepts about the given problem, the participants quickly assimilate the new rules as the rules of a new game. The frame of fiction, the 'formalized pattern of play', provides them with the sense of safety that allows them to go beyond the conventional patterns of behaviour. This characteristic of a game session (art project) as 'separated in time and space'[56] is often used by the artists to help to solve local problems. WochenKlausur organized boat trips on Lake Zurich for local attorneys, councillors, activists and editors to address the drug problem in Zurich. During these journeys the participants could step outside their everyday roles and abandon the rhetoric of the courtroom, the editorial page or Parliament. As Grant Kester remarks:

> On the boat trips they were able to speak and listen, not as delegates and representatives charged with defending *a priori* positions, but as individuals sharing a substantial collective knowledge of the subject at hand; at the least, these external forces were considerably reduced by the demand for self-reflexive attention created by the ritual and isolation of the boat trip itself.[57]

The playful trip is used here as a means to help to arrive at solutions in the public sphere; it is a tactical intervention with non-art goals in mind. The forms of artistic 'game sessions' often take different types of group entertainment as their models: walks, tours, boat trips, cooking parties, parades, creativity workshops, sports events and festivals, among many others. The play models support collective experience, but they are also flexible and easily adopted in almost all situations, in various contexts and locations. When the content of the work of art is serious and challenging, the form of a community fair/parade/festival can serve as a platform for communication. However, from a more critical perspective it can be seen as a rewarding 'carrot' instead of a modernist offensive 'stick'; ultimately, yet another form of manipulation.

The therapeutic artistic game session can be very successful when it is intimate and involves a small group of participants or even just two

players, including the artist. I had the great pleasure to play a game of 'thinking and meditation' designed by German multimedia artist Gesine Storck.

GAME OF LIFE
Game of thinking and meditation.
Play with love, eagerly, lightly.
Rules of the game:
Each player goes with one card at a time.
What is placed is placed. It cannot be changed (as in real life).
The image is created – the reflection – of you at this time of your being.
Observe what was created, discover each other and discover the miracle of this moment. . . . [58]

Storck plays this game with people she knows, friends, viewers and artists, and each time she takes a photo of herself with her player and the unique combination (composition) of cards after the session. This game works as a conversation and to some extent as a psychological analysis of players – it reveals moods, reservations, some aspects of personality. The game session is also simply a collaborative creative process, a very absorbing and challenging one, since there are only two players.

The game session/art process creates a 'temporary community', which in both cases might last and remain integrated in 'real life' as well. The ideal type of temporary community which the relational type of art tries to evoke can be described using the notion of 'communitas' – a term applied by Victor Turner in the 1960s (adopted from Paul Goodman's usage)[59] – referring to a group experience of full, unmediated communication, sharing and togetherness.

The original sense of communitas is spontaneous and concrete, not abstract. The experience of communitas matters much to the participants. . . . Communitas liberates individuals from conformity to general norms. It is the fount and origin of the gift of togetherness, and thus of the gifts of organization, and therefore of all structures of social behaviour, and at the same time it is the critique of structure that is overly law-bound.[60]

Figure 7. Gesine Storck, L=∞. *Spiel des Lebens, Denk und Meditationsspiel*, 2010, a game with Katarzyna Zimna, July 2011, photo by Katarzyna Zimna

According to Turner, communitas is likely to occur in three types of situations: 'through the interstices of structure in *liminality*, times of change of status; at the edges of structure, in *marginality;* and from beneath structure, in *inferiority*'.[61] This is also where today's artists look for inspiration and most often locate their game worlds – within marginal groups (spaces of the Other), temporary states of being, abandoned locations. This is why the 10th-Anniversary Stadium was the perfect place for artistic interventions – the deserted ruin and lively bazaar in a transitory moment of its own history, the relic of the 'glorious' national past colonized by outsiders. The experience offered to the participants of the *Finissage's* episodes was one of communitas – they could share the unique moment beyond the rules of reality, transgress their own identifications for a short while, feel the collective bond of initiation into the mystery of the stadium, the 'invisible' place which was very soon to disappear.

It is also important to ask – and this question will probably remain unanswered – what does it mean, for participants, non-artists, temporary visitors/players in the world or that of art, to join the

artistic game? Is it fun, distraction from routine, a lesson in creativity, play therapy or maybe an aesthetic experience? It is a very individual matter, but can it really become 'communitas', which in principle is unmediated and spontaneous? Can art, as Bourriaud puts it, be like an 'angelic programme' so as to 'patiently re-stitch the relational fabric'?[62] And what if the viewer does not respond to the proposition in the game-like convention? Does he or she become a spoilsport, the group outsider? Bourriaud writes: 'Feeling nothing means not making enough effort.'[63] Relational projects require a willingness to participate, to get immersed, engaged and involved in the rhetoric of the given 'game'. Group activities, as I wrote in Chapter 2, in the context of communal celebrations, apart from the promise of togetherness, contain the element of exclusion. They need outsiders, even scapegoats, to exist. Dave Beech, after Jacques Rancière, points out that participation, as an inclusive practice, cannot include all: 'Seen in this way, participation must be excluding because it sets up a new economy which separates society into participants and non-participants.'[64] And even more importantly, after Butler and Derrida, he argues: 'Outsiders have to pay a higher price for their participation, namely, the neutralisation of their difference and the dampening of their powers of subversion.'[65] Play/game reveals here its ambivalence – blurring boundaries between people and their 'worlds' annihilates differences, which can be both subversive *and* neutralizing.

Another possible problem with the play-frame of relational works is that participants may approach them playfully but not as an inspiration for a deeper reflection, and they may not really distinguish an effect of the art process from other 'playground' experiences: theme parks, paintball sessions, sports events, pub crawling, etc. They may become active participants in play, but not in art. Also, the dialogical, game-session form is not the universal *passé-partout* that opens all doors. Kester, the advocate of dialogical art, nonetheless remarks:

> Not all conflicts can be resolved by free and open exchange because not all conflicts are the result of a failure among a given set of interlocutors to fully 'understand' or empathize with each other. In many cases social conflicts are the result of a very clear understanding of material, economic and political differences.[66]

Addressing differences in order to provoke confrontation, to disturb and not to flatter, can be more effective than trying to evoke the illusion of conviviality and micro-community. Claire Bishop names this tendency, in response to Bourriaud's 'relational aesthetics', as 'relational antagonism' (which echoes Bataille's concept of alteration – destructiveness/transformation as an impulse to create). According to her, the works by Santiago Sierra and Thomas Hirschhorn, among others, do not 'offer an experience of human empathy that smoothes over the awkward situation before us, but a pointed racial/economic non-identification, this is not me'.[67] The role-playing is no longer relevant, as artists confront the viewers with a certain situation but do not necessarily invite them to step inside. This is how Thomas Hirschhorn describes his approach:

> I do not want to invite or oblige viewers to become interactive with what I do; I don't want to activate the public. I want to give of myself, to engage myself to such a degree that viewers confronted with the work can take part, and become involved, but not as actors.[68]

Such a position, paradoxically, can give more autonomy not only to the artist, but also to the viewers. It acknowledges the fact that 'reflection is an activity',[69] and that 'playing house' or having a dinner in a gallery may not necessarily contribute to any insights but may, rather, be a distraction; not a self-directed gesture but a programmed response to the given environment.

Beyond Representation?

I used the model of a role-playing game to analyse recent participatory art, in terms of artists' and viewers' roles, their mutual relationships, and the location, scope and character of art activities and events. I find this model useful in the critical examination and helpful to generate questions about new roles adopted by the artists and new functions of art. It seems that recent artistic activities carefully 'veil' their actual identity, and their function can cause confusion. The 'dialogical' art events are staged either as community-oriented creativity workshops (to work through some specific problems) or

play-like open-ended situations – walks, trips, parades, community fairs (to create the possibility of experience, encounter or exchange). The artists avoid naming these events 'art' or 'representation' – instead of 'artworks' we have 'models', 'platforms', 'stations', 'zones' and 'sites of interaction'. The processes that occur during these events cannot be openly approached as art, because the intention behind them is to cause real life consequences and not produce a 'theatrical' imitation of life. The artists – as animators or game masters – insist that they do not 'own' the projects which emerge during the open-ended, democratic negotiation. They try to mask their authorial and professional positions by pretending not to be there or to be average players. It seems to me that the objection to representation is the main impetus behind many of these masquerades and confusions in recent art.

In her 2004 book *Art Beyond Representation*, Barbara Bolt proposes a non-representational approach to artistic process, with the help of the notions of 'handling' (Heidegger), materiality and performativity. She argues that 'the representational mode of thought manifests itself in instrumentalist understandings of the work of art: that is, in thinking of the process of artistic production as one of mastery – of tools, of materials – under the guidance of a preconceived end'.[70] This notion of representation belongs to the traditional *ergon* of art – the aesthetic production executed according to a predetermined design, plan and intention. What Bolt proposes is the concentration on practice as an immediate experience of 'here and now', with possible distractions from the main path – surprise and indeterminacy – the notions I identified with the traditional *parergon* of the creative process. Bolt places the old and new approaches in opposition to each other according to a series of dichotomies: fixed/open-ended, rational/instinctive, predictable/surprising, and so on. As she writes: 'In the flux of practice, we grope towards an understanding that is not representational. Acts and decisions occur in the heat of the moment and not as the result of rational logic.'[71] The creative act becomes, then, first of all a 'performative act'.[72] I would add, a '*proper* performative act', as parallel to Austin's distinction between performative utterances in 'real' situations and the 'parasitic', 'non-serious' performative utterances in jokes or theatre, i.e. in the situations of representation.[73] Bolt's notion of performativity refers to the 'real' hands-on experience of a spontaneous physical immersion, not a mere enacting, but 'being'

in the given situation. Bolt uses the notion of *methexis* as a matrix for non-representational art and analyses it in the context of indigenous Australian ritual practices. *Methexis* – as a productive (performative) participation – becomes an element spanning ritual, play and artistic practice as activities 'beyond representation': 'In this schema, the terms of the economy of representation shift.... [M]eaning is produced as an embodied, situated event. Imaging produces real material effects.'[74]

The theory of non-representation has also been formulated by Nigel Thrift (in the field of human geography) and designed as a methodology for an 'experimental rather than representational approach to social science and humanities'.[75] In this theory performance and play meet as strategies to arrive at a 'special kind of knowledge' that is practical, engaged and which 'derive[s] from improvisatory immediacy and presence'.[76] Thrift locates performance and play outside representation; as he writes, 'performance cannot be seen as (though it may well involve) "text"'.[77]

It may sound provocative, but in my view, Thrift's theory can serve as a manifesto of what I name as the strategy or tactic of play (of a pre-rational heritage) in arts and culture in the twentieth and twenty-first centuries. As central values, he appoints process, practice, activity and dialogue. The 'relation' becomes a new solution for 'representation'. Performative methodologies allow 'their participants equal rights to disclosure, through dialogical actions rather than texts, through relation rather than representation'.[78] The proposed style of work is therefore democratic and anti-elitist, which does not 'pretend to grand theory' but must rather be seen as an 'attempt to produce strategic and hopefully "therapeutic" interventions which stress the disclosive power of performance as recognition of the fact that all solutions are responsive, relational, dialogical'.[79]

Play and other 'marginal' human actions are credited an important place in non-representationalist methodology:

> ...emphasis on classes of experience which have been too rarely addressed, the productive, the interactive, play; all those responsive activities which are usually involved in 'setting up' situations which, because they are often considered to be always already there, are still too little considered; they are regarded as 'trivial'. This means

moving forward a poetic of encounter which conveys a sense of life in which meaning shows itself only in the living...[80]

Play is thus presented as a kind of experience that is both 'the living' and conveys the sense of life, but not as 'representation'. Thrift quotes Schwarzman: 'play is functional because it teaches about contexts; it teaches about frames not being at the same level as the acts they contain'.[81] Play 'teaches' about representation, but it is not representational. The non-representational theory treats play as a 'process of performative experiment'.[82]

In my view Thrift's theory is an attractive, contemporary version of the 'myth of presence'. No doubt, performance and other relational practices can be treated as important and refreshing elements in the methodologies of human sciences and the arts. However, I cannot agree with the assumption that play, performance and other practices that use them as research or creative tools belong to non-representation. Is the prejudice against 'writing' still so strong that we tend to locate truth and essence in 'speech' and we cannot accept the fact that 'speech' is also a form of representation? I cannot help reading Thrift as echoing Plato ('The art of representation is therefore a long way removed from truth...'[83]) or a modern 'Primitivist' manifesto ('Direct sensual experience is more real than living in the midst of symbols, slogans, worn out plots, clichés – more real than political-oratorical art').[84] As Thrift writes, a non-representational kind of knowledge

...gives up modern assumptions about knowledge, reality, the orderliness of the world, unreal and underlying appearances, in favour of a new stance towards the world-political-moral knowledge which argues that the world is constructed through activity, and especially the activity of talk, talk as action, not communication, which includes the expressive powers of embodiment.[85]

Again, Thrift presents talk as 'truth', as non-representation, existing apart from communication, code and 'writing'. Similarly, dialogue, in dialogical or relational art, attempts to be a non-representational method of expression – a shared *activity* of talk. It brings to mind Gadamer's observation that

To reach an understanding in a dialogue is not merely a matter of putting oneself forward and successfully asserting one's own point of view, but being transformed into a communion in which we do not remain what we were.[86]

Play and performance act in these theories as methods of understanding through embodiment, as pre-rational *pharmaka* for the cognitive interpretation of things.

Play, when analysed as a separate activity, can be perceived as lived and present, existing only in a given moment, 'here and now' and 'natural'. It has a strong performative side to it and cannot exist separately from its players. It can be seen as opposed to art's artificiality and the absence of the author. However, play in all cases is a trigger for metaphor, code, 'writing', representation; the rest is just a form, whether it is a village fair, a community event, a reality TV show or a role-playing game. Therefore, I agree with Derrida when he writes:

We might say in another language that a criticism or a deconstruction of representation would remain feeble, vain, and irrelevant if it were to lead to some rehabilitation of immediacy, of original simplicity, of presence without repetition or delegation, if it were to induce the criticism of calculable objectivity, of criticism, of science, of technique, or of political representation.[87]

As I have argued throughout this book, it is not possible or necessary to go beyond representation in artistic practice, although this desire has always been one of the engines of change within culture and art. But still, no matter how immersive or lifelike today's participatory art seems to be, I would approach it as a 'reality show', a 'guided tour to reality' or a 'role-playing game', rather than an unmediated experience. Even if we approach artistic process as *methexis*, it still belongs to (produces and is produced by) the broader frame of representation. What is more, I see the slogans of non-representation as a mask, a veil, designed to conceal art's frames, the participants' roles, the metaphors they embody, the artist's mastery and the authorial intention (even if it is only within the role of a game master).

I would argue, therefore, that play as a philosophical concept is the condition for representation, and play as an empirical activity is a form of representation. In my view, the image of play as a means of non-representation comes from the one-sided view of play interpreted according to a set of pre-rational or Primitivist characteristics, as direct, sensuous, irrational, unconscious, anti-intellectual and so on. It overlooks play as conceptual, rational, planned and repetitive. It also overlooks the non-erasable frame-*parergon*.

Representation as a 'Game Session'

The approach to play as Derridean 'undecidable', *passé-partout* and *parergon*, irreducible to one-sided descriptions, may be a way to arrive at a more constructive concept of representation than the traditional one driven by *allergy* between art and life, fiction and reality, subjectivity and objectivity, repetition and origin, convention and improvisation, etc. I propose a view acknowledging the necessity of *synergy* – the productive coexistence of both sides of these dichotomies, both terms in the polarities. I think representation is neither good nor bad in and of itself, but can be misused, misinterpreted or imposed by the dominant power.

The model of play as bonding *and* separating different 'realities' opens up the possibility of a flexible approach to representation as an experience *and* a symbolic act – one happening and possible only through the other. As a metaphor for this *synergy* I can employ the figure of the Roman god Janus, borrowed from Mikhail Bakhtin. In the unfinished text *Toward a Philosophy of the Act* (1919-24), he compares human act or deed in art process to

> a two-faced Janus, . . . gazing simultaneously into the cultural sphere and into lived life. Originally the numina or spirit inhabiting the doorway of a dwelling, the Roman god Janus, like Vesta (with whom he was often associated), was without gender or anthropo-morphic form. As a kind of doorkeeper, Janus looked in – to the hearth and home – and he looked out – toward the larger world.

> . . . As the spirit of the doorway, Janus might be thought of as the great *and*: art *and* life, theory *and* practice, historical roots *and* contemporary application.[88]

The doorway, threshold, the passage between two worlds, plays a similar role to the frame. It belongs to the inside and to the outside, and it is a channel of communication. Artistic representation, the process of art, can be approached as a two-way passage, a communicative frame, a meta-narration about the specific situation/act/activity/experience.

The traditional notion of artistic representation has been conceptualized with the help of a vocabulary describing the traditional *ergon* of art: work, production, preconceived end, order and mastery. When we acknowledge the new role of play-*parergon* in contemporary art, all these terms can be redefined with the use of the metaphor of play. However, art has not become play. The ideas of purposefulness, means and ends and authorship are still vital to the practice and theory of art, even if they are often carefully 'veiled'. However, it is possible to inscribe these notions into the more play-oriented model of representation. The metaphor of the game session can serve not only to analyse contemporary process-oriented art, but also as a more universal tool to approach the notion of representation as the possibility of *synergy*, the great *and*. I will address here three main elements of the redefined notion of representation: the initiator of the act, the participants in the act, and the way it happens.

The Artist/Initiator

In the traditional account, artistic activity is initiated by the artist–author. He or she (but more often he) is the creator/producer of the aesthetic object that reflects/refers to or transforms what is real/natural/original. The author is responsible for the meaning he creates. He intends a specific emotion or information to be inscribed within the work and, after the work is completed, to be decoded by the viewer. The attempt to 'go beyond representation' negates this function of the author and the 'authority' as dangerous, totalitarian notions. The artist becomes a disinterested recipient-sender of the information, one among other participants in the creative/post-productive activity, 'being played' by the artistic game. His/her approach is open, the mode of creation is immersive and the course of work is shaped by the flow of events.

The artist is never an ultimate authority or god-creator; neither is she an average participant. He or she can rather be compared to the game master (male or female), someone at once inside *and* outside the game (the creative act), one among other players but performing a different function, with a larger dose of responsibility, although the tactic to make the game successful may be the one of 'letting go'.

The artist as game master can have various predispositions – he/she can be an inventive creator of basic scenarios or plots to be followed, be a great playmate and play-leader full of empathy and able to inspire the others, a master of improvisation and unexpected twists of action, a charismatic storyteller or a provocateur. All these options differ in terms of the degree of authorial intervention; they promise diverse structures of the 'game', and depend on the artist's personality, skills, interests and the artistic tactic he or she adopts. The position of the artist can also be approached as a role he or she intends to perform in a specific project, including the 'magician', 'genius', 'author' or 'DJ', 'independent researcher' and 'animator'. The artist can also try to keep his/her own position transparent, but I do not think it is possible, since each artistic act is inevitably marked by some sort of intention, preconception or tactic.

Bakhtin saw the authorial interpretation as a form of exchange, a necessary dialogue. According to him, the artist 'authors' the situation to the same degree as viewers/participants, and they 'author' each other in the process of interaction. This process can be seen as authoritarian or as a possibility for negotiation, new insights and surprises, depending on the approach to the notion of 'representation'. For Bakhtin, the artist's task is 'godlike' – 'to define others in ways they cannot do for themselves'.[89] In contemporary community-oriented art, this task can be redefined as closer to the Socratic method of *maieutics* – as a service offered to the participants by the artist in order to help them arrive at some insights that may lead to a change of position. In comparison to the Socratic strategy, the contemporary artistic game is much more open-ended (or at least it is intended to be); however, artists in most cases plan the options and the participant's moves in advance, or at least have some ideas of where the whole process may lead to.

Approaching the artist as a 'game master' automatically discloses all possible variations of this function – from authoritarian gestures to empathy, letting go, or experiments with vertigo. It is clear from the beginning that the person named as the artist performs a 'mastery' but within a frame that can be negotiated, and one that cannot be seen as the only possibility, or the best way to look at things. He or she is neither the unquestionable 'master' of the situation nor the average player who enters the game without the pressure of responsibility. The artist faces the attention directed towards him/her in a situation of doubt, conflict and evaluation.

The Viewer/Participant

The chosen position of the artist structures, to some extent, the options which may be exercised by the viewers/participants. However, they should be seen neither in the traditional way as passive consumers; nor as creators of the situation or experience, independent from the artistic proposition, arrangement or invitation. The activity of participants (players) occurs in response to the initial move made by the artist (a plot or a setting proposed by the game master). If they accept the invitation to play – to enter the situation of art, of artistic representation, within the loose or more rule-bound frames – they can offer their own active contribution: follow the script, negotiate it, modify or fill it with the specific content. What is more, as in ordinary games, active participants/players 'will consistently explore what is permissible and what pushes at that boundary between rules and expectations, and player's own agency, within any given environment – no matter how structured that play is'.[90] The players are always unique personalities, and they also compose unique constellations as groups in 'relational' art events. All forms of participation, in different locations and in different contexts, can have different dynamics and meaning for the participants, and can be evaluated in different ways by spectators (critics, theorists, journalists, onlookers). It is almost impossible that the process or the product of interaction represents exactly the same value, experience, feeling or judgement to diverse groups of people in different places and moments of time, no matter how authoritarian the initial plan was. The participants embody the initial plan and fill it with different

meanings, transgress the singular point of view and often surprise the artist-initiator.

What I find paradoxical is that participatory art projects, proclaimed as non-representational or going beyond the authorial subjective vision, are most often analysed in terms of the artist's intention. The viewers are 'offered a possibility to occupy the space', 'engage in unexpected encounters', or 'construct their own narratives', but rarely do the critical texts reveal anything more than these slogans. How do viewers really occupy the space? What do they make out of it? How do they approach this experience? These are important aspects to address if the viewers/participants are to be seriously treated as contributors to the act of representation, and not just manageable and predetermined characters in the artist's play. The answers may be uncomfortable, difficult to deal with and not fit within the agenda of 're-stitching the relational fabric' or any other plan or scenario. The viewers can turn out to be spoilsports, in many cases, and it is their right to behave as such, as well as to join the play or to negotiate the rules.

Sometimes the art action is designed for a specific group in terms of gender, age, geographical location, occupation, social status and so on. However, even then the participants are not obliged to become pawns in the artist's play, to represent the average member of a group as preconceived by the artist. They may not accept the proposition of the common creativity workshop in the initial form, designed to meet their specific needs, because these needs may be estimated incorrectly. They have the right to ask questions of the artist: Why are you here? Why do you want to do something here? What is your master plan? They can agree to take part in *his* or *her* play and possibly make it a *common* experience. There is a huge difference between being a spectator and being an active participant. To impose the active role in the art process upon someone against their will is to display authoritarian control, the same as presupposing someone's passivity and obedience.

When the artist decides to enter the realm of human relations as a location of the 'game world' he or she must be prepared to face the consequences. Local community members may turn out not to be enthusiastic players, or on the contrary, they may be too submissive

to the artist's position as an authority and the 'real' master of the situation. To consider the viewers as voluntary players helps us to acknowledge all their possible reactions, from acceptance, through dialogue, to negation or indifference. It also helps to avoid a didactic attitude on the part of the artist. If the artist claims to approach the viewers as partners or potential playmates, he or she has to accept many different interpretations of the rules of the game and different approaches, including the 'passive' reflexion. The artist may insist on following the 'authorial' rules, enacting the preconceived general plan for action, or may open the process for the participants' invention and interpretation.

How It Happens

The traditional 'how' of artistic representation implies the authorial narrative in the form of aesthetic object or action, embedded within the net of cultural codes and conventions. The opposite, non-representational proposition focuses on process, flow, performance and play – the activities taking place 'here and now' that evoke spontaneous reactions instead of rational, well-established solutions. The main expectation of art 'beyond representation' is that it would 'present' – just 'be' as any 'real' phenomenon, instead of 'represent'.

The notion of a game session can link the above positions. A game session is basically a gathering, a meeting led by the game master who introduces the players to the fictional world. The social situation, the encounter and play take place at once on two planes – that of the experience of being together, in a group, in someone's home or outdoors, and that of being somewhere else, in the game world; being oneself as a player *and* as a character in the game. All conversations and narrations occur in the game world – in between reality and fiction. This process can be compared to Bakhtin's formula of two steps of aesthetic vision:

> They are not necessarily chronological, but interpenetrate each other. There is a moment of 'living-into' that which is being experienced (projecting oneself, experiencing empathy); then a moment of objectification (separating from what one felt, returning to oneself)[91]

In art practice, the performative 'presence' always generates representation on some level, and the process of representation shapes this presence. Representation is both the experience of the fleeting, elusive moment within the specific situation initiated by the artist, *and* the metaphor. This metaphor carries forward the meaning of the experience in its future absence *and* creates specific forms of being in the given situation. One's role in the game follows the flux of 'events', occurs in interaction with other characters *and* shapes one's experience of the given moment.

Representation in the art process occurs on many levels (material, intellectual, emotional, interpersonal, etc.). It is not just an aesthetic monolith produced by the artist. It happens, in effect, through the *synergy* of many different aspects including the artist's intention, plan or initial idea and specific means and actions that represent this approach and problems he or she wants to address. Representation can be an object or event; a specific material or performative entity that generates the intentional or accidental metaphors that go beyond the tangible substance of the 'here and now'; the viewers' contributions, their roles and interpretations; a story about the project produced by the participants and then reproduced in texts, discussions, academic papers, and so on. Representation is then a polyphony or sometimes a cacophony of many different voices, which is not necessarily rational, conventional and predetermined, because it is impossible to control all moments of its becoming. However, it is different from the 'unmediated' flow of events because of the overarching frame – 'this is art'– 'something as something else', because of the adopted roles, shifted rules and conceptual and aesthetic values going beyond the usual 'performance' in the given situation.

We produce and experience representation through the tangible, the material and the performative. Within the frames of art or a game session, immersion, flow, sensation, sudden insights, or 'working hot' are organically connected with representation. When we agree that a certain event is art or game, the rules of 'reality' become complemented or challenged by the rules proposed by the artist/game master or negotiated by the participants/players. The usual rules, gestures, conversations, feelings, etc., are being framed. Non-representation is the attempt to strip art bare, to fix it as a self-referential sensuous act. Barbara Bolt writes that in performativity (as a form of

non-representation) 'the outside world enters the work'.[92] When the 'outside world' gets into the 'artist's hands' we inevitably end up with representation; it does not matter what processes the artist chooses to employ.

I think that the model of play, the game session, can liberate us from prejudice against representation as rigid, rational, traditional, authoritarian and so on. Game is immersive *and* communicative, creative *and* repetitive, limiting *and* liberating. Representation in this sense is not only the product of experience, its imitation or interpretation; it also makes the 'experience', which belongs to the fiction *and* to reality. Representation can then be understood as trespassing, crossing, linking, but not necessarily in an 'arboreal',[93] totalizing, rigid and hierarchical way. It includes the possibility of misinterpretation, misunderstanding and problems with communication and parallel or solitary play. As a fluid process, movement in between, it enables surprise and vertigo, but also assimilation, mimicry and repetition.

However, representation/game can be premeditated or authoritarian as well. It just depends who plays and with whom. A game does not guarantee the ultimate escape from the contest of power, which is inscribed in any and all relations between human beings. Art process cannot suddenly become an ideal kibbutz, and it should not become one, if it is to resonate with (represent) the world.

Play can be approached as a relational experience of togetherness, as 'dark' play testing the boundaries or as competitive play seeking confrontation. The emergence of the art/play temporary community also entails the possibility of the exclusion of those who do not fit into the game world, or those who question its rules. The metaphor of the game helps to frame the notions of mastery, instrumentality, manipulation or provocation as belonging to the process – aspects we must be aware of, but are not necessarily obliged to accept.

The notion of representation as game session exposes the temporal character of every art project, which can be interpreted and updated in many different ways according to the situation and to the participants' individual outlooks. Participants can also refuse to join the game, ignore it, question its rules, or appoint another game master, if that is possible. Play is voluntary and the same refers to art. Representation can then be seen as a safety barrier and a safe experiment. If, hypothetically, art becomes life – non-representation – there would be no frame

left that separates participants from the author's will and control, and vice versa. There would also be no place for art that tests the possibility of destruction, chaos or confrontation, because it would be really dangerous. The possibility of unmediated presence is only attractive when this presence provides excitement and creative stimulation, but not when it is violating, painful or intolerable. What is more, the separation from 'reality', even by the almost transparent frame, makes art a domain which is marginal to 'real life' occupations and hence, at least potentially, detached, independent and able to come up with fresh insights, non-functional solutions or purposeless researches.

4

The Turn to Play

Modern experiments with play presented in the first and second chapters can be interpreted as explorations of the *parergon* (margins) of traditional art, and aimed to question, challenge and eventually transform art's 'proper function'. The examples of participatory postmodern art analysed in the previous chapter indicate that external strategies of play tested by modern artists have been assimilated as part of the integral structure of many recent artworks, and acknowledged by art institutions, critics and curators as an essential part of the vocabulary or popular tactics of contemporary art. Play, from the 'dangerous supplement' of pre-modern art, has become an 'attractive' supplement in the twentieth century – a synonym for creativity, interdisciplinarity, open-endedness, flexibility and so on. The diminished importance of the aesthetic object, the outcome of the goal-oriented, preconceived artistic production (work), has exposed the notion of play – the orientation on the process, with all its unexpected consequences – as the main interest of contemporary artists. In the present chapter I briefly refer to the work/play dichotomy and argue that in the twentieth century, the traditional hierarchy of these two concepts was disturbed, with 'play' becoming significant in many contemporary practices and, in general, an important aspect of today's art and culture. I also briefly discuss the general sociocultural background of the 'turn to play', speculate about the new position of play and discuss some of its potential consequences for the status of art projects. I will also suggest that the post-structural notion of play as 'undecidable' can be seen as a criterion of 'new aesthetics'. This view enables an approach to

the projects of process-oriented art as aesthetic, not merely relational or dialogic experiences.

Attractive Supplement

In Chapter 2, paraphrasing Rousseau and Derrida, I referred to play as a 'dangerous supplement'. That was the position of play within traditional art and society: a risky and improper departure from the straight-and-narrow path of work; or a 'safety valve', a carnivalesque activity which allowed the release of pent-up and potentially dangerous energies, celebrated on clearly designated occasions and within rigid limits. This valuation of play, based upon its contrast to the sphere of 'productive' activities like work, has a very long tradition in European culture. Moreover, the most influential 'stories' of work have affected historical approaches to the 'work' (and 'play') of art.

In the Judeo-Christian tradition, work has been perceived as a punishment for the sin of the first humans. 'By the sweat of your brow you will eat your food until you return to the ground',[1] God said to Adam and Eve when he was expelling them from the Garden of Eden. Work was thus regarded as necessary for survival, but without a value in itself. A similar approach was manifested in the Greek world, where all manual labour was delegated to slaves. A free man could only 'pursue warfare, large-scale commerce, and the arts, especially architecture or sculpture'.[2] In the Middle Ages in Europe, work was still viewed as a divinely ordained obligation one could not escape, and as a way 'to avoid idleness which would lead to sin'.[3]

A new perspective on work was brought about by the Reformation. The modern approach, placing a positive moral value on work, was, to a large degree, shaped by the Protestant work ethic[4] developed by Luther and Calvin. Luther acknowledged the Catholic medieval position that 'God assigns everyone his place, and one serves God by staying in his place and not seeking to rise in the social hierarchy'.[5] Calvin, on the contrary, encouraged work in a chosen occupation if this provided an opportunity to maximize profit. However, they both treated spiritual and secular occupations as equal and proclaimed all work to be sacred. According to the 'doctrine of calling', all work is serving God on earth.[6] In effect, work ceased to be seen as a penance.

It had become positive and creative, as a contribution to the social order and as one's self-fulfilment as a Christian. Moreover, according to Calvin's theory of predestination, a moral, ascetic and hard-working life did not guarantee salvation. Work was therefore an end in itself, as an exercise in faith.[7] Roger Hill summarizes the influence of the Protestant work ethic in the West as follows:

> As time passed, attitudes and beliefs which supported hard work became secularized, and were woven into the norms of Western culture (Lipset, 1990; Rodgers, 1978; Rose, 1985; Super, 1982). Weber (1904, 1905) especially emphasized the popular writings of Benjamin Franklin as an example of how, by the eighteenth century, diligence in work, scrupulous use of time, and deferment of pleasure had become a part of the popular philosophy of work in the Western world.[8]

The phrases often used in a theoretical context to confront the spheres of 'play' and 'work' are *homo ludens* ('Man the Player') and *homo faber* ('Man the Smith' or 'Man the Maker'). This latter term was introduced in modern thought by Henri Bergson[9] and developed in the work of Hannah Arendt, among others. In her 1958 book *The Human Condition* Arendt distinguishes between three modes of *vita activa*: labour, work and action.[10] 'Labour' corresponds to the 'biological process of the human body'[11] and is the most basic, 'animalistic' effort to sustain life. It creates nothing permanent, and consists of nothing more than the ongoing struggle to maintain human physical existence. 'Work' is the fabrication of 'things' distinct from the products of nature. Action occurs in the sphere of human relations 'without the intermediary of things or matter'.[12] Man at 'work', *homo faber*, according to Arendt, 'is the builder of walls (both physical and cultural) which divide the human realm from that of nature and provide a stable context (a "common world") of spaces and institutions within which human life can unfold'.[13] As Arendt has it, *homo faber* is a 'creator of human artifice' and a 'destroyer of nature'.[14] He/she treats the world instrumentally and is confident in his/her tools. 'Work' as a productive activity, with means and ends directly connected, is the source of satisfaction and self-confidence for *homo faber*.[15] In the highest capacity *homo faber* becomes an artist. He or she then goes beyond the ordinary

utilitarian approach – 'in the case of art works, reification is more than mere transformation; it is transfiguration'.[16] According to Arendt, the 'revolution of modernity' has changed the characteristics of 'man the maker' and deprived him of 'permanent measures that precede and outlast the fabrication process'.[17] He or she becomes primarily involved in the *processes* of 'production' as a 'toolmaker', with the radically redefined category of 'usefulness'.

> Now what helps stimulate productivity and lessen pain and effort is useful. In other words, the ultimate standard of measurement is not utility and usage at all, but 'happiness', that is, the amount of pain and pleasure experienced in the production or the consumption of things.[18]

Therefore, 'making' gradually becomes something that is not necessarily material. It is a goal-oriented activity, a means to construct an object, a situation, or an institution. From the contemporary post-industrial perspective, *homo faber* is rarely a maker as a craftsman. He or she becomes rather a provider of services or a 'producer', someone who transforms already existing 'things', both in the material and symbolic spheres. The twenty-first century *homo faber* is still devoted to work as a goal-oriented productive activity, but also as an opportunity for personal growth and satisfaction – a measure of one's happiness.

In terms of *homo faber's* opposition to *homo ludens*, the former follows the rules, codes and conventions of a given reality, with actions planned in advance to reach objective goals. He or she belongs to the 'real' world, shaping it actively with appropriate 'tools'. If *homo faber* allows oneself leisure time, it is also properly structured. *Homo ludens*, on the other hand, devotes his life to dreams, fun, joy and recreation. He/she lives beyond the social structure, 'wasting' time and money or feeding like a parasite on the work of the others; he/she can get lost in the oblivion of play: 'In the moral universe prescribed by the *homo faber* model of existence, *homo ludens* appears either as an object of pity ("the workless") or as an object of allure ("leisure class").'[19] From the perspective of work and productive activities, 'play is an occasion for pure waste', as Roger Caillois writes – a 'waste of time, energy, ingenuity, skill and often of money'.[20]

The above description, of the two opposite modes of existence, is obviously both 'rational' and inspired by the Protestant work ethic. Nevertheless it continues to influence the relationship between the concepts of work and play even in today's post-industrial culture and society. Although, as Applebaum writes, there has occurred a gradual shift in values from the beginning of the twentieth century – from work to leisure, play and consumerism[21] – work still dominates play as a necessary and central field of human activity. Play is inevitably marginal, although it provides a promise of temporary freedom or escape from work's routine. In effect, in modern times, play is perceived as both 'sin' *and* 'salvation'. As Allan Kaprow puts it:

> *Play* is a dirty word. Used in [the] common sense of frolic, make-believe, and an attitude free of care for moral and practical utility, it connotes for Americans and many Europeans idleness, immaturity and the absence of seriousness and substance.[22]

One of Kaprow's ambitions, which he shared with many other modern artists, was to overcome the stereotypical connotations of play and to bring it back to life as a valuable element in society and culture, as it was seen to function in childhood and in 'primitive' communities.

This reinterpretation of play was related to the fascination with 'primitive' art as a model of art's deprofessionalization, offering the possibility of transgressing the deep-rooted identification of Western artists; but also, to a large degree, by general changes in the spheres of economy and production. With the growth of mechanization, the dominant notion of human work as 'physical labour' has been transformed. The development of the entertainment industry in the postwar era contributed to further changes of the notions of work and play in human life. The particular activities which today we treat as play or work differ in many cases from their pre-modern equivalents. As Brian Sutton-Smith puts it, 'these days we "play" at hunting, fishing and boating; while we "work" at group creativity, synectics, and divergent thinking'.[23] However, the approach to work as *ergon* – the proper function of a given object or activity, aimed at an output indicated in advance – is still applicable. It refers to the 'frame', not to the content. Consequently, play can still be described as an activity

performed 'outside the work' (*para ergon*), for its own sake, in between two realms and two sets of rules.

Art has been traditionally conceptualized within the discourse of the proper and the marginal. The conventional – peripheral, outcast – position of play and the history of its (re)discovery by modern artists, can be read according to the logic of supplementarity. Play, in modern art, operates as its embodiment in Derrida's text – the god Thoth, who 'is opposed to its other . . . but as that which at once supplements and supplants it'.[24] 'Pre-rational' play was seen by the avant-garde artists as opposed to its 'other' – work (the conventional, 'rational', aesthetic production of representations). However, play cannot be offered as an innocent gift, an external remedy, because it already belongs to the system and shapes it. Nonetheless, to preserve its (non-)identity is to treat it as an 'outsider' of this system, like the joker in the deck of cards. The danger of the play supplement comes from the fact that as an external/internal force, it influences the 'essence' (*ergon*) of art, questions its identity – which is traditionally 'opposed' to play – and challenges the whole hierarchy of central and marginal values: 'The *pharmakon* is that dangerous supplement that breaks into the very thing that would have liked to do without it yet lets itself *at once* be breached, roughed up, fulfilled, and replaced . . .'[25]

The agenda of modern art was exactly to violate the old system, to replace the old conventional aesthetic 'production' with the new, exciting and unpredictable 'play' of art. For the avant-garde artists play was not the threat – they eagerly welcomed the possibility of revolution. Play was therefore an attractive model, strategy, metaphor or supplement to expose and to experiment with. However, it was not possible to simply overturn the hierarchy and make play a new *ergon* of art. Play cannot be fixed, reduced to a desirable set of characteristics or prescribed as an everlasting 'potency pill'; play implies the ongoing movement, change and shift of perspectives. From an external strategy and tactic, play has, perhaps, become art's methodology, but not its main function or purpose. This function can be very work-like; it can be aimed at transforming relations between individuals, the conditions of social exchange, ecological or political awareness and so on.

I think that modern artists, as the 'avant-garde' term suggests, were operating on the edge between *ergon* and *parergon* of traditional art. They had a unique chance to experience 'the moment of play'

before their experiments crystallized into new conventions. 'Dada cannot live forever'; this proved to be true, but the playful strategies of Dada and the movements which followed have been assimilated in art, education, science, politics and so on. We can easily apply the model of RPGs to analyse contemporary art practices. Play has become a positive concept, ticking many boxes in the agenda of contemporary art. In today's jargon of art and academic research, to be 'playful' means to be creative, interdisciplinary, flexible, independent and open-minded, and this is what every artist and researcher wants to be.

The revolution carried out by the modern avant-gardes disturbed the hierarchy of the traditional main body and the supplement of the concept of art, and has contributed to the change of accents and valuations. The position of play within the concept of art has evolved, at least from the 'dangerous' to the 'attractive supplement'.

Play as Reality

The similar process of the growing position of play can be observed from a broader sociocultural perspective. In the traditional view, play is described as an experimental behaviour detached from real-life goals and consequences, performed in a 'safety mode'. Reality, with its objectives, seems to be a static and unquestionable point of reference, dominant over the whims and exercises of play. An account challenging this perspective comes from the works of Hungarian-American psychology scholar Mihaly Csikszentmihalyi, who notes that this division between play and reality locates play as marginal in human life – as primarily an occupation of children.

> And because children are dependent on adults for survival, the goals and activities they take seriously have acquired a second-class status relative to the doings of adults. Similarly adult play – from chess to rock climbing – is seen as a relatively frivolous enterprise, leading a parasitic existence made possible by earnest productive activities. We are constantly being reminded of the ant and the grasshopper.[26]

Csikszentmihalyi questions the view of reality as an 'invariant external structure'. According to him, 'reality' is relative to the goals and rules

created in the given culture. In other words 'reality', to some extent, as play, is a matter of context.

> It is true, of course, that basic human needs and instincts do suggest a more or less universal set of goals, which in turn help to establish a structured reality in our consciousness. . . . But this does not mean, as the dogma of adaptation would have it, that people always submit to the deterministic rules of the reality they have constructed. What play shows over and over again is the possibility of changing goals and therefore restructuring reality.[27]

Csikszentmihalyi's proposition aims at reframing our approach to 'reality' to make it a more flexible concept open for negotiation and change. He argues that self-actualization and 'peak' experiences such as 'flow'[28] (total immersion in the given activity) are possible not only in play, but also in other spheres of life.

From Csikszentmihalyi's perspective, play is 'a state of subjective experience' and can exist only when there is an 'awareness of alternatives' concerning goals and rules. Although play operates always with two sets of goals and rules (of the given 'reality' and of play), none of them should be 'attributed a higher epistemological status'.[29] They both can be treated (at least to some extent) as interdependent frames to be moved around and arranged in various configurations.

According to Chris Rojek, one of the modern attempts to prioritize play – Huizinga's theory that culture is *sub specie ludi*[30] (that play precedes culture) – has indeed challenged the valuation of play which subordinates it to work. However, Rojek questions the rhetoric of the 'overturned' hierarchy promoting play, and challenges the contemporary view of leisure as 'freedom', 'choice' and 'life-satisfaction'. According to him, non-work activities are inscribed within the net of social, political and economical interrelations, so the freedom of leisure must be seen as utopia:

> In much of our leisure experience we are unsure whether we are satisfied or not; and the freedom and choice that we have is obviously contingent upon place, time and, above all, actions of others. Rather like the concept of utopia, leisure seems to be one place on the map

of the human world where we are constantly trying to land, but which perpetually evades our reach.[31]

Although play/leisure has become a highly desirable reward for everyday effort, and to a large degree a purpose of work (which can be seen as a reversal of the old dichotomy), in Rojek's view it operates as a myth in the contemporary world; a dream that can never be fulfilled, because the freedom is always precisely dosed. He argues that the problem arises from 'the age-old conflict between agency and structure. In pursuing our various projects of freedom we realize that our concept of freedom is itself socially constructed and therefore carries with it particular constraints and limits.'[32]

The image and expectations of work and play existing in the given culture are always connected with the characteristics of this culture. Performance and representation of work and play differ according to place and time, and the dominant outlook of that place and time. According to Rojek, 'under capitalism and modernity strong tendencies existed to associate leisure with "real experience", release, escape and freedom'.[33] This view shows the ambivalent character of play, stretched between freedom and frames; fantasy, aspiration, dream and 'real experience'.

From yet another perspective, this 'real experience' achieved through leisure, play/game or entertainment in our contemporary culture can be described, after Jean Baudrillard, as 'simulacra':

Today abstraction is no longer that of a map, the double, the mirror, or the concept. Simulation is no longer that of a territory, a referential being, or a substance. It is the generation by models of the real without origin or reality: a hyperreal.[34]

Baudrillard suggests that Disneyland is a 'perfect model of all the entangled orders of simulacra, "play of illusions and phantasms"'.[35] The experience of being within the 'hyperreal' world, be it Disneyland, computer game, 3D movie or internet relationship, seems to be an elevated form of reality – exciting, answering one's needs and fulfilling dreams. As a fiction (representation) without origin it evokes states of longing and expectations of reality to become 'hyperreality' – a better place to live. However, one must be aware that there is

another name for 'hyperreality' as we experience it today – a 'matrix' – a threat to one's own agency and freedom, since every form of 'simulation' that one can experience has been created with a certain purpose (commercial, political, etc.) as a more or less veiled form of manipulation. While entering someone else's game – in popular culture, entertainment or art – players must be aware that to some extent they become already programmed figures on a board. 'Real experience, release, escape and freedom' are illusory; they just belong to a different 'structure' than the everyday one, but are no less subject to it.

Each of the contemporary views of play and its various aspects in sociocultural life and the general cultural and philosophical 'turn to play' discussed above find its representation in artistic practices: positions of affirmation or contestation, such as experiments with (group or individual) identity (through role-play); attempts to revive direct inter-human relations and to escape the consumerist Disneyland mode of cultural exchange (through community workshops, collaborative events enhancing viewers'/participants' own agency); subversive and critical uses of computer games, and so on. This interest in play has also been confirmed by the 'art world': critics, curators and writers, institutions and funding bodies influencing politics of art.

The Turn to Play

Richard Jochum, Austrian artist and philosopher, in the text accompanying his *Playground* (2005) exhibition writes:

> Playground is not just a title referring to some of the exhibited 'games', the title also exemplifies a certain understanding of contemporary art which is not just a practise [*sic*] of producing more and more beautiful images but a cultural activity busy with creating playful concepts to deal and cope with reality every day. More over: while artists enjoy a freedom of expression that is extraordinary, the price to do so is remarkably high: Their work is just a game, their exhibition a 'playground'.[36]

Although Jochum's description of contemporary practices remains valid, and artistic play-like activities are still often approached with

caution by the wider public, the term 'playground' has become a buzzword within the art world. The theme of play in the contexts of art, media and culture keeps reappearing in formal and informal conferences, workshops, symposia and web-based activities, such as: 'The Aesthetics of Play', a conference held in Bergen, Norway, in 2005; 'Play Conference', a two day international, interdisciplinary conference hosted by the School of Literatures, Languages and Cultures at the University of Edinburgh (2008); 'The Art of Democracy – Mobile Conference', a 2009 event organized by the South London Gallery (SLG) and Peckham Space, exploring play, democracy and contemporary art in the public realm; 'Tactical Play', a one day colloquium for artists and social scientists about playful enquiry as a tactic for research hosted by the Birkbeck Institute for Social Research, University of London in 2009; the ongoing research project 'The Play Ethic' incorporating a website (www.theplayethic.com), podcast and publications; the international conference on 'Trickster Strategies in Artists and Curatorial Practice,' held by Wroclaw University's Institute of Art History in Poland in 2011; or 'The Rutgers Media Studies Conference: Extending Play' (2013).

To be playful or to use playful tactics has become a fashionable and widely approved approach. It signifies an orientation towards process and experimentation, the ephemerality and open-endedness of the works. It therefore fits within 'New Institutionalism', a recent trend in curatorial and museal practice aimed at transforming art institutions into 'part-community centres, part-laboratory and part-academies'.[37] As Claire Doherty writes:

> New Institutionalism is characterised by the rhetoric of temporary transient encounters, states of flux and open-endedness. It embraces a dominant strand of contemporary art practice – namely that which employs dialogue and participation to produce event or process-based works rather than objects for passive consumption.[38]

According to Doherty, transformation of the conventional gallery or museum (a showroom) into a social space may cause 'a risk of creating a new set of conventions – the convention of role-play or prescribed participation'.[39] Nonetheless, the big international art events, curatorial shows, biennials and triennials which take place

around the world promote works and projects that follow the agenda of participatory, interactive, process-oriented and playful art.

Even the Venice Biennale can serve as an example. Although curatorial exhibitions are still to a large degree selections of traditional works, many of the prizes awarded by the jury in recent editions honoured the artists and curators focused on process, relations and narrations instead of aesthetic production. In 2009 the Golden Lion for the Best Artist in the *Fare Mondi/Making Worlds* exhibition went to Tobias Rehberger 'for taking us beyond the white cube, where past modes of exhibition are reinvented and the work of art turns into a cafeteria. In this shift social communication becomes aesthetic practice.'[40] The same year, curators of the Danish and Nordic countries' pavilions were honoured with a special mention for 'reimagining the national pavilion as a collaborative universe',[41] using art and design objects, painting, sculptures, installation pieces and furniture by numerous artists to create two interiors with the feeling of mysterious film sets, inhabited by imaginary characters. The artworks served only as props and parts of the interior design and were subordinated to the fictional world. The curators acted as game masters and invited the visitors to explore the narrative spaces, where they could hang out, relax, watch videos and try to decipher the stories behind the setting.

The rhetorics of play-*parergon* have entered the discourse of contemporary art for good. To 'occupy marginal spaces', to 'operate in between' sets of rules, 'realities', conventions and to 'generate temporary communities' – these are just a few of the many recurring phrases which describe recent works in a variety of styles and media. All of them may be interpreted within the notion of play, even if it is not the conscious intention of their authors. Cultural theorist (and juror at the 2009 Venice Biennale) Homi K. Bhabha, in his 1994 text *Border Lives: The Art of the Present*, indicates the desirability of engagement with cultural processes as a strategy which promises to enable us to venture beyond well established identities and hierarchies of binary oppositions:

> What is theoretically innovative, and politically crucial, is the need to think beyond narratives of originary and initial subjectivities and to focus on those moments or processes that are produced in the articulation of cultural differences. These 'in-between' spaces

Figure 8. One of the interiors of the Danish and Nordic countries' pavilions, Venice Biennale, 2009, photo by Katarzyna Zimna

provide the terrain for elaborating strategies of selfhood – singular and communal – that initiate new signs of identity, and innovative sites of collaboration, and contestation, in the act of defining the idea of society itself.[42]

The tactic of play, as operating 'in between', has become a general cultural trend, not just in visual art. Zygmunt Bauman describes it as follows:

I propose that in the same way as the pilgrim was the most fitting metaphor for the modern life strategy preoccupied with the daunting task of identity-building, the stroller, the vagabond, the tourist and the player offer jointly the metaphor for the post-modern strategy moved by the horror of being bound and fixed.[43]

All the metaphors used by Bauman can be attached to the contemporary artist who explores the regions which used to be peripheral to the artistic profession. 'Artist the Player', like Bauman's tourist, 'is

the conscious and systematic seeker of experience ... of the experience of difference and novelty.'[44] However, these pursuits are not always systematic. The artists often immerse themselves in the flux of events, in the narratives they encounter; they let things go, improvise, affirm ephemerality and ambiguity.

To be on the move, to be outside, on the margins of, or in between the dominant narratives of power, in cultural, social, political or economical realms, has become the 'proper' space of the artistic activity. The 'margins' of social life are treated as points of departure to pose essential questions. Paradoxically, occupying the 'interstices' of human relations means being at the centre of contemporary discourses on art and culture. It seems, therefore, that the 'marginal' (ephemeral, dialogic, relational, collective, etc.) practices of Deller, Tiravanija or WochenKlausur, among others, have become central to the very notion of art, negotiated and accepted among artists, critics, curators, theorists and cultural workers, representing big institutions, as well as independent galleries, foundations, collectives and so on. The marginal, in other words, has now become part of the establishment.

Can we therefore locate play as the *ergon* (proper and accepted function) of recent art? According to Claire Bishop, 'This mixed panorama of socially collaborative work arguably forms what avant-garde we have today: artists using social situations to produce dematerialized, antimarket, politically engaged projects that carry on the modernist call to blur art and life.'[45] In her essay she lists projects like 'Jeremy Deller's *Social Parade* for more than 20 social organisations in San Sebastian (2004), Lincoln Tobier's training local residents in Aubervilliers, north-east of Paris, to produce half hour radio programmes (*Radio LD'A*, 2002) or Lucy Orta's workshops in Johannesburg (and elsewhere) to teach unemployed people new fashion skills and discuss collective solidarity)'.[46] In terms of play, these projects would fit into the image of play as a process supporting human development, one that is necessary for building competence and social skills. This would be play utilized in education, in creativity and psychological workshops; play promoting progress, the good play accepted by Plato in his ideal state and by every parent, happy that a child plays *and* learns at the same time. But is it play? Or is it play 'decided' as constructive, educational and *productive*, despite the promise of disinterestedness,

open-endedness and a lack of predetermined outcomes? A play-like version of work?

Maybe the proper function of today's art is work, just a different kind of work (or, to use Marxist terms, a 'non-alienated' work or 'self-activity')[47] – a socially, culturally and politically engaged work, which produces new models of interhuman relations. But why is it so difficult to approach these new models as functional propositions, not just ephemeral play situations, representations of authorial micro-utopias? Why is it that the roles of the artist – social worker, researcher, anthropologist, supernova hunter – seem to be *only* roles, temporary identities or characters in his or her games?

Paraphrasing Chris Rojek, it can be said that play is 'the place on the map of the human world artists are constantly trying to land, but which perpetually evades their reach'[48] precisely because any attempt to incorporate play immediately turns it into a strategy, tactic, method or tool. Widely assimilated and accepted by institutions, artistic tactics of play risk losing their revolutionary character and becoming predictable and didactic.

Is it possible at all to avoid such ossification of play? Subversive play can be found among artistic activities not yet 'swallowed' by the official art world – outside the institutions, in urban performative and locative games and critical computer games, for example. Playful artistic guerrilla is often performed by groups and collectives such as Clandestine Insurgent Rebel Clown Army or Blast Theory among many others; Mary Flanagan in her 2009 book *Critical Play: Radical Game Design* gives many examples of these kinds of projects.[49]

Here, I would like to point out one common feature of subversive play characteristic of the aforementioned activities as well as of other forms of independent (avant-garde?) contemporary art – that of dysfunctionality. As analysed by Marie-Laure Ryan,[50] dysfunctionality is a disruptive tactic used in various ways and contexts by artists to articulate political, social or philosophical messages or just to express their resistance towards official and dominant power. Ryan discusses dysfunctionality with reference to digital art, and she lists four types of this tactic: political, ludic, programmatic and inadvertent. Ludic or playful dysfunctionality 'grows out of the question: what can I do with this technology, other than what it was meant for?' This question can be extended to other media, activities and objects as well. If we

consider the question asked by the artist as player (*homo ludens*) – 'what can I do with this other than its "proper function" (*ergon*) of...suggests? How can I play with this function, rule, procedure, convention?' – we can see the value of the concept of ludic dysfunctionality. This approach, applied in digital art – dysfunctional computer games or interactive platforms – can be seen as a contemporary continuation of the Dadaist philosophy of chaos and the absurd, as expressed most famously in Marcel Duchamp's urinal. Ludic dysfunctionality, therefore, can be considered 'the negation of real-world practicality and the creation of a new functionality – the autotelic and self-reflexive functionality of art'.[51]

Portable Frame

It cannot be said that play has become a new *ergon* of art, because for it to be so would annihilate the concept of play. Nonetheless, the production of alternative human relations and modes of interaction between people and their environment – presumably the basic intention of today's process-oriented art – is strongly dominated by the operation of play. It seems that many members of the art world would like to locate play (the 'undecidable') as the central value, the main body of art, but this is not possible. 'Playing is really sinning', as Kaprow wrote; it is the luxurious, decadent ability to sport freely beyond rules and conventions (and this is why it is so attractive; it is a transgression). Contemporary artists try to avoid bonding statements and they try to balance the requirements of the phantom idea of work and promises of the liberating but elusive idea of play. Nonetheless, art has to be productive, goal-oriented and has to leave traces, even if they are ephemeral, fleeting, subtle or almost transparent. Art has to act 'as if' it is a serious adult occupation and to rationalize and contextualize the 'pleasurable and unproductive states of uncertainty and indecision'.[52] However, play simply cannot be fixed as *ergon*. It can be tried on in different configurations and contexts as a temporary strategy, gesture or side-effect, but it cannot become an ultimate purpose of the artistic activity. Moreover, as Norman Denzin writes,

> Persons as players...are always at the edge of moving into the
> moment of play. This moment is always in front of them, and yet

as they move forward into it, they are moving from it. Play, to use William James's (1890) term, is always on the player's horizon.[53]

The most characteristic and efficient function of play in cultural and artistic contexts is therefore to be an unexpected force, a movement in between solid positions, outlooks and methods, hiding in marginality as an attractive supplement measured out in careful doses. Nonetheless, it is quite tempting to see the operation of play in the last century as challenging the whole structure of *ergon* and *parergon*, and questioning the singularity and authority of one 'proper function', one master narrative of artistic activity as a whole, but also of particular artistic forms or individual practices.

Consequently, the most functional perspective while looking at the contemporary position of play is to stick to the notion of *parergon* as a frame. However, the modern revolution shifted the attention from the frame as an ornament and supplement of the main body of work, to the frame as a 'portable device', useful to define some objects and situations as 'art'. With time, the symbolic 'frame' has become the necessary and the only determinant of art. Any object or situation can become art; it is just a matter of context, or frame. From this perspective, play remains *parergon*, a frame, a metacommunicative activity: the border *and* the bond between different 'realities', or 'reality' and 'fiction': the condition for representation. Play as a 'frame' is at once limiting and liberating, as it applies a new set of rules to the framed reality, but at the same time allows for transgressing or suspending the 'original' proper function of this reality, the well-established rules and conventions.

Ergon, in this new configuration, emerges from the specific 'reality' that is being framed. It can be seen as a 'pretext' for entering this reality through the artistic process. It therefore changes from project to project; it does not 'define' the concept of art. However, as a purpose of the particular project, an operation of the given reality, it is indispensable to the production of representation. It can be compared to the Derridean notion of the decentred structure, in which 'the centre had no natural site, that it was not a fixed locus but a function, a sort of non-locus in which an infinite number of sign-substitutions came into play'.[54]

When we look at play-*parergon* as a frame, a 'context' set up by the artist, and when *ergon* becomes conceptualized as a 'pretext' for the

artistic intervention or the act of artistic representation, the art process, the *synergy* of 'pretext' and 'context', can, consequently, be referred to as a 'text'. It resonates quite well with Roland Barthes' description of the text in *From Work to Text* (1971).

> The Text (if only by its frequent 'unreadability') decants the work (the work permitting) from its consumption and gathers it up as play, activity, production, practice. This means that the Text requires that one try to abolish (or at the very last diminish) the distance between writing and reading, in no way by intensifying the projection of the reader into the work but by joining them in a single signifying practice.[55]

Writing and reading, working and playing, the activities of artists and viewers coexist together in the text – one common 'game session'. The work (artwork) emerges in writing *and* reading, in 'being played'.

The act of framing, the playing with the 'pretext' (*ergon*), cannot be mechanical and the frame cannot be seen as an authoritarian statement: 'this is art'. The frame of art modifies a chosen fragment of reality by framing it, but this chosen reality also influences the character of the frame. In other words, artists apply their perspective, intentions and ideas of the specific project to the selected place or situation, but they also research this 'place', they get to know its rules and inhabitants. Their own viewpoint shapes the character of the artistic encounter, the act of framing, but it must be a mutual interaction. The character and form of the frame (of the artistic tactic, means and tools) depends on the structure, rules, needs, functions and narratives belonging to the 'arena' chosen to be framed. The artistic frame can be a 'relaxed' one, open for the unexpected, prepared to let things go, or it can be pre-defined and shaped by the clear authorial intention, the rules of the 'game' invented by the artist.

Play as a portable *parergon* and work as *ergon*, a rule-structure of the given 'reality', collectively shape the contemporary experience of art. It can be, however, difficult to determine which one is the main body and which is a supplement within the process of representation. I think it is best to regard them as equal elements 'working and playing' together.

Play and Aesthetics[56]

The new forms of recent art, discussions of representation and the general cultural and artistic 'turn to play' inevitably provoke questions concerning the criteria of evaluation. What makes a successful/ good/valuable art project? Should it be assessed in terms of ethics or aesthetics? According to Claire Bishop, 'The social turn in art has prompted an ethical turn in art criticism. In other words artists are increasingly judged by their working process – the degree to which they supply good or bad models of collaboration. . . . '[57] Meanwhile, the question of aesthetics is left aside.[58] The 'ethical turn' means that artists and critics focus their attention on the aspects of the projects which aim towards or can be seen to possess some social usefulness. Participatory art and its rhetorics are being used as tools to support democracy, equality and human rights. They offer participants the 'experience' of enhancing human bonds or the participants' own agency, instead of the authorial interpretation or representation of reality, because 'representation' has been discredited in post-modern and post-colonial thought as authoritarian. As 'relational' artist Pierre Huyghe puts it, 'The question is less "what"? than "to whom"?'[59] In her essay, Bishop mentions the Turkish artists' collective Oda Projesi, which works with groups of adults and children in their immediate environments and bases their projects on the decisions 'about where and with whom they collaborate'. The artists, interviewed by Bishop, referred to 'aesthetic' as a 'dangerous word'.[60] It seems that from the perspective of process-based, socially oriented contemporary art, aesthetics becomes a new 'dangerous supplement'. The anti-representation agenda, the call to blur art and life, pushed the problem of the 'aesthetic' to the margins of art, treating beauty and sublimity as ornaments distracting the public from the real value of art projects.

However, I do not think that a productive or enjoyable 'game session' or community project led by an artist automatically qualifies as art. Aesthetic value has to be inscribed within the products and processes of art, no matter in what form. Avoiding aesthetic decisions makes these events didactic; they lose their artistic potential and in consequence the ability to stand out from politically or otherwise-motivated public events. They simply follow one agenda; are located 'here and now' without any sort of aesthetic distance. The more

complex relation of art projects to 'reality' marked by the presence of the aesthetic frame demarcates art, at least potentially, as a domain detached and independent from the conventions of 'real life', and hence able to come up with fresh and inspiring insights. As Bishop suggests, the elements of 'respect for the other, recognition of difference, protection of fundamental liberties' which are often part of process-oriented or participative art should not exclude the possibilities of 'discomfort and frustration – along with absurdity, eccentricity, doubt, or sheer pleasure', which can be 'crucial elements of work's aesthetic impact'.[61] Her proposition provokes questions about the contemporary interpretation of aesthetics. What are the criteria for the aesthetic judgement of works that are no longer material objects but are rather interwoven in the 'social fabric'? How can we inscribe the notion of play within the discourse of contemporary aesthetics?

I argue that the post-modern, post-structural reading of the concept of play-*parergon* as 'undecidable', following the writings by Jacques Derrida, can be taken into consideration as a condition of the 'new aesthetics'. The main characteristic of play (as post-structural philosophical concept and empirical activity) is that it always refers to 'something else'; that it always evokes double or multiple frames of action or layers of experience. Play is always 'at the same time in and out of reality'.[62] Play as aesthetic criterion can be best explained as 'playing with reality', with social situation, rules, concepts and narratives. Artistic creation and aesthetic judgement are not disinterested; they create an alternative reality that temporarily subverts the rules and logic of everyday routines and the conventions of social exchange. Artists using play as a powerful tool of ludic dysfunctionality create and implement their own rules as refreshing deviations from the standard rules and characteristics of specific situations, places or objects. In order to achieve this state of 'playing with reality', they have to engage with the rule-structure of the given reality. Such engagement eliminates the risk of aesthetic alienation. Play as an aesthetic criterion, instead of beauty or sublimity, is achieved only when there is a relation of constant exchange and tension between the situation of art and the reality (pretext) that is being questioned, subverted or just slightly and temporarily modified.

'Playfulness' does not imply simply mocking reality in a frivolous way. The modes of 'playful' engagement range from improvisation to

analytical research; they can be sensual, emotional or intellectual. They can take the form of ephemeral interventions as in the actions by Polish performer Cezary Bodzianowski or British group Blast Theory, in the tradition of the Situationists, or introduce the permanent presence of the critical voice, as in the case of the public artwork *Greetings from Jerusalem Avenue* (2002) by Joanna Rajkowska. This latter artist placed a life-size artificial palm tree on the traffic island at the junction of Aleje Jerozolimskie (Jerusalem Avenue) and Nowy Świat (New World Street) in Warsaw. The project is not participatory or process-based *per se*, but it can be described as relational. It enters into dialogue with the public, the residents of Warsaw, through the choice of location and the intention of introducing social change. As we can learn from the project's website, its origins date back to the artist's journey to Israel in 2001 and her subsequent attempt to bring public attention 'to the significance of Jerusalem Avenue to Warsaw, the street's history and the vacuum caused by the absence of Jewish community. It was supposed to be also a social experiment, testing whether the Polish society was ready to absorb such a culturally alien item. The spot at which the palm has been placed before the year 2002 had been used for a Christmas tree.'[63] This project's strength lies in its aesthetic impact, which derives from its playfulness; interpreted here as a movement in between different realities and meanings, as undermining the status of the given reality as the only possible and right one. The palm acts as a question mark in the Warsaw panorama, provoking, irritating and initiating dialogue.

Carsten Höller's installations utilize yet another aesthetic dimension of play addressing the aspects of human perception, states of vertigo, disorientation, pure sensual joy or anxiety. Works such as *Upside Down Mushroom Room* (2000), *Mirror Carousel* (2005) or *Test Site* (2006) enabled viewers/players to immerse in playful activities within the gallery space. *Upside Down Mushroom Room* as the title suggests was the room filled with upside down, slowly turning giant imitations of red and white flyagaric mushrooms lit from underneath. Viewers could spend their time sitting or lying on the floor and gazing at the hallucinatory objects, feeling like Alice in Wonderland. The artist's intention was to reflect on experiencing things in a different way – as when triggered by drugs, or by art. In consequence this work, playing with perception, elicited doubt about the foundation of the

experience of reality and consequently of one's interpretation of the experience. *Mirror Carousel* and *Test Site* directly rferred to the status of contemporary artworks as play devices to be used, not just looked at, by offering a ride or a slide in a quite unusual context. The artist created these playgrounds to transport gallery goers to the world of childhood memories, but also to test their reactions and behaviour.

Test Site has become especially famous, due to its size and location (huge steel slides installed in the Tate Modern Turbine Hall in London) as an artwork challenging the contemporary definition of a gallery but also of an aesthetic experience. The participants experienced the well known activity of sliding as something uncanny[64] (familiar and unfamiliar at the same time), that may have triggered reflection, surprise and change of perspective.

> For Carsten Höller, the experience of sliding is best summed up in a phrase by the French writer Roger Caillois as a 'voluptuous panic upon an otherwise lucide mind'.... What interests Höller, is both the visual spectacle of watching people sliding and the 'inner spectacle' experienced by the sliders themselves, the state of simultaneous delight and anxiety that you enter as you descend.[65]

The experience of sliding, situated in such a specific context, had a chance to become an 'aesthetic experience' – 'the experience' perceived differently and more intensively than the usual activity of sliding at the playground or in the amusement park. There also emerged the possibility for a double plane of action in play – the actual joyful and fearful act of sliding and the artistic meta-narration providing the new context. Projects like this have a 'transporting' play-like dimension – they provide the participants with an experience that supports unique perceptual, emotional or intellectual discoveries.

The new aesthetics based on play is inclusive of the notions of indeterminacy, ambiguity and change, collective or anonymous creativity, and being 'in between' the dominant narratives of power. Importantly, the element of play, interpreted this way, guarantees that art does not become alienated from goal-oriented reality and from immediate experience. Art becomes a process of playing with reality, never absolutely engaged with its goals nor indifferent to them. This is, in my view, the crucial difference between art and activism. Art

occurs in the play mode, but this play can be serious, challenging and subversive.

The aesthetic criterion of play challenges the politically correct rhetorics of recent participatory art. Play (and art) cannot serve external rules; they exist in between various 'realities', including political systems and regulations. Therefore, 'playful' art cannot be decided as a tool of either democracy or authoritarian control. It is also never totally independent from the political or any other reality. Art has to respond to the rules of a given political and social system *and* play with them, testing different outlooks. Participatory art loses its aesthetic potential when it is fixed and categorized in political terms; its ability to be subversive lies in its play-like ambiguity. Play as the 'undecidable' is unpredictable and not innocent, with the power to transform the social realm and to undermine the *decorum* of any situation from within.

The importance of play as a crucial element of 'new aesthetics' can be summarized by the motto of UK based art collective The Clandestine Insurgent Rebel Clown Army: 'We are circa because we are approximate and ambivalent, neither here nor there, but in the most powerful of all places, the place in between order and chaos.'[66] The play of art initiates the journey in between order and chaos, reality and potentiality, 'here' and 'there', I and the Other, real and make-believe, serious and non-serious. As Bishop suggests, it can evoke frustration, as well as confusion or enchantment. However, most importantly, play initiates *movement*: it sets ideas, concepts, thoughts, images and identities in motion. And it is difficult to imagine a better starting point for revolution and social change.

Conclusion

This book's primary aim was the development of a perspective on play that could be effectively applied in the context of art. With the help of this redefined notion of play, I then proceeded to address two further issues – the use of play as a rhetorical tool in the discourse of artistic representation and as a creative strategy or tactic in twentieth and twenty-first-century art.

Play turned out to be an elusive, ambivalent term and, according to Spariosu, subject to interpretations structured by rational or pre-rational rhetorics in Western thought. Pre-rational play appears as a vital, excessive 'manifestation of ceaseless physical Becoming',[1] freedom and chance. Rational play, in turn, is narrated as a non-violent work-like activity, limited by rules and conventions, supporting sociability and communication. However, I argued that it is best to approach play as a concept based on contradictions rather than to reduce it to just one aspect of its character which fits into one's predetermined outlook. This view proved to be helpful because it enabled me to identify narratives and 'persuasive discourses' behind the actual uses of play in art theory and practice, and to negotiate between different perspectives. Depending on the given rhetoric, play has been located as dominant or marginal in relation to the 'opposite' concepts like 'reality', 'game' and 'work'. I focused primarily on the notion of work, as the terms 'making', 'production', 'tools' and 'work of art' belong to the traditional vocabulary of art and culture.

I argued that the traditional approach to artistic representation has been grounded within the concept of work as *ergon* – a 'proper

function' or activity. This classical notion, developed by Plato and Aristotle, connotes hierarchy, order, permanence, structure, stable identification, determination and purposefulness. It is the activity of the self-conscious *homo faber* who, with the use of proper tools, creates the human-made world as imitation or transformation of the natural world. Play, as it does in social life (in Western culture influenced by the Protestant work ethic), acts as a supplement to the dominant *ergon* – it is a desirable but temporary relaxation. When excessive it can be dangerous or destructive for the dominant order. To contextualize the role of play in art I used the notion of *parergon*, applied originally by Kant to describe an ornament, a drapery or a frame that supplements the work of art. However, according to Derrida, the supplement is not simply external or marginal to the main body of work but in some sense its condition; there is a structural link between them. Derrida highlights the essentiality of *parergon* to the constitution of the identity of *ergon*. The supplement is therefore threatening, dangerous, because it shows the incompleteness of the 'main body' and exposes the fact that its identity is deficient or non-existent without the supplement. Play-*parergon* emerges perhaps as dangerous but ultimately as the indispensable supplement of the artistic *ergon*, and consequently as an essential element of the concept of art. It plays with the functional and purposive *ergon* through challenge, parody, experiment and subversion.

The metaphor of *parergon*, which in Derrida evokes further connotations of *passé-partout*, master key and passport, *pharmakon* and *pharmakos*, exemplifies the characteristics of play that I find relevant in the context of art. Play as *parergon* can be read after Derrida as 'undecidable' – as lock *and* key, locus *and* movement, here *and* there, inside *and* outside. Therefore, play cannot be reduced to just one interpretation according to the given rhetoric; it does not have a stable identity or a proper function. It is 'pre-rational' *and* 'rational' – it operates 'in between' these poles. This ability of play to be 'something *and* something else', to link disconnected elements, makes play-*parergon* a condition for the creation of metaphors and, more broadly, the trigger for representation.

Instead of the metaphysical *allergy* between work and play (*ergon* and *parergon*), I have suggested the necessity to consider art as a conceptual and performative *synergy* (working/playing together). This allows us

to look at work *and* play as indispensable and equal elements, and to overcome the rhetoric of supplementarity. However, when we approach art and aesthetics from a historical perspective it turns out that in actual theory and practice the marginal position of play has been taken for granted. Artists either ignored the operation of play or, as in the case of modern avant-gardes, tried to overturn the hierarchy with the use of play as an external strategy, a remedy for the traditional *ergon* of art and representation. What is more, play has been used as a rhetorical or creative tool to serve specific needs and to support specific outlooks – either 'rational' or 'pre-rational'.

I argued that these two poles of the concept of play proved to be supportive of two opposite models of the aesthetic experience, two approaches to the idea of artistic representation. The rational model (discussed in reference to Kant's theory) assumes the primacy of the subject (player) over the artistic process (play). Although disinterested and not productive of concepts, this 'rational' play appears to be very work-like – it acts as an inner, reliable mechanism of art that allows for the harmonious collaboration of cognitive faculties of imagination and understanding. It guards the possibility of universal communication and prevents excessive freedom of imagination as personal nonsense. I argued that the 'rational' play in Kant, similarly to work-*ergon*, acts as a leading principle of the traditional notion of representation.

'Pre-rational' play, after Gadamer, can be seen as a metaphor for being – an original experience/understanding in which things (beings) are revealed to the subject. Consequently, such play dominates the players/participants who are not in total control of their experience. Play is no longer a subjective negotiation of rules and modes of behaviour; it is rather the 'mode of being of the work of art'. Art, instead of representation, becomes a manifestation, a 'presentation' of life, reality and natural powers. Unlike traditional representation this approach does not focus on artworks – regarded as detached and fixed objects – but on the processes that occur 'in between' artists, artworks and viewers. The 'pre-rational' play of art entails the promise of non-representation – unmediated experience in the situation of art, beyond subjective control.

In the artistic practice and art theory of the twentieth and twenty-first-centuries, play, interpreted in most cases as pre-rational, has served

as a tool to oppose the traditional *ergon*-like notion of representation. The Kantian idea of art as autonomous from reality, and as a manifestation of the subjective will to control, became a matter of contestation in modern avant-garde movements. Artists reached for the concept of play, but specifically 'pre-rational' play, to bring art back to life as a meaningful experience – not a traditionally interpreted 'representation'. This strategy was directed against 'high' and academic art and the 'proper function' of the artist and the viewer.

I argued that the emergence of play as an external creative 'strategy' was catalysed by the modern fascination with 'primitive' art and the rhetoric of Primitivism in particular. I discussed the Primitivist approach as supported by pre-rational outlooks on play and the metaphysical myths of origin and of presence. Both play and the creative process in savage art were treated by modern avant-gardes as unmediated experience – unconscious, anti-intellectual, anti-rational and innocent. The Primitivist myths located these two 'pre-activities', the sources of untamed creativity, as more valuable than traditional, rational, rule- and convention-bound representation. Due to his or her 'strategic' encounter or even identification with the Other (the savage artist, the child or the insane person), the modern artist could have arrived at non-rational states of mind, productive of anti-intellectual, sensual art. The Primitivist Other gradually became the alter ego of the modern artist, like a mask or costume which has the power to transform its wearer. This symbolic encounter inspired the use of unconventional procedures or techniques, such as experiments with chance and automatism, direct work on canvas without preparatory drawings or use of 'raw' colours and 'crude' forms. More generally, positing the Other as the constitutive aspect of the self (as in the works of Freud and Lacan) has contributed to the process of 'decentring' the subject and destabilizing one's *ergon* (in life and art). In consequence, play-*parergon*, movement and transgression, has become an alternative and attractive path to follow for modern (and especially) post-modern artists. The modern 'strategy of play', although rooted in Primitivist narrations, in the course of the twentieth century belonged to artistic practices quite detached from the purely visual attraction of modern artists to children's drawings or tribal sculpture.

In order to discuss the 'why and how' of the strategy of play in modern avant-gardes, I analysed a few types of human playgrounds

that served as models for artists from Dada to Fluxus, including cabaret, festival, excursion, parlour and language games, masquerades or games of chance. Artistic activities that were resminiscent of or took the form of empirical play helped the artists to arrive at a state of creative 'playfulness', which promised potential transgressions of well-established roles and rules in the domain of art. Play became an attractive method for exploring the margins of proper artistic production, making the creative process exciting and unpredictable and interacting with the public. To some extent, artists, especially Dadaists and Surrealists, consciously occupied the role of society's jesters (to 'shock the middle class'), strengthening the stereotype of an artist as a playing child, and that of play as synonymous with irrationality, irresponsibility and frivolity. However, the equally provocative masquerades and puns employed by Duchamp highlighted play not as an exotic and 'primitive' supplement but as a philosophical condition for the artistic act. He proved that while play is not opposed to the rational mind, it can act as a conceptual tool to bring new unexpected insights into the creative process and communication with the viewer. John Cage introduced the Zen Buddhism-inspired playful strategy of letting go. Chance, immersion, flow, oblivion, unknowing and non-functional research had become popular creative and cognitive tools. Some artists (such as the Viennese Actionists) departed to explore the 'dark', excessive and violent sides of play in the tradition of Nietzsche, de Sade and Bataille. Such 'play of art' must be seen as a constructive as well as a deconstructive force; it transgresses the 'proper' and the 'accepted', and enters the spheres of doubt, anxiety and ambiguity.

In postwar art the strategy of play was mainly employed to foster communication, interaction and relationships between human beings, rather than to shock and provoke (the works of Cage, Kaprow and the Fluxus movement are all good examples of this tendency). Viewers were invited to step into the world of Environments and Installations and to join artistic play – to become active playmates of the artist. Kaprow's Happenings, based on the model of children's play, were intended to eliminate the public, to blur the boundaries between the artist and the viewer, between art and life, experience and representation. Gradually, the strategy of play became a widely accepted element of the creative process.

I argued that, organized around certain central values and loaded with the notion of power, 'strategy' of play has been replaced by the 'tactic' (to use de Certeau's terms) of play in post-modern art. The 'tactic of play' operates within the given structure to gradually transform it, but it does not follow a revolutionary agenda. Play as a tactic becomes an undercurrent of the artistic and social network. I described the operation of the contemporary tactic of play with the use of metaphors coming from the world of games, namely role-playing games (RPGs). I compared the participatory projects by Deller, Janin, WochenKlausur and the collaborative actions of *The Finissage of Stadium X*, among others, to the elements of the game. I analysed the artist's position as a game master, and the real-life arena of the project, framed by the artist's intervention, as a game world. Consequently, I described the real or fictional characters enacted by the participants as roles (characters) within the game. This analogy allowed me to expose the game or play-like structure of many recent projects. The artwork as 'game session', in a fashion similar to reality television, offers the possibility of 'having an experience', in the form of a symbolic re-enactment of past events, community workshop, guided tour, boat trip, training and so on. It helps to make human connections, to look at things as if for the first time, as the Other or as a 'true' self freed from the obligations of everyday reality. The tactic of play allows us, therefore, to occupy social 'interstices' and to 'make sense' or nonsense of the world through the *methetic* techniques of performance and role-play, in which the social processes operate 'as real'.

This promise of unmediated experience, which inspires many participatory projects, subscribes to the pre-rational, Primitivist view of play as an anti-intellectual performance. This notion of play serves as an element in Nigel Thrift's theory of non-representation. I argued that play, as immersive and embodied experience (a village fair, a community event, a reality show or a role-playing game), nevertheless and in all cases evokes representation. The experience of play/art is possible because play is a metacommunicative frame; it emerges from immediate experience *and* shapes it – makes it different from itself. Play cannot, therefore, serve as a non-representational tool, because through the immediate, the embodied and the performative it evokes representation.

In order to overcome the prejudice against traditional representation, as well as the insistent idea of non-representation (which ignores the characteristics of play-*parergon* as a metacommunicative frame), I suggested approaching the notion of representation with the help of the metaphor of the game session. Representation conceptualized in this way becomes a symbolic act *and* an experience – one happening and possible only through the other. This redefined notion of representation must be seen as a *synergy* of, and a two-way passage between, art *and* life, fiction *and* reality, subjectivity *and* objectivity, repetition *and* origin, convention *and* improvisation. It allows diverse approaches and responses within a variety of contexts – improvisational, experimental, chance-driven; or rule-bound, repetitive and defined in advance. The role of the artist as game master reveals the multi-layered dynamics of this function – from authoritarian gestures and mastery in the traditional sense to empathy, letting go and immersion within collaborative, communal activities. Representation as a game session is a very flexible and open-ended concept, and it embraces play as both 'rational' and 'pre-rational'. Finally, I argued that the non-erasable frame of representation, established by play-*parergon* as 'undecidable', is necessary for art's experimental, provocative and transgressive functions. It makes art a subject of aesthetic, and not only ethical, considerations.

Finally, I speculated on the contemporary position of play in the *ergon-parergon* model and briefly discussed the general sociocultural 'turn to play'. I argued that the modern revolution brought about the disturbance of the traditional hierarchy of work/play, *ergon/parergon*. Analysis of recent participatory and relational works revealed that play, from an external strategy, has gradually become more of an internal tactic or structural element of the works; indeed, part of the essential vocabulary of art and curatorial practice. I asked, therefore, whether we could locate play as a new *ergon* of art, a new central value, a new proper function. In my view such a perspective would annihilate play as 'undecidable', as locus *and* movement. Hence, I proposed to persevere with the notion of play as *parergon* – a frame. However, it is no longer a Kantian, ornamental frame, which merely enhances and supplements the main body of work (*ergon*). It is rather a symbolic, conceptual frame as 'portable device', employed to define some objects and situations as 'art'. This metacommunicative artistic play (frame),

a 'context' creating a work of art, acts as a border *and* a bond between different 'realities', or 'reality' and 'fiction'. Play-*parergon* is then the condition for representation, as well as producing representations by framing certain fragments of 'reality' as art. Consequently, the redefined *ergon* is not attached to the frame. It can be seen, rather, as a 'pretext' for the artistic intervention emerging from the given reality, for example, in the form of a specific problem to be addressed. A work of art, a 'text', comes into being through the creative *synergy* of *ergon* and *parergon* – a pretext and a context – a given 'world' that attracts the artist and a frame employed in the project. It seems to me, then, that play, although it can still be used as an external provocative strategy or a more dialogue-oriented tactic, has become an internal 'default' structure of many works.

Contemporary artists use participatory (*methetic*, role-playing) techniques in order to evoke 'experience', but also to generate meaning and knowledge. Art and play are performed to 'make sense' (or nonsense) of the real and unreal, of past, present and future. The operation of the element of play within the domain of art enables representation – the double plane of action. The strategy or tactic of play enables representation through the immediate experience. Therefore, as I have argued throughout this book, play as a philosophical notion is the *condition for* representation, and play as an actual activity (employed as an artistic strategy or tactic) is a *form of* representation, despite its performative, embodied character.

This book was not written with the goal of arriving at an ultimate answer to the questions of what play is and how it operates within the theory and practice of art. Through the writing, rather, I wanted to come up with a methodological key to open the notion of play for further discussion, to negotiate between different uses of this concept, to contextualize it and find a way to visualize its complexity in order to go beyond popular or stereotypical views. I was interested in constructing a general map that would help to locate and examine play in more detail in further studies. I think that the *ergon/parergon* model fulfils this function and can help to redefine play as both an indispensable element of the concept of art and a useful aesthetic criterion in process-oriented art.

Apart from this main proposition, this book has developed other concepts and approaches that contribute to the study of play as an

aesthetic element. The distinction between the modern strategy of play and the post-modern tactic is a useful, although inevitably schematic, research tool. However, it clearly situates play as a post-modern method – not revolutionary and external but a widely accepted and assimilated artistic means. This shift proves that the traditional notion of representation needs to be supplemented with the concept of play (no longer a dangerous, but rather an attractive component). The proposed 'game session' model of artistic representation overcomes the fixity and rigid frames of the traditional approach, but also shows that it is not necessary (and not possible) to go beyond representation in the realm of art. The metaphor of the role-playing game itself also seems to be a useful tool to discuss the functions, roles and activities of contemporary artists and viewers. Additionally, this book contributes to studies on Primitivism in Western art. I inscribed this trend into the chain of developments which reached its contemporary manifestation in participatory, process-oriented projects.

I am aware that the ideas developed in this book generate further questions, especially from the field of practice. I hope that *Time to Play* will inspire further research on this ambiguous notion and will bring many unexpected insights. It is impossible to categorically answer the seemingly simple questions of what play is and how it 'works' in the context of art and aesthetics. We can only generate numerous theoretical variations of this theme and endless metaphors. So, at the very end of this book, I will add another: play as the 'dark energy' of art, essential for art's existence and responsible for the constant expanding of the artistic universe – or for its ongoing deconstruction.

Notes

Introduction

1 The most significant books in English devoted to the concept of play, which address certain aspects of the operation of play in art and aesthetics, are: Mihai Spariosu's *Dionysus Reborn: Play and the Aesthetic Dimension in Modern Philosophical and Scientific Discourse* (Cornell University Press, Ithaca and London, 1989) discussing theoretical approaches to play in modern philosophical and scientific theories and, more recently published, Mary Flanagan's *Critical Play: Radical Game Design* (The MIT Press, Cambridge, Massachusetts, London, 2009) emerging from computer game studies, and analysing different forms of play (e.g. board games, language games, etc.) as models for artistic practices in the twentieth and twenty-first centuries. The purpose of the latter book is to propose an alternative model of game design, based on avant-garde artists' experiments with play.

2 Steven Winn, 'Childhood isn't what it used to be. In the arts, it's dark and complex', 17 November 2004, at: http://www.sfgate.com/entertainment/article/Childhood-isn-t-what-it-used-to-be-In-the-arts-2635505.php, last accessed 5 August 2013.

3 Gretchen Owocki, 'Play and Developmentally Appropriate Practices', in: *Literacy through Play* (Heinemann, Portsmouth, 1999), p. 1.

4 See for instance: Jean Piaget, *Play, Dreams and Imitation in Childhood* (Norton, New York, 1962).

5 Susanna Millar, *The Psychology of Play* (Penguin Books, Baltimore, Maryland, 1968), p. 56.

6 Spariosu *Dionysus Reborn*, pp. 193–5, 200.

7 Lev Vygotsky, *Play and its Role in the Mental Development of the Child* (1933), online version: Psychology and Marxism Internet Archive, 2002, at: http://www.marxists.org/archive/vygotsky/works/1933/play.htm, last accessed 13 July 2013.

8 Ibid.

9 Ibid.

10 Millar, *The Psychology of Play*, p. 25.

11 Sigmund Freud, 'Beyond the Pleasure Principle', in *Complete Works*, Vol. 18, trans. J. Strachey (Hogarth Press, London, 1955), p. 8.

12 Donald Winnicott, *Playing and Reality* (1971) (Routledge, New York, 2005), p. 71.

13 Ibid., p. xii.

14 Joan Packer Isenberg and Nancy Quisenberry, 'Play: Essential for all Children, A Position Paper of the Association for Childhood Education International', *Childhood Education*, Vol. 79, 2002, at: http://acei.org/wp-content/uploads/PlayEssential.pdf, last accessed 29 August 2011.

15 Brian Sutton-Smith, 'Conclusion: The Persuasive Rhetorics of Play', in *The Future of Play Theory: A Multidisciplinary Inquiry into the Contribution of Brian Sutton-Smith*, ed. by A. D. Pellegrini (State University of New York Press, Albany), 1995, p. 278.

16 Ibid., pp. 292–3.

17 Spariosu, *Dionysus Reborn*, p. 5.

18 Ibid., p. 12.

19 Ibid., p. 14.

20 Roger Caillois, *Man, Play and Games* (1958), trans. M. Barash (University of Illinois Press, Urbana and Chicago, 2001), p. 12.

21 Johan Huizinga, 'The Nature and Significance of Play as a Cultural Phenomenon', in *The Performance Studies Reader*, ed. H. Bial, 2nd edition (Routledge, London, New York, 2007), pp. 137–8.

22 Ibid., p. 138.

23 Ibid.

24 Ibid.

25 Ibid., pp. 139–40.

26 Johan Huizinga, *Homo Ludens: a Study of Play Element in Culture* (1938) (Taylor & Francis, Inc., International Library of Sociology Series, London, 2003), p. 1.

27 Ibid., p. 6.

28 Ibid.

29 Ibid., p. 7.

30 Hector Rodriguez, 'The Playful and the Serious: An approximation to Huizinga's *Homo Ludens*', *Game Studies: The International Journal of Computer Game Research*, Vol. 6 No. 1, December 2006, at: http://gamestudies.org/0601/articles/rodriges, last accessed 20 February 2010.

31 Huizinga, *Homo Ludens*, p. 8.

32 Ibid., p. 7.

33 Ibid., p. 10.

34 Ibid.

35 Ibid.

36 Ibid.

37 Ibid.

38 Ibid.

39 Ibid.

40 Ibid., p. 13.

41 Ibid., p. 14.

42 Ibid., p. 15.

43 See Barbara Bolt, *Art Beyond Representation: The Performative Power of the Image*, I.B.Tauris (London, 2004).

44 'Unproductive' does not suggest that play is not creative. It rather points to the disinterestedness of play activities as not productive of real life, practical outputs – in a similar way as fine art is differentiated from craft in Kant's *Critique of Judgement*.

45 Caillois, *Man, Play and Games*, pp. 9–10.

46 Gregory Bateson, 'A Theory of Play and Fantasy' (1955), in *The Performance Studies Reader*, ed. H. Bial, 2nd edition (Routledge, London, New York, 2007), p. 141.

47 Ibid., p. 142.

48 Alfred Korzybski, 'A Non-Aristotelian System and its Necessity for Rigour in Mathematics and Physics', paper presented at the meeting of the American Association for the Advancement of Science, New Orleans, 1931, reprinted in: *Science and Sanity*, 1933, pp. 747–61.

49 Bateson, 'A Theory of Play and Fantasy', p. 144.

50 Spariosu, *Dionysus Reborn*, p. 200.

51 Elliott M. Avedon and Brian Sutton-Smith, *The Study of Games* (John Wiley & Sons, New York, London, Sydney, Toronto, 1971), p. 7.

52 Katie Salen and Eric Zimmerman, *Rules of Play: Game Design Fundamentals* (MIT Press, Cambridge, MA, 2003), p. 50.

53 Ibid., p. 80.

54 Ibid., pp. 405–6.

55 Gary A. Fine, 'Fantasy Role-Play Gaming as a Social World: Imagination and the Social Construction of Play', in: *The Paradoxes of Play*, ed. J. Loy (The Association for The Anthropological Study of Play, Leisure Press, New York, 1982), p. 215.

56 Ibid., p. 216.

57 Caillois, *Man, Play and Games*, p. 13.

58 Caillois, *Man, Play and Games*, p. 27.

59 Caillois, *Man, Play and Games*, p. 33.

60 Caillois, *Man, Play and Games*, p. 31.

61 Rob Pope, *Creativity: Theory, History, Practice* (Routledge, Abingdon, 2005), p. 122.

62 Mike Sharples, *How We Write: Writing as Creative Design*, 1999, p. 41, quoted in: Pope, *Creativity*, p. 122.

63 '66. Consider for example the proceedings that we call "games". I mean board-games, card-games, ball-games, Olympic games, and so on...What is common to them all? – Don't say: "There must be something common, or they would not be called "games"' – but look and see whether there is anything common to all. – For if you look at them you will not see something that is common to all, but similarities, relationships, and a whole series of them at that....
67. I can think of no better expression to characterize these similarities than "family resemblances"; for the various resemblances between members of a family: build, features, colour of eyes, gait, temperament, etc. etc. overlap and criss-cross in the same way. – And I shall say: "games" form a family.' Ludwig Wittgenstein, *Philosophical Investigations*, trans. G.E.M. Anscombe, Blackwell, Oxford, 1953, pp. 31–2.

64 Norman K. Denzin, 'The Paradoxes of Play', in: *The Paradoxes of Play*, ed. J. Loy (The Association for The Anthropological Study of Play, Leisure Press, New York, 1982), p. 13.

65 Ibid.

66 Mihaly Csikszentmihalyi, 'Some Paradoxes in the Definition of Play', in: *Play as Context*, ed. A. Taylor Cheska (The Association for The Anthropological Study of Play, Leisure Press, New York, 1981), p. 14.

67 Denzin, 'The Paradoxes of Play', p. 20.
68 Denzin, 'The Paradoxes of Play', p. 23.

Chapter 1: Modern Perspectives on Play

1 Mihai Spariosu, *Dionysus Reborn: Play and the Aesthetic Dimension in Modern Philosophical and Scientific Discourse* (Cornell University Press, Ithaca and London, 1989), p. 14.
2 Immanuel Kant, *Critique of Judgement* (1790), trans. J. C. Meredith (Clarendon Press, Oxford, 1952), p. 42.
3 Kant, *Critique of Judgement*, p. 164.
4 Ibid.
5 Ibid.
6 Ibid., p. 166.
7 Ibid., p. 168.
8 Ibid., p. 183.
9 Ibid., p. 174.
10 Ibid., p. 180.
11 Ibid., p. 183.
12 Barbara Bolt, *Art Beyond Representation: The Performative Power of the Image* (I.B.Tauris, London, 2004), p. 17.
13 The phrase popularized by Théophile Gautier in 1833.
14 Austin Harrington, *Art and Social Theory: Sociological Arguments in Aesthetics* (Polity Press, Cambridge, 2004), p. 14.
15 Harrington, *Art and Social Theory*, p. 73.
16 Raymond Williams, 'The Creative Mind', in *The Long Revolution* (Chatto & Windus, London, 1961), pp. 6, 8.
17 Summarized in Rosalind Krauss, 'The social history of art: models and concepts', in *Art since 1900: Modernism, Antimodernism, Postmodernism*, Hal Foster et al. (eds) (Thames and Hudson, London, 2004), pp. 22–5.
18 Peter Bürger, *Theory of the Avant-Garde* (1984), trans. M. Shaw, University of Minnesota Press, Minneapolis, 2004, p. 42.
19 Krauss, 'The social history of art: models and concepts', pp. 24–5. See also: Walter Benjamin, 'The Author as Producer', trans. E. Jephcott, and 'The Work of Art in the Age of Mechanical Reproduction', trans. H. Zohn, in: *Modern Art and Modernism: A Critical Anthology*, eds. F. Frascina and C. Harrison (Paul Chapman Publishing, New York, 1982).
20 Krauss, 'The social history of art: models and concepts', p. 25.

21 Ibid., p. 25.

22 Hans Arp, 'I become more and more removed from aesthetics', *On My Way* (1948), quoted in: *Concepts of Modern Art: From Fauvism to Postmodernism*, ed. N. Stangos (Thames and Hudson, London, 1994), p. 114.

23 Lucio Fontana, 'The White Manifesto' (1946), in: *Art in Theory. 1900–2000. An Anthology of Changing Ideas*, eds. C. Harrison and P. Wood. (Blackwell Publishing, Oxford, 2003), p. 655.

24 Robert Goldwater, *Primitivism in Modern Art* (The Belkin Press of Harvard University Press, Cambridge, Massachusetts and London, 1986), p. 261.

25 Ernst Ludwig Kirchner, 'Programme of the Brücke' (1906), translated from the woodcut, in: *Art in Theory. 1900–2000*, p. 65.

26 Tristan Tzara, 'Dada Manifesto 1918', trans. R. Mannheim, in: *Art in Theory. 1900–2000*, pp. 254, 256, 257.

27 Stanisław Przybyszewski, 'Primitivists to the Nations of the World and to Poland' (1920), in: *Manifesto: A Century of Isms*, ed. M. A. Caws (University of Nebraska Press, Lincoln and London, 2001), p. 101.

28 André Breton, 'From the First Manifesto of Surrealism' (1924), trans. H. R. Lane and R. Seaver, in: *Art in Theory. 1900–2000*, pp. 448, 452.

29 Ibram Lassaw, 'On Inventing Our Own Art', American Abstract Artists Group Statement (1938), in: *Art in Theory. 1900–2000*, p. 398.

30 Lucio Fontana, 'The White Manifesto', pp. 654, 655.

31 George Maciunas, 'Manifesto' (1963), in *fLuxus deBris*, at: http://www.artnotart.com/fluxus/gmaciunas-manifesto.html, last accessed 4 May 2009.

32 Ian Chilvers, 'Primitivism', in *Oxford Dictionary of 20th Century Art* (Oxford University Press, Oxford, 1999), p. 495.

33 Colin Rhodes, *Primitivism and Modern Art* (Thames and Hudson, London, 1994), p. 8.

34 Rhodes, *Primitivism and Modern Art*, p. 9.

35 August Macke, 'Masks' (1912), in *Art in Theory. 1900–2000*, p. 95.

36 Emil Nolde, 1912, quoted in: J. Lloyd, 'Emil Nolde's "ethnographic" still lifes: primitivism, tradition, and modernity', in: *The Myth of Primitivism: Perspectives on Art*, ed. S. Hiller (Routlege, London and New York, 1991), p. 100.

37 Wörwag Barbara, '"There is an Unconscious, Vast Power in the Child": Notes on Kandinsky, Münter and Children's Drawings', in *Discovering*

Child's Art, ed. J. Fineberg (Princeton University Press, Princeton, 1998), p. 87.

38 Wassily Kandinsky, 'On the Spiritual in Art' (1911), fragment in Goldwater, *Primitivism in Modern Art*, p. 128.

39 Rhodes, *Primitivism and Modern Art*, p. 150.

40 Hans Arp, quoted in: E. Mauer, 'Dada and Surrealism', in: *"Primitivism" in 20th Century Art. Affinity of the Tribal and the Modern*, ed. W. Rubin (The Museum of Modern Art, New York, published in conjunction with an exhibition of the same title, 1984), p. 538.

41 Hans Richter, *Dada: Art and Anti-Art* (Thames and Hudson, London, 1997), p. 50.

42 Ibid., p. 51.

43 Ibid.

44 Ibid., p. 58.

45 Ibid., p. 59.

46 Goldwater, *Primitivism in Modern Art*, p. 260.

47 Victor Li, *The Neo-Primitivist Turn: Critical Reflections on Alterity, Culture and Modernity* (University of Toronto Press, Toronto, 2006), p. viii.

48 Ibram Lassaw, 'On Inventing Our Own Art', American Abstract Artists group statement (1938), in: *Art in Theory. 1900–2000*, p. 398.

49 Goldwater, *Primitivism in Modern Art*, p. 255.

50 Hermann Bahr, 'Expressionism' (1914), trans. R. T. Gribble, in: *Art in Theory. 1900–2000*, p. 118; emphasis is mine.

51 'Performative' and 'constative' are terms introduced by J. L. Austin to differentiate between utterances that cause certain effects – are a form of action (performative), and those that only state facts (descriptive or 'constative'), in: John Langshaw Austin, 'Performatives and Constatives', in *How to Do Things with Words* (1955) (Oxford University Press, Oxford, New York, 1975).

52 Sigmund Freud, *Totem and Taboo*, trans. J. Strachey (W.W. Norton, New York, 1950), p. 90.

53 Pablo Picasso, 'Discovery of African Art, 1906–1907', in: *Primitivism and 20th Century Art: A Documentary History*, eds. M. Deutch and J. Flam (University of California Press, Berkeley, 2003), p. 33.

54 Čapek Josef, 'Negro Sculpture' (1918), in *Primitivism and 20th Century Art*, p. 114.

55 Li, *The Neo-Primitivist Turn*, p. 15.

56 Tristan Tzara, 'Note on African Art' (1917), in *Primitivism and 20th Century Art*, p. 111.

57 Chilvers, 'Primitivism', p. 495.

58 Stuart Hall, 'The Spectacle of the Other', in *Representation: Cultural Representations and Signifying Practices*, ed. S. Hall (Sage Publications, London, 1997), p. 237.

59 Hugo Ball, quoted in Richter, *Dada: Art and Anti-Art*, p. 49.

60 Mechthild Nagel, *Masking the Abject: a Genealogy of Play* (Lexington Books, Lanham, 2002), p. 63.

61 Michel De Certeau, '"Making Do": Uses and Tactics', in *The Practice of Everyday Life*, Vol. 1 (University of California Press, London, 1988), p. 38.

62 De Certeau, '"Making Do": Uses and Tactics', pp. 35–6.

63 André Breton, published in 'MEDIUM II, 2', 1954, in *A Book of Surrealist Games*, ed. M. Gooding (Redstone Press, London, 1995), p. 137.

64 Strategy of play, like Primitivism, must be seen as a 'relational concept that expresses various "modern needs"'.

65 Soon, the Cabaret attracted a diverse group of artists and poets including Tristan Tzara, Marcel Janco, Hans Arp and Hans Richter, who contributed to the shows and formed the first Dada group.

66 Hugo Ball, Dada publication, 15 May 1916, in Richter, *Dada: Art and Anti-Art*, p. 14.

67 Hugo Ball, quotation in: RoseLee Goldberg, *Performance Art: From Futurism to the Present* (Thames and Hudson, London, 1988), p. 56.

68 Ibid., p. 85.

69 Ibid., p. 30.

70 Johannes Baader, 1918, quoted in Richter, *Dada: Art and Anti-Art*, p. 215.

71 Goldberg, *Performance Art*, p. 52.

72 The name of this game comes from the first sentence produced in its written version: 'The exquisite corpse shall drink the new wine'.

73 For the full list of Surrealist games, their rules and examples of outcomes see: Mel Gooding (ed.), *A Book of Surrealist Games* (Redstone Press, London, 1991).

74 Ibid., p. 82.

75 André Breton, in: Gooding, *A Book of Surrealist Games*, p. 138.

76 Gooding, *A Book of Surrealist Games*, p. 156.

77 Ibid., p. 156.

78 Katia Samaltanos, *Apollinaire: Catalyst for Primitivism, Picabia and Duchamp* (UMI Research Press, Michigan, 1984), p. 66.

79 Stephen Jay Gould, 'The Substantial Ghost: Towards a General Exegesis of Duchamp's Artful Wordplays', *Tout-Fait. The Marcel Duchamp Studies Online Journal*, May 2000, at: http://www.toutfait.com/issues/issue_2/Articles/gould.html, last accessed 20 June 2009.

80 Marcel Duchamp, 1960, in: Kuh, Katherine, *The Artist's Voice: Talks with seventeen modern artists* (Da Capo Press, New York, 2000), p. 89.

81 Ibid., p. 89.

82 Joe Scanlan, 'Duchamp's wager: disguise, the play of surface and disorder', *History of the Human Sciences*, Vol. 16 No. 3, 2003, at: http://hhs.sagepub.com/cgi/content/abstract/16/3/1, last accessed 1 June 2009.

83 Katharine Conley, *Robert Desnos, Surrealism, and the Marvellous in Everyday Life* (University of Nebraska Press, Lincoln, 2002), p. 27.

84 Judith Butler, *Gender Trouble: Feminism and the Subversion of Identity* (Routledge, New York, 1990).

85 Conley, *Robert Desnos*, pp. 28–9.

86 Amelia Jones, 'The Ambivalence of Rrose Sélavy and the (Male) Artist as "Only Mother of the Work"', in: *Postmodernism and the En-Gendering of Marcel Duchamp* (Cambridge University Press, Cambridge, 1994), p. 151.

87 Ibid., p. 151.

88 The role of Duchamp as a 'father' of post-modernism is extensively and critically discussed in Jones, *Postmodernism and the En-Gendering of Marcel Duchamp*.

89 For the analysis of Gadamer's application of play in the aesthetic theory see the chapter, 'Play and Ontological Hermeneutics: Hans Georg Gadamer', in: Spariosu, *Dionysus Reborn*. Spariosu writes, 'Gadamer again invokes its [play's] natural aspect as self-representation and self-movement without any goal or purpose. To this notion of play as natural, spontaneous movement he adds Schiller's concept of play as excess of energy, which as we have seen is borrowed from Plato and is also used by Nietzsche and Heidegger in order to underscore the pre-rational character of play. When Gadamer turns to defining art as play however, he emphasizes its orderly character', p. 139.

90 Spariosu, *Dionysus Reborn*, p. 134.

91 Hans-Georg Gadamer, 'Aesthetic and Hermeneutic Consequences', in: *Truth and Method* (1960), trans. J. Weinsheimer and D. G. Marshall (Continuum, London, New York, 2006), p. 131.

92 Ibid., p. 105.

93 Ibid., p. 102.

94 Ibid., p. 104.

95 Huizinga, quoted in: Gadamer, *Truth and Method*, pp. 104–5.

96 Gadamer, *Truth and Method*, p. 106.

97 Ibid., p. 105.

98 Ibid., p. 102.

99 Ibid., p. 103.

100 Jean Grondin, 'Play, Festival and Ritual in Gadamer: on the theme of the immemorial in his later works', trans. L. K. Schmidt, reproduced at: http://mapageweb.umontreal.ca/grondinj/pdf/play_festival_ritual_gadam.pdf, last accessed 15 November 2009.

101 Ibid., p. 110.

102 Ibid., p. 111.

103 Ibid., p. 112.

Chapter 2: Play is a Movement in between the Opposites

1 Hans-Georg Gadamer, 'Aesthetic and Hermeneutic Consequences', in: *Truth and Method* (1960), trans. J. Weinsheimer and D. G. Marshall (Continuum, London, New York, 2006), p. 131.

2 Niall Lucy, *A Derrida Dictionary* (Blackwell Publishing, Oxford, 2004), p. 95.

3 Jacques Derrida, *Writing and Difference*, trans. A. Bass (Routledge and Kegan Paul, London, 1978), p. 292.

4 Plato, *The Republic*, Book 1, trans. D. Lee (Penguin Books, London, 1955), p. 40.

5 Nickolas Pappas, *Routledge Philosophy Guidebook to Plato and the Republic* (Routledge, London and New York, 1995), p. 49.

6 Plato, *The Republic*, Book 2, p. 60.

7 'Aristotle's Ethics' (published 2001, revised 2010), *Stanford Encyclopedia of Philosophy*, available at: http://plato.stanford.edu/entries/aristotle-ethics/#HumGooFunArg, last accessed 25 November 2011.

8 Mechthild Nagel, *Masking the Abject: A Genealogy of Play* (Lexington Books, Lanham, 2002), p. 48.

9 'Ergon', *The Blackwell Dictionary of Western Philosophy*, eds. N. Bunnin and Y. Jiyuan, available at: http://www.blackwellreference.com/public/tocnode?id=g9781405106795_chunk_g97814051067956_ss1-107, last accessed 5 August 2013.

10 Lucy, *A Derrida Dictionary*, p. 104.

11 'Dangerous supplement' is a phrase used by Rousseau in his reflection on natural love versus masturbation: 'Soon I was reassured, however, and I learned that dangerous means of cheating Nature [*ce dangereux supplément*], which leads young men of my temperament to various kinds of excess, that eventually imperil their health, their strength, and sometimes their lives. This vice, which shame, and timidity find so convenient, has a particular attraction for lively imaginations.' Jean-Jacques Rousseau, *The Confessions*, 1765, trans. J. M. Cohen (Penguin Books, Victoria, Australia, 1970), pp. 108–9. Derrida employs this term in his analysis of the logic of supplementarity in *Of Grammatology*, 1967.

12 Jacques Derrida, *Dissemination*, trans. B. Johnson (The Athlone Press, London, 1997), p. 85.

13 Barbara Johnson, 'Translator's Introduction', in Derrida, *Dissemination*, p. ix.

14 Derrida also analyses the logic of supplementarity in reference to Plato and Rousseau in the context of speech/writing opposition.

15 Immanuel Kant, *Critique of Judgement* (The Clarendon Press, Oxford, 1982), p. 69.

16 K. Malcolm Richards, *Derrida Reframed: A Guide for the Arts Student* (I.B.Tauris, London and New York, 2008), p. 32.

17 Jacques Derrida, *The Truth in Painting*, trans. G. Bennington and I. McLeod (The University of Chicago Press, Chicago, 1987), p. 57.

18 Ibid., p. 59.

19 In Huizinga, as quoted in the introduction, play is also compared to ornament: 'Play is something added there-to and spread out over it like a flowering, an ornament, a garment.' It connotes something added, extra and special. Johan Huizinga, *Homo Ludens: a Study of Play Element in Culture* (1938) (Taylor & Francis, Inc., International Library of Sociology Series, 2003), p. 7.

20 Christopher Norris, *Derrida* (Fontana Press, London, 1987), p. 30.

21 Ibid., p. 35.

22 As Derrida writes: 'Plato thinks of writing, and tries to comprehend it, to dominate it, on the basis of opposition as such. In order for these

contrary values (good/evil, true/false, essence/appearance, inside/ outside, etc.) to be in opposition, each of the terms must be simply external to the other. . . . ' Derrida, 'Plato's Pharmacy', in *Dissemination*, p. 103.

23 Derrida, 'Plato's Pharmacy', p. 126.
24 Ibid., p. 126.
25 Ibid., p. 127.
26 'Thoth', WordNet, Princeton University, available at: http://word netweb.princeton.edu/perl/webwn?s=thoth, last accessed 8 March 2008.
27 Ibid., p. 91.
28 Derrida, 'Plato's Pharmacy', p. 93.
29 Ibid., p. 133.
30 Ibid., p. 91.
31 Ibid., p. 142.
32 Alan Goldberg, after D. Handleman (1977), 'Play and Ritual in Haitan Voodoo Shows for tourists', in *The Paradoxes of Play*, *The Paradoxes of Play*, ed. J. Loy (The Association for The Anthropological Study of Play, Leisure Press, New York, 1982), p. 43.
33 Don Handleman (1977), quotation after: J. Schwartzman, 'Play: Epis- temology and Change', in: *Play as Context*, ed. A. Taylor Cheska (The Association for The Anthropological Study of Play, Leisure Press, New York, 1981), p. 42.
34 Bobby C. Alexander and Edward Norbeck, 'Rite of passage', *Encyclo- paedia Britannica Online*, at: http://www.britannica.com/EBchecked/ topic/504562/rite-of-passage/283998/Victor-Turner-and-anti- structure, last accessed 8 August 2009.
35 Fritz Graf, *Greek Mythology: An Introduction*, trans. T. Marier (The Johns Hopkins University Press, Baltimore, 1993), p. 143.
36 Eva Stehle, *Performance and Gender in Ancient Greece: Nondramatic poetry in its setting* (Princeton University Press, Princeton, 1997), p. 60.
37 Mikhail Bakhtin, *Rabelais and His World*, trans. H. Iswolsky (The Mas- sachusetts Institute of Technology, Cambridge, Massachusetts, 1968), p. 7.
38 Ibid., p. 10.
39 Michael D. Bristol, 'The Dialectic of Laughter', in *Carnival and Theater: Plebeian Culture and the Structure of Authority in Renaissance England* (Routledge, New York and London, 1989), p. 138.

40 Ibid., p. 138.

41 Plato, *The Republic*, Book 10, p. 364.

42 Jean-Jacques Rousseau, *On the Origin of Languages*, trans. J. H. Moran (The University of Chicago Press, Chicago and London, 1966), p. 21.

43 In Norris, *Derrida*, p. 97.

44 Penelope Deutscher, *How to Read Derrida* (Granta Books, London, 2005), pp. 10–1.

45 Norris, *Derrida*, p. 147.

46 Ibid., p. 147.

47 'From Buddhist Zen', quoted in Lester Thurow, *Head to Head* (William Morrow & Co, 1992), at: http://www.icodap.org/ZenWorkAndPlay.htm, last accessed 22 June 2009.

48 John Cage, in conversation with Daniel Charles, 'For the Birds' in 'Nietzsche's Return', *Semiotexte*, Vol. III, No. 1, 1978, p. 33.

49 Nancy W. Ross, 'Humour in Zen', in *The World of Zen: An East-West Anthology*, ed. N. W. Ross (Collins, London, 1962), p. 188.

50 Robert Linssen, 'Zen Buddhism and Everyday Life', in *The World of Zen: An East-West Anthology*, p. 221.

51 Richard Kostelanetz, *Conversing with Cage*, 2nd Ed. (Routledge, London, 2003), p. 17.

52 John Cage, *Silence: Lectures and Writings by John Cage* (Calder and Boyars, London, 1968), p. xii.

53 Hans-Georg Gadamer, 'The ontology of the work of art and its hermeneutic significance', p. 104.

54 John Cage, in conversation with Daniel Charles, 'For the Birds', p. 28.

55 Paul Griffiths, *Cage* (Oxford University Press, London, 1981), p. 37.

56 Ken Friedman, 'Fluxus & Company', 1989, in *The Fluxus Reader*, ed. K. Friedman (Academy Editions, Chichester, 1998), p. 244.

57 Friedman, 'Fluxus & Company', p. 249.

58 Friedman, 'Fluxus & Company', p. 251.

59 Yoko, Ono, 'Sun Piece', 1962, in: M. Flanagan, *Critical Play: Radical Game Design* (The MIT Press, Cambridge, Massachusetts, London, 2009), p. 140.

60 In Flanagan, *Critical Play: Radical Game Design*, p. 97.

61 Duchamp Marcel, 'The Creative Act', 1957, at: http://www.wisdomportal.com/Cinema-Machine/Duchamp-CreativeAct.html, last accessed 2 June 2009.

62 Claire Bishop, *Installation Art: A Critical History* (Tate Publishing, London, 2005), p. 6.

63 Nicolas de Olivieira, Nicola Oxley and Michael Petry, *Installation Art in the New Millennium: The Empire of the Senses* (Thames and Hudson, London, 2003), p. 14.

64 Ian Chilvers, *Oxford Dictionary of 20th-Century Art* (Oxford University Press, Oxford, 1999), p. 495.

65 For the detailed description of this and other Surrealist shows see: Lewis Kachur, *Displaying the Marvelous: Marcel Duchamp, Salvador Dali, and Surrealist Exhibition* (The MIT Press, Cambridge, Massachusetts, 2001); in the context of installation art: Bishop, *Installation Art: A Critical History*.

66 I will not refer here to the sociocultural analysis of Disneyland as a metaphor for the modern experience of 'reality'. See: Umberto Eco, *Travels in Hyperreality*, 1975; Baudrillard, Jean, *Simulacra and Simulations*, 1981.

67 Mark Rozenthal, *Understanding Installation Art: From Duchamp to Holzer* (Prestel, Munich, 2003), p. 39.

68 Quoted in Matthew W., Smith, 'Total World: Disney's Theme Parks', in *The Total Work of Art: From Bayreuth to Cyberspace* (Routledge, London and New York, 2007), p. 124.

69 Ibid., p. 126.

70 Ibid., p. 122.

71 Ibid., p. 121.

72 Bishop, *Installation Art*, pp. 102–16.

73 Jeff Kelley, *Childsplay: the Art of Allan Kaprow* (University of California Press, Berkeley, London, 2004), p. 14.

74 John Dewey, *Art as Experience* (1934), Perige Books, New York, 2005, p. 1.

75 Dewey, *Art as Experience*, p. 2.

76 Ibid., p. 22.

77 Ibid., p. 50.

78 Ibid., p. 37.

79 Allan Kaprow, *Essays on the Blurring of Art and Life* (1993) (University of California Press, Berkeley, Los Angeles, London, 2003), p. 12.

80 Allan Kaprow, quotation from the minutes of the meeting at the Judson Gallery, NY, 1959, in Julie H. Reis, *From Margins to Center: The Spaces of Installation Art* 1999 (MIT Press, Massachusetts, 2001), p. 24.

81 Kelley, *Childsplay*, p. 21.

82 Quotation in Olivieira et al., *Installation Art in the New Millennium*, p. 106.

83 Dewey, *Art as Experience*, p. 109.

84 Ibid., p. 253.

85 Kelley, *Childsplay*, p. 51.

86 Ibid., p. 52.

87 Ibid., p. 100.

88 Kaprow, *Essays on the Blurring of Art and Life*, p. 125.

89 Ibid., p. 104.

90 Ibid., p. 1.

91 Ibid., p. 115.

92 Ibid., p. 121.

93 Richard Schechner, *The Future of Ritual: Writings on Culture and Performance* (Taylor & Francis, London, 1993), pp. 38–9.

94 Georges Bataille, quoted in Briony Fer, 'Poussière/peinture: Bataille on Painting', in: *Bataille. Writing the Sacred*, ed. Caroline Bailey Gill (Routledge, London), p. 158.

95 Michael Richardson, *Georges Bataille* (Routledge, London and New York, 1994), p. 26.

96 'In this world only play, play as artists and children engage in it, exhibits coming-to-be and passing away, structuring and destroying, without any moral additive, in forever equal innocence. And as children and artists play, so plays the ever-living fire. It constructs and destroys, all in innocence.' Friedrich Nietzsche, *Philosophy in the Tragic World of the Greeks*, quoted in: Mihai Spariosu, *Dionysus Reborn: Play and the Aesthetic Dimension in Modern Philosophical and Scientific Discourse* (Cornell University Press, Ithaca and London, 1989), p. 74.

97 Michael Richardson, 'Introduction' to: Georges Bataille, *The Absence of Myth: Writings on Surrealism* (Verso, London, New York, 2006), p. 23.

98 Ibid., p. 18.

99 Ibid., p. 18.

100 Günter Berghaus, 'Happenings in Europe: Trends, Events, and Leading Figures', in: *Happenings and Other Acts*, ed. Mariellen R. Sandford (Routledge, London, 1995), p. 363.

101 Ibid., p. 364.

102 The instruction was: 'There are 72 objects on the table that one can use on me as desired.' Quoted in 'Marina Abramović', Alexandra Balfour

and Pitchaya Sudbanthad, *Museo 99*, available at: http://www.duke
.edu/web/museo/spring99/marina.html, last accessed 10 August 2009.

Chapter 3: Play: From Modern Strategy to Postmodern Tactic

1 Nicolas Bourriaud, *Relational Aesthetics*, 1998, trans. S. Pleasance and F.
 Woods (les presses du réel, Dijon, 2002), p. 14.
2 Michel De Certeau, '"Making Do": Uses and Tactics', in: *The Practice
 of Everyday Life*, Vol. 1, University of California Press, London, 1988,
 p. 37.
3 Ibid., p. 38.
4 Ibid., p. 37.
5 Hans Richter, *Dada: Art and Anti-Art* (Thames and Hudson, London,
 1997), p. 65.
6 Gavin Grindon, 'Autonomy, Activism, and Social Participation in the
 Radical Avant-Garde', *Oxford Art Journal* Vol. 34 Issue 1, 2011, p. 91.
7 RoseLee Goldberg, *Performance Art: From Futurism to the Present* (Thames
 and Hudson, London, 1988), p. 84.
8 Ibid., p. 84.
9 Richter, *Dada*, p. 79.
10 'Workshop', *The Politics of Play: Enabling Collaborative Networks in
 Public Spaces* (at: http://www.futurefarmers.com/play/workshop.html,
 last accessed 2 January 2012.
11 'Anonymous Letter Box – Howto', *Irational*, 20 January 2005, at:
 http://status.irational.org/letter_box/, last accessed 6 January 2012.
12 Gary Alan Fine, 'Fantasy Role-Play Gaming as a Social World: Imagi-
 nation and the Social Construction of Play', in *The Paradoxes of Play*, ed.
 J. Loy (The Association for The Anthropological Study of Play, Leisure
 Press, New York, 1982), p. 215.
13 Lisa Padol, 'Playing Stories, Telling Games: Collaborative Storytelling
 in Role-Playing Games', 1996, quoted in Anders Drachen and Michael
 Hitchens, 'The Many Faces of Role-Playing Games', *International Journal
 of Role-Playing*, Issue 1, 2008, p. 6, at: http://journalofroleplaying.org/,
 last accessed 14 October 2009.
14 Fine, 'Fantasy Role-Play Gaming as a Social World', p. 222.
15 Tuomas Harviainen, 'A Hermeneutical Approach to Role-Playing
 Analysis', *International Journal of Role-Playing*, Issue 1, 2008, p. 70, at:
 http://journalofroleplaying.org/, last accessed 14 October 2009.

16 Ibid., p. 69.

17 Hitchens Drachen, 'The Many Faces of Role-Playing Games', p. 5.

18 Harviainen, 'A Hermeneutical Approach to Role-Playing Analysis', p. 70.

19 Joanna Warsza, 'A place that never was', in *Stadium X: A Place that Never Was: A Reader*, ed. J. Warsza (Bęc Zmiana Foundation, Warszawa, Kraków, 2008), p. 7.

20 Warsza, 'A place that never was', p. 7.

21 Joanna Warsza, '*Boniek!* A One-man re-enactment of the 1982 Poland–Belgium Football Match by Massimo Furlan, with commentary by Tomasz Zimoch', in: *Stadium X*, pp. 28, 31.

22 Anda Rottenberg, in conversation with C. Polak, S. Szabłowski and T. Stawiszyński, 'Boniek. The Hero in the Piranesian Ruins', 25 October 2008, *Strefa Alternatywna* television show on TVP Kultura, transcript in *Stadium X*, p. 40.

23 Joanna Warsza, in the interview with D. Buczek, 'Miejsce którego nie było', ('Place that never was'), *Wysokie Obcasy*, December 2009, p. 36.

24 Zuzanna Janin, 'I've seen my death', text at: http://www.janin.art.pl/english/texts/texty_htm/pl/text_mydeath.htm, last accessed 27 October 2009.

25 Michael Richardson, 'Introduction' to Georges Bataille, *The Absence of Myth: Writings on Surrealism* (Verso, London, New York, 2006), p. 18.

26 Allan Kaprow, *Essays on the Blurring of Art and Life* (1993) (University of California Press, Berkeley, Los Angeles, London, 2003), p. 104.

27 In 1961 Kaprow installed *Yard*, a work consisting of hundreds of tyres dumped in the back yard of the gallery. As Jeff Kelley recounts, 'As the tyres were rolled out of the gallery and returned to the world [which turned out to be a serious logistical problem], Kaprow realized that he was getting very close to the tyre business. The art world, by contrast, was the place he could play with tyres all he wanted without going into the tyre business.' Jeff Kelley, *Childsplay: the art of Allan Kaprow* (University of California Press, Berkeley, London, 2004), p. 61.

28 Alexandra Mir, interview on BBC Radio Bristol, in *Contemporary Art: From Studio to Situation*, ed. Claire Doherty (Black Dog Publishing, London), p. 67.

29 *Altermodern*, www.tate.org, at: http://www.tate.org.uk/britain/exhibitions/altermodern/participants.shtm#e21, last accessed 2 June 2009.

30 Wietske Maas, (ed.), *An Architecture of Interaction*, Mondriaan Foundation and The Netherlands Foundation for Visual Arts, Design and Architecture, Amsterdam, 2008, p. 44.

31 Ibid., p. 44.

32 In: Grant Kester, *Conversation Pieces: Community + Communication in Modern Art* (University of California Press, London, 2004), pp. 124, 127.

33 Sigmund Freud, 'Creative Writers and Day-Dreaming' (1907), in: *Art and Literature, The Penguin Freud Library*, Vol. 14, trans. J. Strachey, ed. A. Dickson (Penguin Books, London, 1990), p. 47.

34 *Making Worlds*, 53rd International Art Exhibition, Venice Biennale, Marsilio, 2009, p. 156.

35 Bruce Barber, 'Sentences on Littoral Art', at: http://www.wizya.net/sentence.htm, last accessed 6 July 2009.

36 'A Trip to Asia: An Acoustic Walk Around the Vietnamese Sector of the 10th-Anniversary Stadium', website of the Laura Palmer Foundation, at: http://www.laura-palmer.pl/en/projects/9/podroz-do-azji-/, last accessed 15 July 2009.

37 Ibid.

38 'The pagoda was built over a couple of days, without any building permits, and it is not listed in any official record (nor are many of its builders).' Ibid.

39 Ibid.

40 Miwon Kwon, quoted in Nicolas de Olivieira, Nicola Oxley and Michael Petry *Installation Art in the New Millennium: The Empire of the Senses* (Thames and Hudson, London, 2003), p. 108.

41 Kester, *Conversation Pieces*, p. 1.

42 Doherty, *Contemporary Art: From Studio to Situation*, p. 10.

43 Bourriaud, *Relational Aesthetics*, p. 108.

44 A summary of my ideas referring to the notion of the artist as a game master was also published as: Katarzyna Zimna. 'Artist – the Game Master', *Stimulus-Respond* online journal, August 2010, 'Master' at: http://issuu.com/stimulusrespond/docs/stimulusmaster, and Katarzyna Zimna, 'Tricksters lead the game' in *Trickster Strategies in the Artists and Curatorial Practice*, ed. A. Markowska (Polish Institute of World Art Studies & Tako Publishing House, Warszawa, Toruń), 2013.

45 Kester, *Conversation Pieces*, p. 140.

46 http://www.tate.org.uk/britain/turnerprize/2004/deller.shtm, last accessed 4 July 2009.

47 Claire Bishop, 'The Social Turn: Collaboration and Its Discontents', in *Stadium X*, p. 53.

48 Jeremy Deller, in conversation with Claire Doherty, in *Contemporary Art: From Studio to Situation*, p. 94.

49 Ibid., p. 94.

50 Kester, *Conversation Pieces*, p. 150.

51 Wolfgang Zinggl, 'Frequently Asked Questions', 2001, quoted in Kester, *Conversation Pieces*, p. 68.

52 Maas, *An Architecture of Interaction*, p. 42.

53 Nicolas Bourriaud, *Postproduction* (2002) (Lukas & Sternberg, New York, 2007), p. 19.

54 Bishop refers to Bourriaud's relational aesthetics. Claire Bishop, *Installation Art: A Critical History* (Tate Publishing, London, 2005), p. 116.

55 Anthony Storr, 'Creativity and Play', in *The Dynamics of Creation* (Secker & Warburg, London, 1972), p. 116.

56 Roger Caillois, *Man, Play and Games* (1958), trans. M. Barash (University of Illinois Press, 2001), p. 9.

57 Kester, *Conversation Pieces*, p. 111.

58 Gesine Storck, 'L=∞. Spiel des Lebens, Denk und Meditationsspiel', 2010, trans. K. Zimna.

59 In Paul Goodman, *Communitas: Means of Livelihood and Ways of Life* (University of Chicago Press, Chicago, 1947).

60 Edith Turner, 'Communitas, Rites of', in *Encyclopedia of Religion, Communication and Media*, ed. D. A. Stout, p. 98, available at: http://www.routledge-ny.com/ref/religionandsociety/rites/communitas.pdf, last accessed 22 July 2009.

61 Ibid.

62 Bourriaud, *Relational Aesthetics*, p. 36.

63 Ibid., p. 80.

64 Dave Beech, 'Include me out! Dave Beech on participation in art', *Art Monthly*, April 2008, at: http://findarticles.com/p/articles/mi_6735/is_315/ai_n28512975/?tag=content;col1, last accessed 2 November 2009.

65 Ibid.

66 Kester, *Conversation Pieces*, p. 182.

67 Bishop, *Installation Art: A Critical History*, p. 123.

68 Thomas Hirschhorn, quoted in Bishop, *Installation Art: A Critical History*, p. 123.

69 Bishop, *Installation Art: A Critical History*, p. 127.

70 Bantinaki Katerina, 'Art Beyond Representation: The Performative Power of the Image', *The British Journal of Aesthetics*, Vol. 46 Issue 2, 2006, at: http://bjaesthetics.oxfordjournals.org/cgi/content/full/46/2/213, last accessed 17 July 2009.

71 Barbara Bolt, *Art Beyond Representation: The Performative Power of the Image*, I.B.Tauris London, 2004, p. 50.

72 Ibid., p. 149.

73 See: John L. Austin, 'Performatives and Constatives', in: *How to Do Things with Words* (1955) (Oxford University Press, Oxford, New York, 1975), p. 9.

74 Bolt, *Art Beyond Representation*, p. 142.

75 Nigel Thrift, *Non-Representational Theory. Space/politics/affect* (Routledge, London and New York, 2008). The extract is from the back cover copy.

76 Ibid., p. 135.

77 Ibid., p. 135.

78 Ibid., p. 148.

79 Ibid., p. 147.

80 Ibid., p. 147.

81 Schwarzmann, 1978, p. 169, in Thrift, *Non-Representational Theory*, p. 119.

82 Thrift, *Non-Representational Theory*, p. 119.

83 Plato, *The Republic*, Book 10, trans. D. Lee (Penguin Books, London, 1955), p. 364.

84 Ibram Lassaw, 'On Inventing Our Own Art', American Abstract Artists Group Statement, 1938, in: *Art in Theory. 1900–2000. An Anthology of Changing Ideas*, eds. C. Harrison and P. Wood (Blackwell Publishing, 2003), p. 398.

85 Thrift, *Non-Representational Theory*, p. 122.

86 Hans–Georg Gadamer, *Truth and Method* (1960), trans. J. Weinsheimer and D. G. Marshall (Continuum, London, New York, 2006), p. 371.

87 Jacques Derrida, 'Sending: On Representation', trans. P. Caws and M. A. Caws, *Social Research* Vol. 49 Issue 2, 1982, p. 311.

88 Deborah Haynes, *Bakhtin and the Visual Arts* (Cambridge University Press, Cambridge, 1995), pp. xiii, xiv.

89 Ibid., p. 72.

90 Mary Flanagan, *Critical Play: Radical Game Design* (The MIT Press, Cambridge, Massachusetts; London, 2009), p. 13.

91 Haynes, *Bakhtin and the Visual Arts*, p. 53.

92 Bolt, *Art Beyond Representation*, p. 10.

93 'Arboreal' and 'rhizomatic' (tree and rhizome) are metaphors for the organization of human experience, created by Gilles Deleuze and Felix Guattari (*A Thousand Plateaus*, 1987). The tree connotes solidity, hierarchy, longevity and totality.

Chapter 4: The Turn to Play

1 Genesis 3: 17, *The Holy Bible: New International Version*, at: http://www.biblica.com/bible/verse/?q=Genesis%203:1-24&=yes, last accessed 8 September 2009.

2 Roger B. Hill, 'Historical Context of the Work Ethic', *History of the Work Ethic*, 1996, at: http://www.coe.uga.edu/~rhill/workethic/hist.htm, last accessed 7 July 2009.

3 Ibid.

4 'Protestant work ethic' is a term coined by Max Weber in *The Protestant Ethic and the Spirit of Capitalism*, 1905.

5 Herbert A. Applebaum, *The Concept of Work: Ancient, Medieval, and Modern* (State University of New York Press, Albany, New York, 1992), p. 322.

6 Ibid., p. 322.

7 Ibid., p. 326.

8 Hill, 'Historical Context of the Work Ethic'.

9 In his 1907 book *The Creative Evolution*.

10 Hannah Arendt, *The Human Condition* (The University of Chicago Press, Chicago, 1958), p. 7.

11 Ibid., p. 7.

12 Ibid., p. 7.

13 Majid Yar, 'Hannah Arendt (1906-1975)', *Internet Encyclopedia of Philosophy*, 23 October 2001, revised 22 July 2005, at: http://www.iep.utm.edu/arendt/#SH4a, last accessed 7 September 2009.

14 Arendt, *The Human Condition*, p. 139.

15 Ibid., p. 140.

16 Ibid., p. 168.

17 Ibid., p. 309.

18 Ibid., p. 309.

19 Chris Rojek, *Decentring Leisure: Rethinking Leisure Theory* (Sage Publications, London, 1995), p. 187.

20 Roger Caillois, *Man, Play and Games* (1958), trans. M. Barash (University of Illinois Press, Urbana and Chicago, 2001), pp. 5–6.

21 See 'The Work Ethic: Consumerism and Leisure', in Applebaum, *The Concept of Work*.

22 Allan Kaprow, *Essays on the Blurring of Art and Life* (1993) (University of California Press, Berkeley, Los Angeles, London, 2003), p. 113.

23 Brian Sutton-Smith and Robin Herron E., *Child's Play*, John Wiley & Sons, New York, 1971, p. 1.

24 Jacques Derrida, 'Plato's Pharmacy', fragments in: *A Derrida Reader: Between the Blinds*, ed. P. Kamuf (Columbia University Press, New York, 1991), p. 122.

25 Jacques Derrida, 'Plato's Pharmacy', p. 135.

26 Mihaly Csikszentmihalyi, 'Some Paradoxes in the Definition of Play', in *Play as Context*, ed. Cheska A. Taylor (The Association for The Anthropological Study of Play, Leisure Press, New York), 1981, p. 18. Csikszentmihalyi refers to the fable attributed to Aesop, 'The Grasshopper and the Ants', which provides a moral lesson about the value of work – ants work hard to store food for the winter while the grasshopper plays fiddle during the whole summer and autumn, and then is forced to ask for their help in leaner times.

27 Csikszentmihalyi, 'Some Paradoxes in the Definition of Play', p. 17.

28 For the detailed exposition of the notion of 'flow' see: Mihaly Csikszentmihalyi, *Flow: the Psychology of Optimal Experience* (Harper Perennial, New York, 1991).

29 Csikszentmihalyi, 'Some Paradoxes in the Definition of Play', p. 19.

30 Johan Huizinga, *Homo Ludens: a Study of Play Element in Culture* (1938), Taylor & Francis, International Library of Sociology Series, London, 2003, p. 5.

31 Huizinga, *Homo Ludens*, p. 1.

32 Ibid., p. 2.

33 Rojek, *Decentring Leisure*, p. 2.

34 Jean Baudrillard, *Simulacra and Simulation*, trans. S. F. Glaser (University of Michigan Press, Michigan, 2006), p. 1.

35 Ibid., p. 12.

36 Richard Jochum, *Playground*, exhibition in El Sawy Center Zamalek, Cairo, 11-19 February 2005, at: www.richardjochum.net/playground-e.html, last accessed 21 November 2007.

37 www.proyectotrama.org, quoted in Claire Doherty, 'The institution is dead! Long live the institution! Contemporary Art and New Institutionalism', engage review, *Art of Encounter*, Issue 15, Summer 2004, at: www.engage.org/readmore/..%5Cdownloads%5C152E25D29_15.%20Claire%20Doherty.pdf, last accessed 5 September 2009.

38 Ibid.

39 Ibid.

40 Venice Biennale, www.labiennale.org/en/art/news/awards-n.html, last accessed 8 July 2009.

41 Ibid.

42 Homi K. Bhabha, 'Border Lives: The Art of the Present', 1994, in *Art in Theory. 1900–2000. An Anthology of Changing Ideas*, eds. C. Harrison and P. Wood (Blackwell Publishing, Oxford, 2003), p. 1111.

43 Zygmunt Bauman, 'From Pilgrim to Tourist – or a Short History of Identity', in: *Cultural Identity*, eds. S. Hall and P. du Gay (Sage Publications, London, 1996), pp. 25–6.

44 Bauman, 'From Pilgrim to Tourist', p. 29.

45 Claire Bishop, 'The Social Turn: Collaboration and Its Discontents', in *Stadium X: A Place that Never Was: A Reader*, ed. J. Warsza (Bęc Zmiana Foundation, Warszawa, Kraków, 2008), p. 49.

46 Bishop, 'The Social Turn', p. 48.

47 See Karl Marx, *A Critique of German Ideology* (1932), available at: www.marxists.org/archive/marx/works/download/Marx_The_German_Ideology.pdf, last accessed 4 August 2013.

48 Rojek, *Decentring Leisure*, p. 1.

49 Mary Flanagan, 'Artists' Locative Games' and 'Critical Computer Games', in *Critical Play: Radical Game Design* (MIT Press, Cambridge, Massachusetts; London), 2009.

50 Marie-Laure Ryan, 'Between Play and Politics: Dysfunctionality in Digital Art', *Electronic Book Review* online, 3 March 2010,

www.electronicbookreview.com/thread/imagenarrative/diegetic, last accessed 25 February 2012.

51 Ibid.

52 Emma Cocker, 'Not Yet There: Endless Searches and Irresolvable Quests', paper presented at *Telling Stories: Theories and Criticism*, Conference at Loughborough University, 20 April 2007.

53 Norman K. Denzin, 'The Paradoxes of Play' in: *The Paradoxes of Play*, ed. J. Loy (The Association for The Anthropological Study of Play, Leisure Press, New York, 1982), p. 14.

54 Jacques Derrida, 'Structure sign and play', in: *Writing and Difference*, trans. A. Bass (Routledge and Kegan Paul, London, 1978), p. 280.

55 Roland Barthes, 'From Work to Text', in *Art in Theory*, eds. C. Harrison and P. Wood, pp. 968–9.

56 This section is based on my paper 'The Criterion of Play' presented at the European Congress of Aesthetics, Madrid, Spain 2010 and published in the conference proceedings: *Societies in Crisis. Aesthetic Perspectives for Europe*, Universidad Autónoma de Madrid, 2011.

57 Bishop, 'The Social Turn', in *Stadium X*, p. 49.

58 This argument has been more recently developed by Bishop in her book: Claire Bishop, *Artificial Hells: Participatory Art and the Politics of Spectatorship* (Verso, New York), 2012.

59 Pierre Huyghe, quoted in *Art since 1900: Modernism, Antimodernism, Postmodernism*, H. Foster et al. (Thames and Hudson, London, 2004), p. 667.

60 Bishop, 'The Social Turn', p. 50.

61 Ibid., p. 51.

62 Csikszentmihalyi, 'Some Paradoxes in the Definition of Play', p. 14.

63 Joanna Rajkowska, 'Project's Description', *Greetings from Jerusalem Avenue*, http://www.palma.art.pl/pages/show/25, last accessed 4 August 2013.

64 See: Freud, Sigmund, *The Uncanny*, 1919, http://web.mit.edu/allanmc/www/freud1.pdf, last accessed 14 January 2014.

65 *The Unilever Series: Carsten Höller: Test site*, http://www.tate.org.uk/modern/exhibitions/carstenholler/, last accessed 14 January 2014.

66 'About the Army', Clandestine Insurgent Rebel Clown Army, http://www.clownarmy.org/about/about.html, last accessed 4 August 2013.

Conclusion

1 Mihai Spariosu, *Dionysus Reborn: Play and the Aesthetic Dimension in Modern Philosophical and Scientific Discourse* (Cornell University Press, Ithaca and London, 1989), p. 6.

References

'About the Army', Clandestine Insurgent Rebel Clown Army, http://www.
clownarmy.org/about/about.html, last accessed 4 August 2013

Agamben, Giorgio, 'In Playland: Reflections on History and Play', in *Infancy and History: the Destruction of Experience*, Verso, London, 1993

Alexander, Bobby C. and Edward Norbeck, 'Rite of passage', *Encyclopaedia Britannica Online*, at: http://www.britannica.com/EBchecked/topic/504562/rite-of-passage/283998/Victor-Turner-and-anti-structure, last accessed 8 August 2009

Altermodern, www.tate.org, at: http://www.tate.org.uk/britain/exhibitions/altermodern/participants.shtm#e21, last accessed 2 June 2009

Annas, Julia, 'An Introduction' to Plato's *The Republic*, Clarendon Press, Oxford, 1981

'Anonymous Letter Box – Howto', *Irational*, 20 January 2005, at: http://status.irational.org/letter_box/, last accessed 6 January 2012

Applebaum, Herbert A., *The Concept of Work: Ancient, Medieval, and Modern*, State University of New York Press, Albany, New York, 1992

Arendt, Hannah, *The Human Condition*, The University of Chicago Press, Chicago, 1958

Aristotle, *Nicomachean Ethics*, trans. W. D. Ross, at: http://classics.mit.edu/Aristotle/nicomachaen.html, last accessed 5 August 2013

'Aristotle's Ethics' (published 2001, revised 2010), *Stanford Encyclopedia of Philosophy*, available at http://plato.stanford.edu/entries/aristotle-ethics/#HumGooFunArg, last accessed 25 November 2011

'A Trip to Asia: An Acoustic Walk Around the Vietnamese Sector of the 10th-Anniversary Stadium', website of the Laura Palmer Foundation, at: http://www.laura-palmer.pl/en/projects/9/podroz-do-azji-/, last accessed 15 July 2009

Austin, John, L., 'Performatives and Constatives', in *How to Do Things with Words* (1955), Oxford University Press, Oxford, New York, 1975

Avedon, Elliot M. and Sutton-Smith, Brian, *The Study of Games*, John Wiley & Sons, New York, London, Sydney, Toronto, 1971

Bahr, Hermann, 'Expressionism' (1914), trans. R. T. Gribble, in *Art in Theory. 1900–2000. An Anthology of Changing Ideas*, C. Harrison and P. Wood (eds.), Blackwell Publishing, Oxford, 2003

Bakhtin, Mikhail, *Rabelais and His World*, trans. H. Iswolsky, The Massachusetts Institute of Technology, Cambridge, Massachusetts, 1968

Balfour, Alexandra and Sudbanthad, Pitchaya, 'Marina Abramovic', at: http://www.duke.edu/web/museo/spring99/marina.html, last accessed 5 August 2013

Bantinaki, Katerina, 'Art Beyond Representation: The Performative Power of the Image', *The British Journal of Aesthetics*, Vol. 46 Issue 2, 2006 at: http://bjaesthetics.oxfordjournals.org/cgi/content/full/46/2/213, last accessed 17 July 2009

Barber, Bruce, 'Sentences on Littoral Art', at: http://www.wizya.net/sentence.htm, last accessed 6 July 2009

Barker, Chris, 'Key Concepts in Cultural Studies', in *Cultural Studies. Theory and Practice*, Sage Publications, London, New Dehli, 2000

Barthes, Roland, 'From Work to Text', in *Art in Theory. 1900–2000. An Anthology of Changing Ideas*, C. Harrison and P. Wood (eds.), Blackwell Publishing, Oxford, 2003

Bataille, Georges, 'Primitive Art' (1930), fragments in *Primitivism and 20th Century Art. A Documentary History*, M. Deuth and J. Flam (eds.), University of California Press, Berkeley, 2003

Bateson, Gregory, 'A Theory of Play and Fantasy' (1955), in *The Performance Studies Reader*, H. Bial (ed.), 2nd edition, Routledge, London, New York, 2007

Baudrillard, Jean, *Simulacra and Simulation*, trans. S. F. Glaser, University of Michigan Press, Michigan, 2006

Bauman, Zygmunt, *Intimations of Postmodernity*, Routledge, London and New York, 1997

———— 'From Pilgrim to Tourist – or a Short History of Identity', in *Cultural Identity*, S. Hall and P. du Gay (eds.), Sage Publications, London, 1996

Beech, Dave, 'Include me out! Dave Beech on participation in art', *Art Monthly*, April 2008, at: http://findarticles.com/p/articles/mi_6735/is_315/ai_n28512975/?tag=content;col1, last accessed 2 November 2009

Berghaus, Gunter, 'Happenings in Europe. Trends, Events, and Leading Figures', in *Happenings and Other Acts*, M. R. Sandford (ed.), Routledge, London, 1995

Bhabha, Homi K., 'Border Lives: The Art of the Present', 1994, in *Art in Theory. 1900–2000. An Anthology of Changing Ideas*, C. Harrison and P. Wood (eds.), Blackwell Publishing, Oxford, 2003

Bishop, Claire, *Installation Art. A Critical History*, Tate Publishing, London, 2005

———— *Artificial Hells: Participatory Art and the Politics of Spectatorship*, Verso, London and New York, 2012

———— (ed.), *Participation*, Whitechapel, London, 2006

Bolt, Barbara, *Art Beyond Representation: The Performative Power of the Image*, I.B.Tauris, London, 2004

Bourriaud, Nicolas, *Relational Aesthetics* (1998), trans. S. Pleasance and F. Woods, les presses du réel, Dijon, 2002

———— *Postproduction* (2002), trans. J. Herman, Lukas & Sternberg, New York, 2007

Breton, André, 'from the First Manifesto of Surrealism' (1924), trans. H. R. Lane and R. Seaver, in *Art in Theory. 1900–2000. An Anthology of Changing Ideas*, C. Harrison and P. Wood (eds.), Blackwell Publishing, Oxford, 2003

Bristol, Michael, D., 'The Dialectic of Laughter', in *Carnival and Theater: Plebeian Culture and the Structure of Authority in Renaissance England*, Routledge, New York and London, 1989

Bürger, Peter, *Theory of the Avant-Garde* (1984), trans. M. Shaw, University of Minnesota Press, Minneapolis, 2004

Burke, Edmund, *A Philosophical Enquiry into the Sublime and Beautiful and Other Pre-Revolutionary Writings* (1757), D. Womersley (ed.), Penguin Books, London, 2004

Butler, Judith, *Gender Trouble: Feminism and the Subversion of Identity*, Routledge, New York, 1990

Cage, John, *Silence: Lectures and Writings by John Cage*, Calder and Boyars, London, 1968

—— and Charles, Daniel, 'For the Birds', in 'Nietzsche's Return', *Semiotexte*, Vol. III, No. 1, 1978

Caillois, Robert, *Man, Play and Games* (1958), trans. M. Barash, University of Illinois Press, Urbana and Chicago, 2001

Čapek, Josef, 'Negro Sculpture' (1918), in *Primitivism and 20th Century Art. A Documentary History*, M. Deutch and J. Flam (eds.), University of California Press, Berkeley and Los Angeles, 2003

Chilvers, Ian, 'Primitivism', in *Oxford Dictionary of 20th-Century Art*, Oxford University Press, Oxford, 1999

Cocker, Emma, 'Not Yet There: Endless Searches and Irresolvable Quests', paper abstract, *Telling Stories: Theories and Criticism Conference*, Loughborough University, 20 April 2007

Conley, Katharine, *Robert Desnos, Surrealism, and the Marvelous in Everyday Life*, University of Nebraska Press, Lincoln, 2002

Croce, Benedetto, 'Theoretic and Practical Activity', in *Aesthetic as Science of Expression and General Linguistic*, trans. D. Ainslie, BiblioBazaar, Charleston, 2007

Csikszentmihalyi, Mihaly, 'Some Paradoxes in the Definition of Play', in *Play as Context*, A. Taylor Cheska (ed.), The Association for The Anthropological Study of Play, Leisure Press, New York, 1981

'DaDa in Zürich', *DaDa Online*, available at http://www.peak.org/~dadaist/English/TextOnly/dadazurich.html, last accessed 5 August 2013

Danto, Arthur C., *After the End of Art: Contemporary Art and the Pale of History*, Princeton University Press, New York, 1997

De Certeau, Michel, '"Making Do": Uses and Tactics', in *The Practice of Everyday Life*, Vol.1, University of California Press, London, 1988

Dean, Carolyn J., *The Self and its Pleasures: Bataille, Lacan and the History of the Decentred Subject*, Cornell University Press, Ithaca and London, 1992

Deleuze, Gilles and Guattari, Félix, 'Introduction: Rhizome', in *A Thousand Plateaus*, 1987, trans. B. Massumi, Continuum Impacts, London and New York, 2004

Denzin, Norman K., 'The Paradoxes of Play', in *The Paradoxes of Play*, J. Loy (ed.), The Association for The Anthropological Study of Play, Leisure Press, New York, 1982

Derrida, Jacques, *Writing and Difference*, trans. A. Bass, Routledge and Kegan Paul, London, 1978

———— 'Sending: On Representation', trans. P. Caws and M. A. Caws, in *Social Research* Vol. 49 No. 2, 1982

———— *The Truth in Painting*, trans. G. Bennington and I. McLeod, The University of Chicago Press, Chicago, 1987

———— *Dissemination*, trans. B. Johnson, The Athlone Press, London, 1997

Deutscher, Penelope, *How to Read Derrida*, Granta Books, London, 2005

Dewey, John, *Art as Experience* (1934), A Perige Book, New York, 2005

Doherty, Claire (ed.), *Contemporary Art: From Studio to Situation*, Black Dog Publishing, London, 2004

———— 'The institution is dead! Long live the institution! Contemporary Art and New Institutionalism', *Art of Encounter*, Issue 15, Summer 2004, online at: http://www.engage.org/readmore/..%5Cdownloads%5C152E25D29_15.%20Claire%20Doherty.pdf, last accessed 5 September 2009

Drachen Anders, Hitchens, Michael, 'The Many Faces of Role-Playing Games', *International Journal of Role-Playing*, Issue 1, 2008, p. 6, at: http://journalofroleplaying.org/, last accessed 5 August 2013

Duchamp, Marcel, 'The Creative Act' (1957), at: http://www.wisdomportal.com/Cinema-Machine/Duchamp-CreativeAct.html, last accessed 2 June 2009

Edgar, Andrew and Peter Sedgwick (eds.), 'Production', in *Cultural Theory. The Key Concepts*, 2nd Edn., Routledge, London and New York, 2008

Engels, Friedrich and Karl Marx, *The German Ideology*, 1932, at: http://www.marxists.org/archive/marx/works/download/Marx_The_German_Ideology.pdf

'Ergon', *The Blackwell Dictionary of Western Philosophy*, N. Bunnin and Y. Jiyuan (eds.), available at: http://www.blackwellreference.com/public/tocnode?id=g9781405106795_chunk_g97814051067956_ss1-107, last accessed 5 August 2013

Fer, Briony, 'Poussière/peinture: Bataille on Painting', in *Bataille. Writing the Sacred*, Gill C. Bailey (ed.), Routledge, London, 1995

Fine, Gary, A., 'Fantasy Role-Play Gaming as a Social World: Imagination and the Social Construction of Play', in *The Paradoxes of Play*, J. Loy (ed.), The Association for The Anthropological Study of Play, Leisure Press, New York, 1982

Flanagan, Mary, *Critical Play: Radical Game Design*, The MIT Press, Cambridge, Massachusetts; London, 2009

Fontana, Lucio, 'The White Manifesto' (1946), in *Art in Theory. 1900–2000. An Anthology of Changing Ideas*, C. Harrison and P. Wood (eds.), Blackwell Publishing, Oxford, 2003

Foster, Hal, 'The Primitive Unconscious of Modern Art' (1985), in *Primitivism and 20th Century Art. A Documentary History*, M. Deuth and J. Flam (eds.), University of California Press, Berkeley, 2003

————— Rosalind Krauss, Yve-Alain Bois and Benjamin Buchloh, *Art since 1900: Modernism, Antimodernism, Postmodernism*, Thames and Hudson, London, 2004

Freud, Sigmund, *Totem and Taboo*, trans. J. Strachey, W.W. Norton, New York, 1950

————— 'Beyond the Pleasure Principle', in *Complete Works*, Vol. 18, trans. J. Strachey, Hogarth Press, London, 1955

————— 'Creative Writers and Day-Dreaming' (1907), in *Art and Literature*, The Penguin Freud Library, Vol. 14, trans. J. Strachey and A. Dickson (ed.), Penguin Books, Harmondsworth, 1990

Friedman, Ken, 'Fluxus & Company' (1989), in *The Fluxus Reader*, K. Friedman (ed.), Academy Editions, Chichester, 1998

Gadamer, Hans-Georg, *The Relevance of the Beautiful and Other Essays*, trans. N. Walker and R. Bernasconi (ed.), Cambridge University Press, Cambridge, 1986

————— 'Aesthetic and Hermeneutic Consequences', in *Truth and Method* (1960), trans. J. Weinsheimer and D. G. Marshall, Continuum, London, New York, 2006

————— 'The ontology of the work of art and its hermeneutic significance', in *Truth and Method* (1960), trans. J. Weinsheimer, D. G. Marshall, Continuum, London, New York, 2006

Genesis 3: 17, *The Holy Bible: New International Version*, at: http://www.biblica.com/bible/verse/?q=Genesis%203:1-24&=yes, last accessed 8 September 2009

Goldberg, Alan, 'Play and Ritual in Haitan Voodoo Shows for Tourists', in *The Paradoxes of Play*, J. Loy (ed.), The Association for the Anthropological Study of Play, Leisure Press, New York, 1982

Goldberg, Roselee, *Performance Art: From Futurism to the Present*, Thames and Hudson, London, 1988

Goldwater, Robert, *Primitivism in Modern Art*, The Belkin Press of Harvard University Press, Cambridge, Massachusetts; London, 1986

Gooding, Mel (ed.), *A Book of Surrealist Games*, Redstone Press, London, 1995

Goodman, Paul, *Communitas: Means of Livelihood and Ways of Life*, University of Chicago Press, Chicago, 1947

Gould, Stephen Jay, 'The Substantial Ghost: Towards a General Exegesis of Duchamp's Artful Wordplays', *Tout-Fait: The Marcel Duchamp Studies Online Journal*, May 2000, at: http://www.toutfait.com/issues/issue_2/Articles/gould.html, last accessed 20 June 2009

Graf, Fritz, *Greek Mythology: An Introduction*, trans. T. Marier, The Johns Hopkins University Press, Baltimore, 1993

Green, Christopher, 'The Infant in the Adult', in *Discovering Child Art*, J. Fineberg (ed.), Princeton University Press, Princeton, 1998

Griffiths, Paul, *Cage*, Oxford University Press, Oxford, 1981

Grindon, Gavin, 'Autonomy, Activism, and Social Participation in the Radical Avant-Garde', *Oxford Art Journal* Vol. 34 Issue 1, 2011

Grondin, Jean, 'Play, Festival and Ritual in Gadamer: on the theme of the immemorial in his later works', trans. L. K. Schmidt, available at: http://mapageweb.umontreal.ca/grondinj/pdf/play_festival_ritual_gadam.pdf, last accessed 15 November 2009

Hall, Stuart, 'Introduction: Who Needs Identity?', in *Cultural Identity*, S. Hall and P. du Gay (eds.), Sage Publications, London, 1996

——— 'The Spectacle of the Other', in *Representation. Cultural Representations and Signifying Practices*, S. Hall, (ed.), Sage Publications, London, 2001

Handleman, Don, 'Play: Epistemology and Change', in *Play as Context*, A. Taylor Cheska (ed.), The Association for the Anthropological Study of Play, Leisure Press, New York, 1981

Harrington, Austin, *Art and Social Theory: Sociological Arguments in Aesthetics*, Polity Press, Cambridge, 2004

Harviainen, Tuomas, 'A Hermeneutical Approach to Role-Playing Analysis', in *International Journal of Role-Playing*, Issue 1, 2008, p. 70, at: http://journalofroleplaying.org/, last accessed 5 August 2013

Haynes, Deborah, *Bakhtin and the Visual Arts*, Cambridge University Press, Cambridge, 1995

Hill, Roger B., 'Historical Context of the Work Ethic', *History of the Work Ethic*, 1996, at: http://www.coe.uga.edu/~rhill/workethic/hist.htm, last accessed 7 July 2009

Hobson, Marian, 'Mimesis, presentation, representation', in *Jacques Derrida and the Humanities. A Critical Reader*, T. Cohen (ed.), Cambridge University Press, Cambridge, 2001

Huizinga, Johan, *Homo Ludens: a Study of Play Element in Culture* (1938), Taylor & Francis, Inc., International Library of Sociology Series, London, 2003

――― 'The Nature and Significance of Play as a Cultural Phenomenon', in *The Performance Studies Reader*, H. Bial (ed.), 2nd Edn., Routledge, London, New York, 2007

Isenberg, Joan Packer and Nancy Quisenberry, 'Play: Essential for all children, A Position Paper of the Association for Childhood Education International', *Childhood Education*, Vol. 79, 2002, at: http://www.acei.org/playpaper.htm, last accessed 28 August 2011

Janin, Zuzanna, 'I've seen my death', at: http://www.janin.art.pl/english/texts/texty_htm/pl/text_mydeath.htm, last accessed 27 October 2009

Jochum, Richard, *Playground*, exhibition in El Sawy Center Zamalek, Cairo, 11-19 February 2005, at: www.richardjochum.net/playground-e.html, last accessed 21 November 2007

Jones, Amelia, *Postmodernism and the En-Gendering of Marcel Duchamp*, Cambridge University Press, Cambridge, 1994

Johnson, Barbara, 'Translator's Introduction', in J. Derrida, *Dissemination*, The Athlone Press, London, 1997

Kachur, Lewis, *Displaying the Marvelous: Marcel Duchamp, Salvador Dali, and Surrealist Exhibition*, MIT Press, Cambridge, Massachusetts, 2001

Kamuf, Peggy (ed.), *A Derrida Reader. Between the Blinds*, Columbia University Press, New York, 1991

Kant, Immanuel, *Critique of Judgement* (1790), trans. J. C. Meredith, Clarendon Press, Oxford, 1952

Kaprow, Allan, *Essays on the Blurring of Art and Life* (1993), University of California Press, Berkeley, Los Angeles, London, 2003

――― 'Assemblages, Environments and Happenings', in *Happenings and Other Acts*, M. R. Sandford (ed.), Routledge, London, 1995

Katz-Freiman, Tami (Curator), *Power Games: Contemporary Art from Poland*, 24 January–20 June 2009, Haifa Museum of Art, text at: http://www.slashseconds.org/issues/003/002/articles/aestheticsof violence/articles/powergames/index.php, last accessed 5 August 2013

Kelley, Jeff, *Childsplay: the Art of Allan Kaprow*, University of California Press, Berkeley, London, 2004

Kester, Grant H., *Conversation Pieces: Community + Communication in Modern Art*, University of California Press, London, 2004

Kirchner, Ernst Ludwig, 'Programme of the Brücke' (1906), in *Art in Theory. 1900–2000. An Anthology of Changing Ideas*, C. Harrison and P. Wood (eds.), Blackwell Publishing, Oxford, 2003

Korzybski, Alfred, 'A Non-Aristotelian System and its Necessity for Rigour in Mathematics and Physics', paper presented at the meeting of the American Association for the Advancement of Science, New Orleans, 1931, reprinted in *Science and Sanity*, 1933

Kostelanetz, Richard, *Conversing with Cage*, 2nd Edn., Routledge, London, 2003

Kuh, Katharine, 'Marcel Duchamp', in *The Artist's Voice. Talks with Seventeen Modern Artists*, Da Capo Press, New York, 2000

Kwon, Miwon, *One Place after Another: Site-Specific Art and Locational Identity*, MIT Press, Cambridge, Massachusetts, 2004

Lassaw, Ibram, 'On Inventing Our Own Art', American Abstract Artists group statement (1938), in *Art in Theory. 1900–2000. An Anthology of Changing Ideas*, C. Harrison and P. Wood (eds.), Blackwell Publishing, Oxford, 2003

Li, Victor, *The Neo-Primitivist Turn. Critical Reflections on Alterity, Culture and Modernity*, University of Toronto Press, Toronto, 2006

Linssen, Robert, 'Zen Buddhism and Everyday Life', in *The World of Zen. An East-West Anthology*, N. W. Ross (ed.), Collins, London, 1962

Lucy, Niall, *A Derrida Dictionary*, Blackwell Publishing, Oxford, 2004

Luquet, Georges, 'Primitive Art' (1930), fragments in *Primitivism and 20^{th} Century Art. A Documentary History*, M. Deuth and J. Flam (eds.), University of California Press, Berkeley, 2003

Maas, Wietske (ed.) *An Architecture of Interaction*, Mondriaan Foundation and The Netherlands Foundation for Visual Arts, Design and Architecture, Amsterdam, 2008

Macey, David, 'Introduction', in J. Lacan, *Four Fundamental Concepts of Psycho-Analysis*, trans. A. Sheridan, J-A. Miller (ed.), Penguin Books, London, 1994

Maciunas, George, 'Manifesto' (1963), in *fLuxus deBris,* at: http://www.artnotart.com/fluxus/gmaciunas-manifesto.html, last accessed 4 May 2009

Macke, August, 'Masks' (1912), in *Art in Theory. 1900–2000. An Anthology of Changing Ideas*, C. Harrison and P. Wood (eds.), Blackwell Publishing, Oxford, 2003

Making Worlds, 53 International Art Exhibition, Venice Biennale, Marsilio, 2009

Marx, Karl, 'The Labour-Process and the Process of Producing Surplus-Value Capital', in *Capital*, Vol. 1, Part III, at: http://www.marxists.org/archive/marx/works/1867-c1/ch07.htm, last accessed 5 August 2013

Millar, Susanna, *The Psychology of Play*, Penguin Books, Baltimore, Maryland, 1968

Nagel, Mechthild, *Masking the Abject: A Genealogy of Play*, Lexington Books, Lanham, 2002

Nolde, Emil (1912) in J. Lloyd, 'Emil Nolde's "ethnographic" still lifes: primitivism, tradition, and modernity', in *The Myth of Primitivism. Perspectives on Art*, S. Hiller (ed.), Routledge, London and New York, 1991

Norris, Christopher, *Derrida*, Fontana Press, London, 1987

Olivieira, Nicolas de, Nicola Oxley and Michael Petry, *Installation Art in the New Millennium. The Empire of the Senses*, Thames and Hudson, London, 2003

Owen, Craig, *Beyond Recognition: Representation, Power and Culture*, S. Bryson, et al. (eds.), University of California Press, Los Angeles, London, 1994

Owocki, Gretchen, 'Play and Developmentally Appropriate Practices', in *Literacy through Play*, Heinemann, Portsmouth, 1999

Pappas, Nickolas, *Routledge Philosophy Guidebook to Plato and The Republic*, Routledge, London and New York, 1995

Picasso, Pablo, 'Discovery of African Art' (1906–1907), in *Primitivism and 20th Century Art. A Documentary History*, M. Deutch and J. Flam (eds.), University of California Press, Berkely, California, 2003

——— 'Picasso Speaks', from the interview with M. De Zayas (1923), in *Art in Theory. 1900–2000. An Anthology of Changing Ideas*, C. Harrison and P. Wood (eds.), Blackwell Publishing, Oxford, 2003

Pitkin, Hanna, *The Concept of Representation*, University of California Press, Berkeley, California, 2006

Plato, *The Republic*, Books 1, 2, 10, trans.D.Lee, Penguin Books, London, 1955

Przybyszewski, Stanisław, 'Primitivists to the Nations of the World and to Poland' (1920), in M. A. Caws (ed.), *Manifesto: A Century of Isms*, University of Nebraska Press, Lincoln and London, 2001

Rajkowska, Joanna, 'Project's Description', *Greetings from Jerusalem Avenue*, http://www.palma.art.pl/pages/show/25, last accessed 4 August 2013

Reiss, Julie H., *From Margin to Center. The Spaces of Installation Art*, Massachusetts Institute of Technology, Massachusetts, 2001

Rhodes, Colin, *Primitivism and Modern Art*, Thames and Hudson, London, 1994

Richards, K. Malcolm, *Derrida Reframed. A Guide for the Arts Student*, I.B. Tauris, London and New York, 2008

Richardson, Michael, *Georges Bataille*, Routledge, London and New York, 1994

―――― 'Introduction' to: G. Bataille, *The Absence of Myth: Writings on Surrealism*, Verso, London, New York, 2006

Richter, Hans, *Dada: Art and Anti-Art*, Thames and Hudson, London, 1997

Rodriguez, Hector, 'The Playful and the Serious: An approximation to Huizinga's *Homo Ludens*', *Game Studies: The International Journal of Computer Game Research*, Vol. 6, No. 1, December 2006, at: http://game studies.org/0601/articles/rodriges, last accessed 20 February 2011

Rojek, Chris, *Decentring Leisure: Rethinking Leisure Theory*, Sage Publications, London, 1995

Ross, Nancy W., 'Humour in Zen', in *The World of Zen: An East-West Anthology*, N. W. Ross (ed.), Collins, London, 1962

Rousseau, Jean-Jacques, *On the Origin of Languages*, trans. J. H. Moran, University of Chicago Press, Chicago and London, 1966

―――― *The Confessions*, 1765, trans. J. M. Cohen, Penguin Books, Victoria, Australia, 1970

Royle, Nicholas, *Jacques Derrida*, Routledge, London, 2003

Rozenthal, Mark, *Understanding Installation Art: From Duchamp to Holzer*, Prestel, Munich, 2003

Rubin, William, (ed.), *'Primitivism' in 20th Century Art: Affinity of the Tribal and the Modern*, The Museum of Modern Art, New York, Published in conjunction with an exhibition of the same title, 1984

Ryan, Marie-Laure, 'Between Play and Politics: Dysfunctionality in Digital Art', *Electronic Book Review* online, 3 March 2010, www.electronicbook review.com/thread/imagenarrative/diegetic, last accessed 25 February 2012

Salen, Katie and Eric Zimmerman, *Rules of Play: Game Design Fundamentals*, MIT Press, Cambridge, MA, 2003

Samaltanos, Katia, *Apollinaire: Catalyst for Primitivism, Picabia and Duchamp*, UMI Research Press, Studies in the Fine Arts: The Avant-Garde, Michigan, 1984

Scanlan, Joe, 'Duchamp's wager: disguise, the play of surface, and disorder', *History of the Human Sciences*, Vol. 16, No. 3, 2003, at: http://hhs.sagepub.com/cgi/content/abstract/16/3/1, last accessed 1 June 2009

Schechner, Richard, *The Future of Ritual: Writings on Culture and Performance*, Taylor & Francis, London, 1993

Shevchenko, Aleksandr, 'Neo-Primitivism: Its Theory, Its Potentials, Its Achievements' (1913), in *Art in Theory. 1900–2000. An Anthology of Changing Ideas*, C. Harrison and P. Wood (eds.), Blackwell Publishing, Oxford, 2003

Smith, Matthew W., 'Total World: Disney's Theme Parks', in *The Total Work of Art: From Bayreuth to Cyberspace*, Routledge, London and New York, 2007

Spariosu, Mihai, *Dionysus Reborn: Play and the Aesthetic Dimension in Modern Philosophical and Scientific Discourse*, Cornell University Press, Ithaca and London, 1989

Spencer, Herbert, *The Principles of Psychology* (1855), Gregg, Farnborough, 1970

Stangos, Nikos (ed.), *Concepts of Modern Art: From Fauvism to Postmodernism*, Thames and Hudson, London, 1994

Stehle, Eva, *Performance and Gender in Ancient Greece: Nondramatic Poetry in its Setting*, Princeton University Press, Princeton, 1997

Storck, Gesine, 'L=∞. Spiel des Lebens, Denk und Meditationsspiel', trans. K. Zimna, 2010

Storr, Anthony, 'Creativity and Play', in *The Dynamics of Creation*, Secker & Warburg, London, 1972

Sutton-Smith, Brian, 'Conclusion: The Persuasive Rhetorics of Play', in *The Future of Play Theory: A Multidisciplinary Inquiry into the Contribution of Brian Sutton-Smith*, A. D. Pellegrini (ed.), State University of New York Press, Albany, 1995

—— and R. E. Herron, *Child's Play*, John Wiley & Sons, New York, 1971

Tate: Turner Prize, http://www.tate.org.uk/britain/turnerprize/2004/deller.shtm, last accessed 4 July 2009

The Art of Participation: 1950 to Now, exhibition catalogue, San Francisco Museum of Modern Art, Thames and Hudson, 2008

'Thoth', WordNet, Princeton University, available at: http://wordnetweb.princeton.edu/perl/webwn?s=thoth, last accessed 8 March 2008

Thrift, Nigel, *Non-Representational Theory: Space/Politics/Affect*, Routledge, London and New York, 2008

Thurow, Lester, *Head to Head*, William Morrow & Co, 1992, at: http://www.icodap.org/ZenWorkAndPlay.htm

Turner, Edith, 'Communitas, Rites of', in *Encyclopedia of Religion, Communication and Media*, D. A. Stout (ed.), p. 98, online at: http://www.routledge-ny.com/ref/religionandsociety/rites/communitas.pdf, last accessed 22 July 2009

Tzara, Tristan, 'Dada Manifesto 1918', trans. R. Mannheim, in *Art in Theory. 1900–2000. An Anthology of Changing Ideas*, C. Harrison and P. Wood (eds.), Blackwell Publishing, Oxford, 2003

———— 'Note on African Art', 1917, in *Primitivism and 20th Century Art: A Documentary History*, M. Deutch and Flam J. (eds.), University of California Press, Berkeley, 2003

Warsza, Joanna (ed.), *Stadium X: A Place that Never Was: A Reader*, Bęc Zmiana Foundation, Warszawa, Kraków, 2008

————, in the interview with Buczek, D., 'Miejsce którego nie było', ('Place that never was'), in *Wysokie Obsasy*, December 2009

Williams, Raymond, 'The Creative Mind', in *The Long Revolution*, Chatto & Windus, London, 1961

Winn, Steven, 'Childhood isn't what it used to be. In the arts, it's dark and complex', *SFGate*, 17 November 2004, at: http://www.sfgate.com/entertainment/article/Childhood-isn-t-what-it-used-to-be-In-the-arts-2635505.php, last accessed 5 August 2013

Winnicott, Donald, *Playing and Reality* (1971), Routledge, New York, 2005

Wittgenstein, Ludwig, *Philosophical Investigations*, Blackwell, Oxford, 1958

'Workshop', *The Politics of Play: Enabling Collaborative Networks in Public Spaces*, at: http://www.futurefarmers.com/play/workshop.html, last accessed 2 January 2012

Wörwag, Barbara, '"There is an Unconscious, Vast Power in the Child": Notes on Kandinsky, Münter and Children's Drawings', in *Discovering Child's Art*, J. Fineberg (ed.), Princeton University Press, Princeton, 1998

Venice Biennale, http://www.labiennale.org

Vygotsky, Lev, *Play and its Role in the Mental Development of the Child* (1933), online version (2002): Psychology and Marxism internet archive, at: http://www.marxists.org/archive/vygotsky/works/1933/play.htm, last accessed 13 July 2013

Yar, Majid, 'Hannah Arendt (1906-1975)', *Internet Encyclopedia of Philosophy*, 23 October 2001, revised 22 July 2005, at: http://www.iep.utm.edu/ arendt/#SH4a, last accessed 7 September 2009

Zimna, Katarzyna, 'The Criterion of Play', the European Congress of Aesthetics, Madrid, Spain 2010 proceedings: *Societies in Crisis. Aesthetic Perspectives for Europe*, Universidad Autónoma de Madrid, 2011

────── 'Artist – the Game Master', *Stimulus-Respond* online journal, 'Master' issue, August 2010, http://issuu.com/stimulusrespond/ docs/stimulusmaster, last accessed 7 August 2013

────── 'Tricksters lead the game' in *Trickster Strategies in the Artists and Curatorial Practice*, A. Markowska (ed.), Polish Institute of World Art Studies & Tako Publishing House, Warszawa, Toruń, 2013

Selected Bibliography

Aries, Philippe, *Centuries of Childhood. A Social History of Family Life*, Vintage Books, New York, 1962

Benjamin, Walter, 'The Author as Producer', trans. E. Jephcott; 'The Work of Art in the Age of Mechanical Reproduction', trans. H. Zohn, in: *Modern Art and Modernism. A Critical Anthology*, F. Frascina and C. Harrison, (eds.), Paul Chapman Publishing, New York, 1982

Best, Steven and Douglas, Kellner, *Postmodern Theory: Critical Interrogations*, Macmillan, London, 1991

Bruner, Jerome S., Alison Jolly and Kathy Sylva (eds.), *Play. Its Role in Development and Evolution*, Penguin Books, New York, 1976

Carroll, Noël, *Philosophy of Art: A Contemporary Introduction*, Routledge, London, 1999

Cheyne, J. Allan, 'Serious Play from Peregrination to Cultural Change: A Bateson-Gadamer-Harris Hypothesis', University of Waterloo, Canada, 1989, at: www.watarts.uwaterloo.ca/~acheyne/Misc/SeriousPlay.htm, last accessed 7 June 2009

Cohen, David, *The Development of Play*, Croom Helm, London, 1986

Colebrook, Claire, *Philosophy and Post-Structuralist Theory: From Kant to Deleuze*, Edinburgh, University Press, Edinburgh, 1993

Combs, James E., *Play World: the Emergence of the New Ludenic Age*, Praeger Publishers, Westport, 2000

Crowther, Paul, *Critical Aesthetics and Postmodernism*, Clarendon Press, Oxford, 1993

Csikszentmihalyi, Mihaly, *Beyond Boredom and Anxiety. The Experience of Play in Work and Games*, San Francisco, California, 1975

———— *Flow: the Psychology of Optimal Experience*, Harper Perennial, New York, 1991

———— 'Finding Flow' (1997), *Psychology Today*, at: http://www.psychology today.com/articles/pto-19970701-000042.html, last accessed 5 August 2013

Culture in Action: a Public Art Program of Sculpture Chicago, curated by Mary Jane Jacob, essays by Mary Jane Jacob, Michael Brenson and Eva M. Olson, Bay Press, Seattle, 1995

Danto, Arthur, *Beyond the Brillo Box: the Visual Arts in Post-Historical Perspective*, University of California Press, Berkely, 1998

Derrida, Jacques, *Of Grammatology*, trans. G. Spivak, Johns Hopkins University Press, Baltimore, 1976

———— *Positions*, 1972, trans. A. Bass, University of Chicago Press, Chicago and London, 1981

Deutscher, Penelope, *How to Read Derrida*, Granta Books, London, 2005

Eldridge, Richard, *An Introduction to the Philosophy of Art*, Cambridge University Press, Cambridge, 2003

Ellis, Michael J., *Why People Play*, Prentice-Hall International, London, 1973

Erikson, Erik, *Childhood and Society*, Norton, New York, 1958

Feagin, Susanne and Patric Maynard, (eds), *Aesthetics*, Oxford University Press, Oxford, 1997

Foster, Hal (ed.), *Postmodern Culture*, Pluto Press, London, 1985

Garvey, Catherine, *The Developing Child Series – Play*, Harvard University Press, Cambridge, Massachusetts, 1990

Gombrich, Ernst, 'Meditations on a Hobby Horse', in *Meditations on a Hobby Horse and Other Essays on the Theory of Art*, Phaidon Press, London, 1963

Grondin, Jean, *The Philosophy of Gadamer* (1999), trans. K. Plant, Acumen Publishing, Chesham, 2003

Groos, Karl, *The Play of Man*, trans. Elizabeth L. Baldwin, D. Appleton and Company, New York, 1901

Guss, Faith, 'Reconceptualizing Play: aesthetic self-definitions', Oslo University College, Norway, *Contemporary Issues in Early Childhood*, Vol. 6, No. 3, 2005

Harnad, Stevan, 'Creativity: Method or Magic?' *Cogprints: Cognitive Sciences Eprint Archive*, 19 June 2001, at: http://www.cogprints.org/1627/, last accessed 5 August 2013

Harris, Pauline, Pauline Lysaght and Irina Verenikina, 'Child's Play: Computer Games, Theories of Play and Children's Development', paper presented at the IFIP Working Group 3.5 Conference: *Young Children and Learning Technologies*, University of Wollongong State Parramatta, July 2003, at: http://www.crpit.com/confpapers/CRPITV34 Verenikina.pdf, last accessed 5 August 2013

Järvinen, Aki, 'Motives and Manifestations of Enjoyment in Gaming Encounter', unpublished PhD manuscript, version 0.9 – 3 January 2007, University of Tampere, Finland, at: http:www.gameswithoutfrontiers .net/g2/wpcontent/09_GwF_motives_manifestations_enjoyment.pdf, last accessed 3 June 2009

Kaprow, Allan, *Assemblage, Environments and Happenings*, H. N. Abrams, New York, 1966

Lacy, Susanne (ed.), *Mapping the Terrain: New Genre Public Art*, Bay Press, Seattle, Washington, 1995

Lakoff, George and Mark Johnson, *Metaphors we Live By*, University of Chicago Press, Chicago, London, 2003

Lewis, Pericles, *The Cambridge Introduction to Modernism*, Cambridge University Press, Cambridge, 2007

Lieberman, Josefa N., *Playfulness. Its Relationship to Imagination and Creativity*, Academic Press, New York, 1997

Lindqvist, Gunilla, 'The Aesthetics of Play: A didactic study of play and culture in preschools', doctoral dissertation, Uppsala University, Sweden, 1995

Livescu, Simona, 'From Plato to Derrida and Theories of Play', *Comparative Literature and Culture: A WWWeb Journal*, December 2003, at: http://docs.lib.purdue.edu/clcweb/vol5/iss4/5/, last accessed 5 August 2013

Meecham, Pam and Julie Sheldon, *Modern Art: a Critical Introduction*, Routledge, London and New York, 2004

Neill, Alex and Aaron Ridley (eds.), *The Philosophy of Art. Readings Ancient and Modern*, McGraw Hill, New York, 1995

Nelson, Robert S. and Richard Shiff, (eds.), *Critical Terms for Art History*, University of Chicago Press, Chicago, 1996

Norris, Christopher, *The Deconstructive Turn: Essays in the Rhetoric of Philosophy*, Methuen, London, 1983

Orton, Andrew (ed.), *Metaphor and Thought*, Cambridge University Press, Cambridge, 1993

Parr, Adrian (ed.), *The Deleuze Dictionary*, Columbia University Press, New York, 2005

Piaget, Jean, *Play, Dreams and Imitation in Childhood*, Norton, New York, 1962

Pope, Rob, *Creativity: Theory, History, Practice*, Routledge, Abingdon, 2005

Reiber, Lloyd, *Seriously Considering Play*, 1996, at: http://lrieber.coe.uga.edu/play.html, last accessed 5 August 2013

Rojek, Chris, *Leisure and Culture*, Macmillan, Basingstoke, 2000

Schechner, Richard, *Performance Studies: an Introduction*, Routledge, London, 2002

Schiller, Friedrich, *Letters on the Aesthetic Education of Man* (1794), trans. Reginald Snell, Dover Publications, New York, 2004

Segal, Hanna, *Dream, Phantasy and Art*, Vol. 12, The New Library of Psychoanalysis, Routledge, 1991

Stallybrass, Peter and White, Allon, *The Politics and Poetics of Transgression*, Cornell University Press, New York, 1986

Sutton-Smith, Brian, *The Ambiguity of Play*, Harvard University Press, Cambridge, Massachusetts and London, 1997

Turner, Victor, *From Ritual to Theatre: the Human Seriousness of Play*, Performing Arts Journal Publications, New York, 1982

———— *The Ritual Process: Structure and Anti-Structure*, Aldine de Gruyter, New York, 1995

Wallis, Brian (ed.), *Art After Modernism: Rethinking Representation*, New York, New Museum of Contemporary Art in association with David R. Godine, Publisher, Inc., Boston, 1984

Wood, David (ed.), *Derrida: A Critical Reader*, Blackwell Publishers, Oxford, 1999

Index